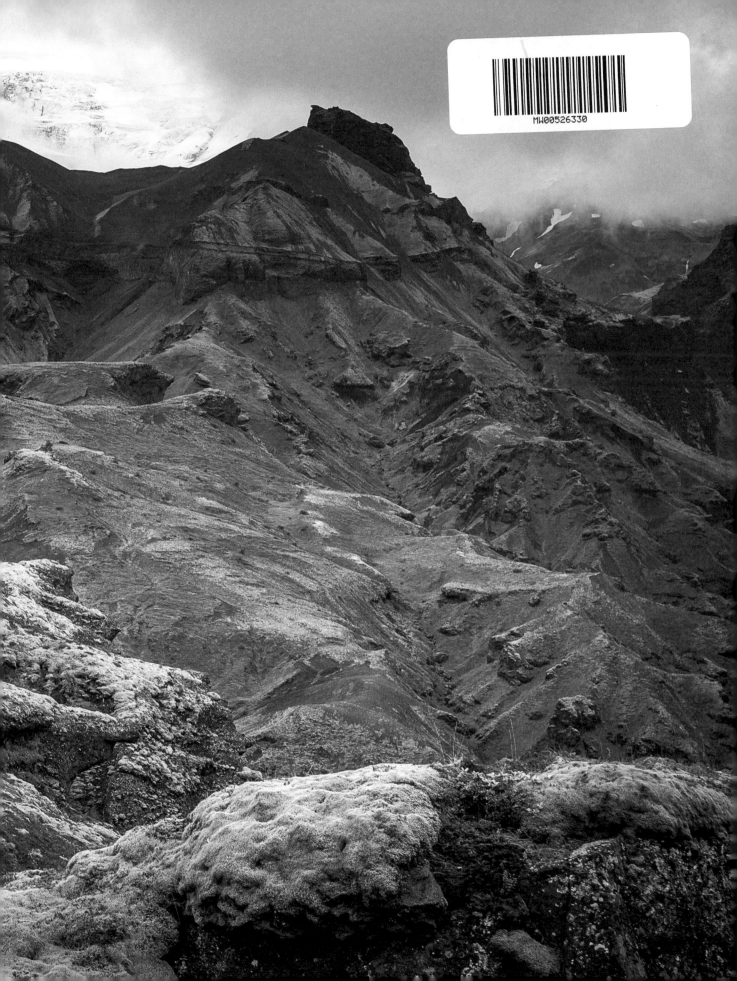

MW00526330

NORDIC CYCLE

Bicycle Adventures
in the North

gestalten

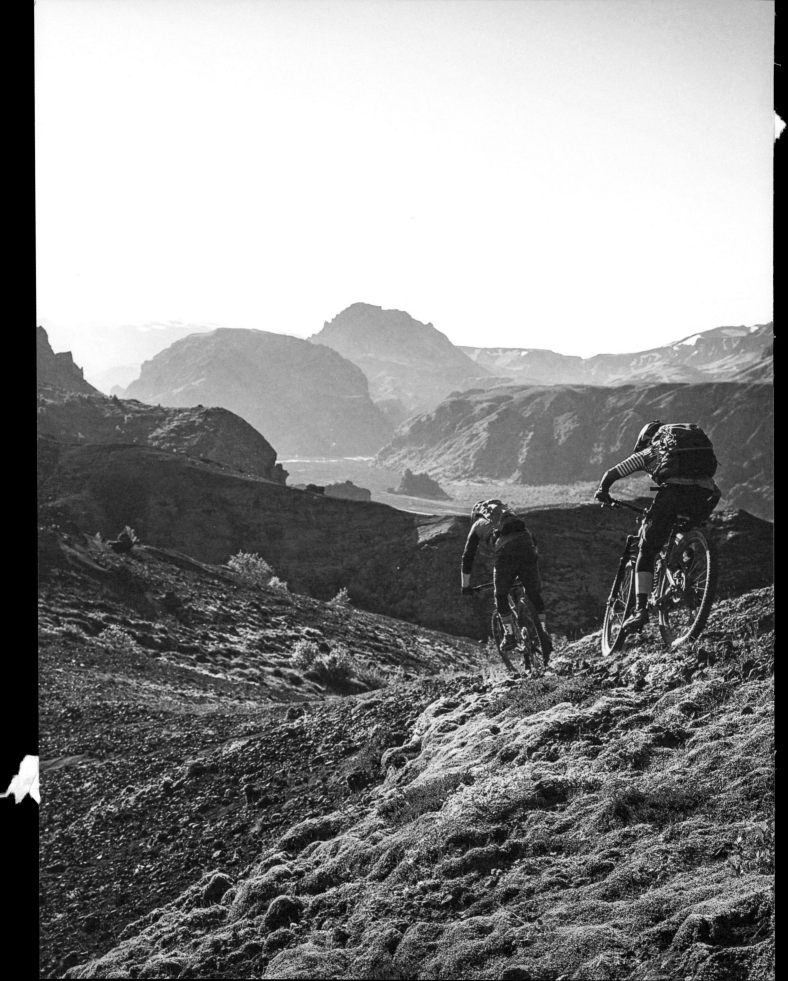

CONTENTS

PREFACE

Exploring New Grounds

4–13

>>>>>>>> ◆ <<<<<<<<

SCOTLAND

Highlands and Islands

14–37

FAROE ISLANDS

Remote Islands in the North Atlantic

38–71

ICELAND

Island of Fire and Ice

72–101

GREENLAND

The World's Largest Island

102–133

KAMCHATKA

The Simmering Peninsula

134–159

>>>>>>>> ◆ <<<<<<<<

RECIPES

Cuisine From the Road

160–195

IMPRINT

196

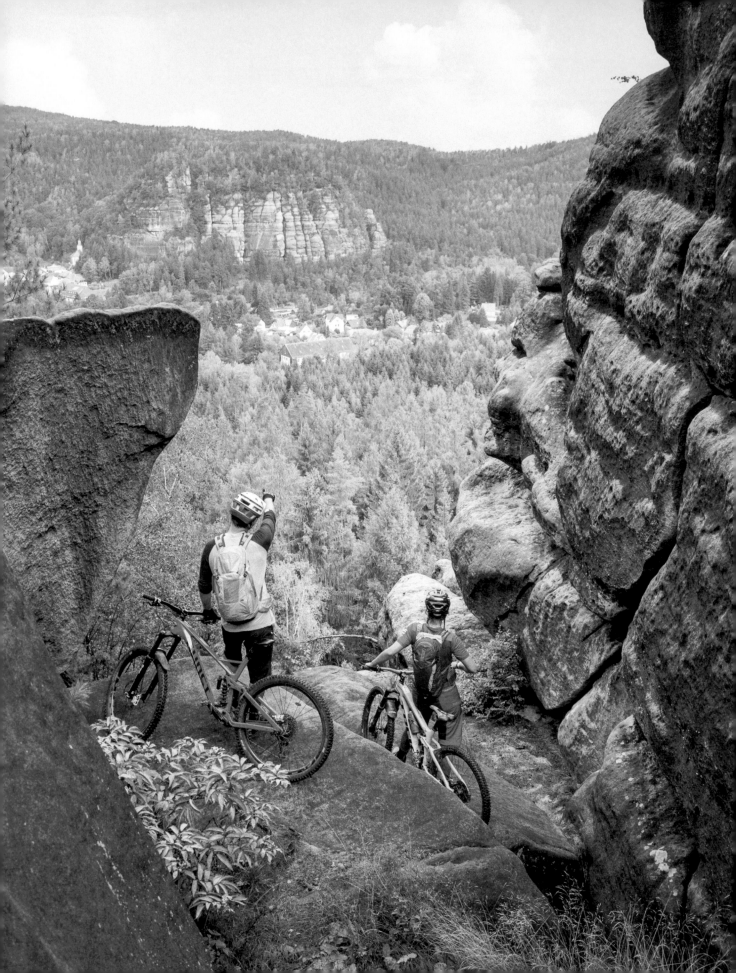

Exploring New Grounds

Author/Mountainbiker

TOBIAS

Tobias was born and raised in Bergneustadt, in the middle of North Rhine-Westphalia, Germany—an area where "mountain biker" is not a common career choice. But there was nothing else on his mind, so he spent every free minute on his bike. He even trained as a landscape gardener just to be able to build his own trails. Eventually he became one of the fastest German enduro racers. He had made it to the top and rode at World Cups. Yet he decided to turn his back on the colorful racing circuit to go on a mountain bike trip.

Mountain biking is the smell of fresh air, plants, leaves, and earth; the contrasting play of light in the forest; and the intoxicating view of mountain panoramas. It can also be an encounter with foreign countries, cultures, and great people. But for a long time, mountain biking meant exactly the opposite of all of this for me.

Athletes who ride World Cups runs, jump from wooden ramps over the heads of hundreds of spectators, and travel from competition to competition, do not have time to learn much about the countries they visit.

I was not a hero when I was in school. Back then, I naturally spent most of my time with my friends in the middle of nature on a bike.

I later became a landscape gardener because I wanted to build my own trails. Somehow I knew that my teachers were wrong when they said, "Forget about the mountain bike. Cycling is not a job." What I did not know, however, was that my career as a professional mountain biker was actually pushing me further away from what originally brought me to mountain biking: nature.

I realized I had to somehow redefine my profession as a mountain biker. In retrospect, I would like to say I was determined and clever, but in reality, I did not have a plan.

I started to explore the countries I had competed in, but never saw beyond the sporting venues. I traveled to new areas, paying attention not only to the trails, but also to what surrounded them. I felt that I had to look for particularly exotic destinations to find what I had lost. 〉〉〉

There is no other sport where you can get into the flow as well as mountain biking. Mountain biking condenses events and emotions.

>>> Surprisingly, I found everything that sparked my love for mountain biking nearby in the middle of Germany in the Ore Mountains: the forest, the varied and challenging landscape, and the exchanges with like-minded people. I also discovered a mountain biking infrastructure that I never expected in Germany.

No Place Like Home

Although today Germany has some of the best conditions for trail centers, similar to those in Scotland, it took a long time before they were first created. The high and steep mountains of the Alps are not as well suited for these types of trails as the low mountain regions. Here on these trails, both beginners with trekking bikes and mountain bike professionals can experience the same riding pleasure.

The mountain bike infrastructure in the Ore Mountains is wonderfully implemented and, in my opinion, a perfect model for any trail in Germany. The forest area in the far east of the country rises gently on the German side and drops steeply on the Czech side, offering perfect conditions. The trail parks Klínovec and Stoneman, as well as the neighboring hotels and restaurants, create a bike region that brings together cycling enthusiasts of all ages and skill levels. >>>

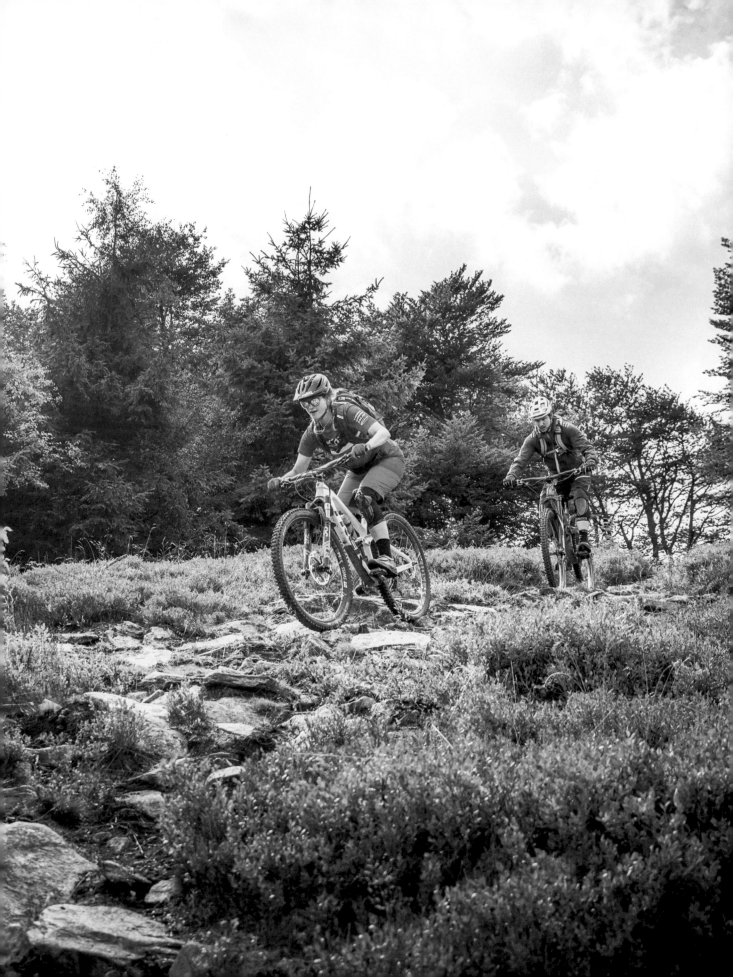

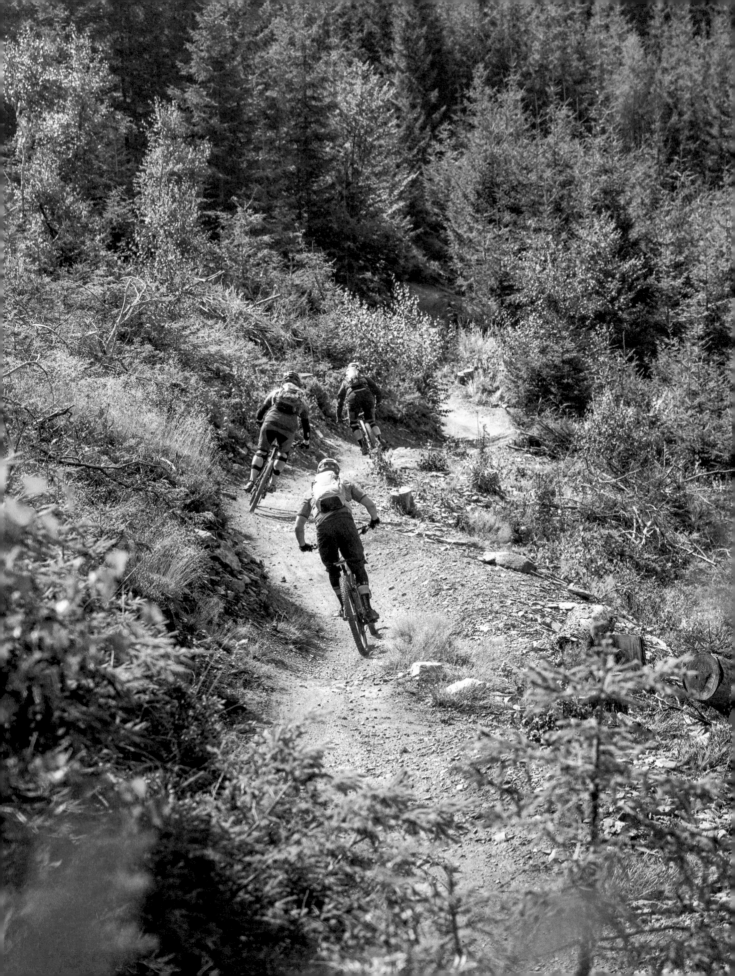

German low mountain ranges offer perfect terrain for bike trails, but their potential is rarely used.

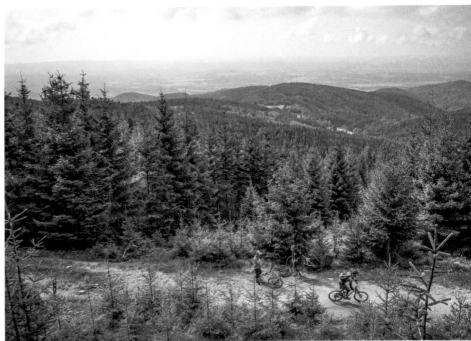

>>> Here you will find trails that were built exclusively for mountain biking and routes that are not designed for maximum length, but for maximum pleasure. It is where I rediscovered what I had lost on the world's racetracks: the fun of cycling. There is no other sport where you can get into the flow as well as mountain biking, where a well-taken curve, a victorious jump, or a descent offers countless successes. Mountain biking condenses events and emotions.

Many local mountain bikers long for the endless trails in Canada, the green hills of Iceland, or the dusty routes of Colorado. However, you should always remain open to the opportunities that arise in your own area. When I started to see my home through the eyes of the people I met all over the world, it completely changed my perception. Today, I know that Germany's low mountain ranges are just as exotic, new, and exciting for a mountain biker from Colorado as the dusty trails and wide landscapes of his home country are to us. And actually, everyone agrees that there is nothing better than spontaneous bike rides where you get surprised by tracks that you seemed to know by heart. >>>

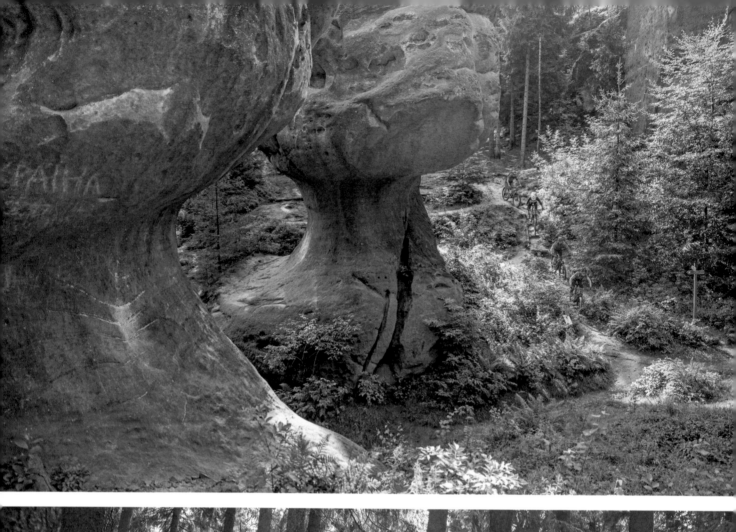
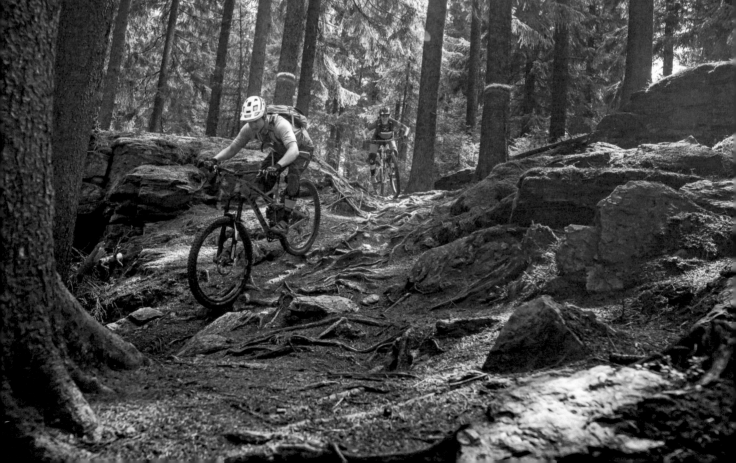

More Than Expected

During my travels I also discovered something that I had not even looked for. I found the diverse ways of life of the people we met so impressive that I wanted to focus more on how the environment in which we live shapes our view of the world and influences our actions.

Talking to people like the Icelandic fisherman Ove or Alex, the guide in Kamchatka, changes your own view of things. You realize that there are many different ways of living. You meet people who are at peace with themselves although—or because—they do not take part in our consumer society, where everything is always available. While we can buy strawberries or asparagus in Germany at any time of the year, other people cook and eat to the rhythm of nature. The result of this kind of lifestyle is a surprisingly delicate and varied cuisine. »»»

Left side: **Whether sandstone cliffs in the Zittau Mountains or root terrain covering the Rabenberg—German trails are incredibly versatile.** / Below: The adventure starts right in front of your door. You just have to get involved.

Co-Author/Chef

MARKUS

After exhausting years in Munich's top restaurants, Markus pulled the ripcord shortly after the turn of the millennium and took a break. He went to Australia to go camping, where over 24,000 kilometers (40,000 mi.) he not only perfected his tent set-up skills, but also the art of creating the finest dishes using ingredients from the respective region and under camping conditions. To this day, he has remained true to this style of cooking.

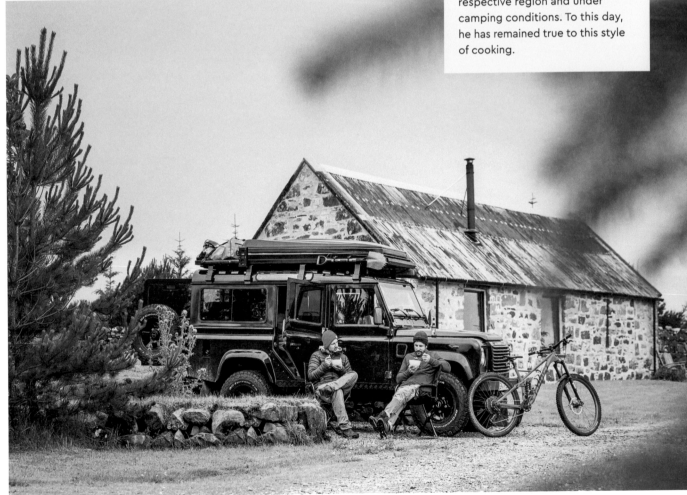

Co-Author/Photographer

PHILIP

When Phillip met Tobias in 2010 at a parking lot on the Canary Islands, there was nothing he could care less about than shooting outside of his studio. Except for one thing, maybe: mountain biking. He still works with well-known models for big brands, but at the same time, Philip has become one of the most famous photographers in the bike scene and has had all the stars in front of his lens. His qualifications for this bike trip? Hundreds of nights with Tobias in a tent somewhere in the middle of nowhere, countless bike and outdoor photos, and not one minute spent on a bike.

>>> What I find or experience while travelling is one thing, but perhaps much more important is what is coming after. I believe it is crucial that every trip changes the traveler's view of the world. Flooded by emotions and inspiration, all of these journeys leave their marks in my daily life forever. I find that incredibly exciting.

Take a Ride

This book is intended to convey what mountain bike travel means to me and hopefully, it inspires you to go on your own adventure. This book itself is kind of a discovery trip, where you might find what you were looking for. Or something surprisingly different. My trips are about experiencing and discovering the unexpected. It does not matter whether it is a sudden shower of hail, a majestic landscape, a delicious dinner with exciting people, or even a wasp in a sleeping bag. ♦

When I set out on my journey, I am not only curious about what I experience, but also about what the experience does to me.

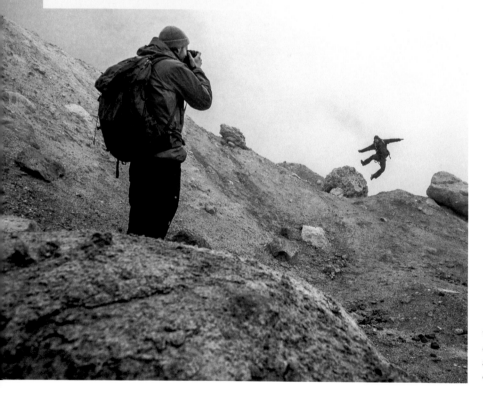

Whether on a volcano in Kamchatka (left) or a trail in the Ore Mountains (right)—the adventure starts in your head. It depends on what you make of it.

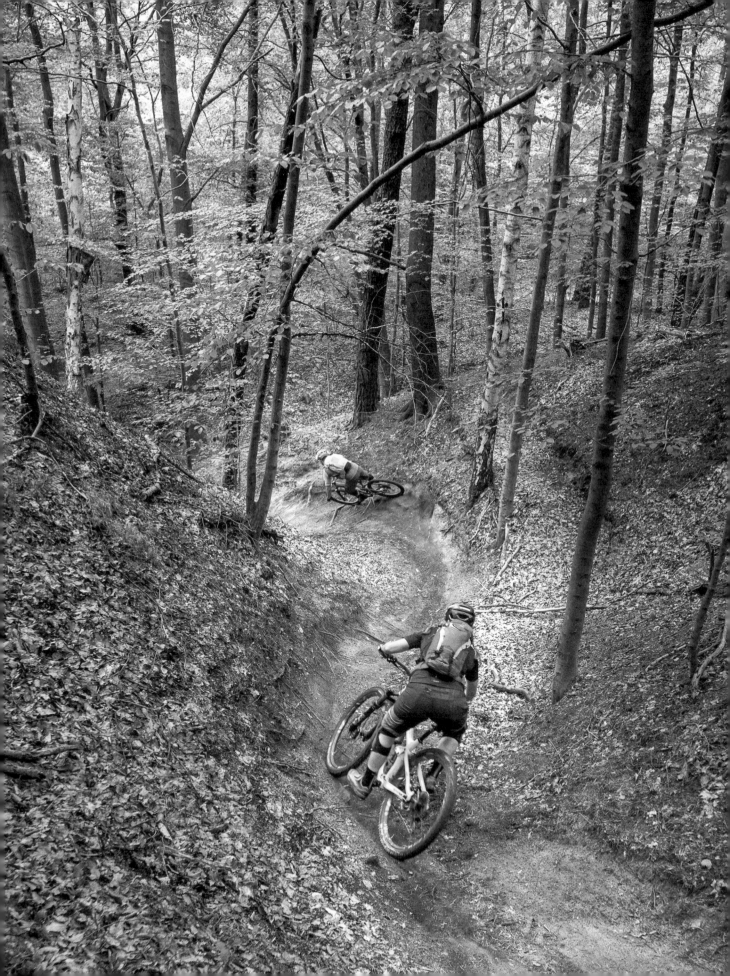

SCOTLAND

HIGHLANDS *AND* **ISLANDS**

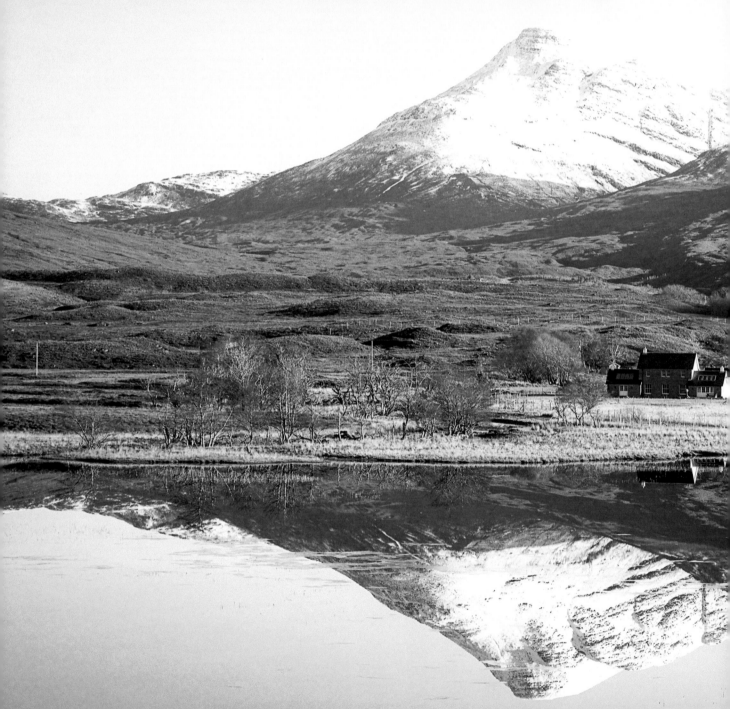

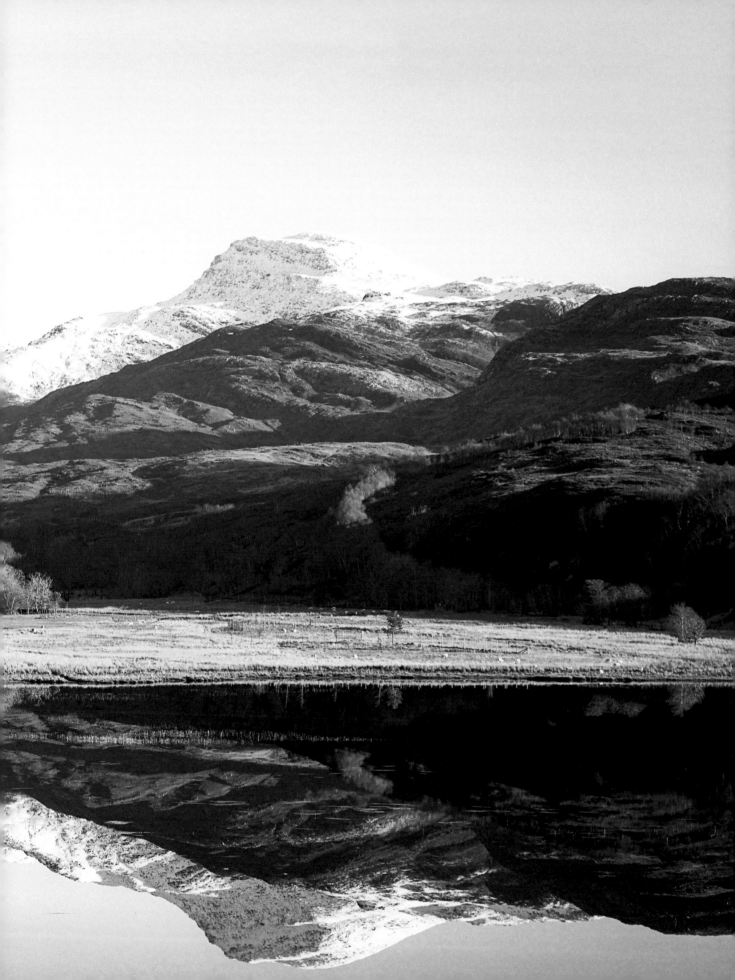

Prepared for unpredictable weather changes, Scotland's breathtaking coasts, mountains, and forests are best explored.

Scotland covers almost a third of Great Britain and includes several island groups in the North Sea and the North Atlantic. Scotland is officially part of the United Kingdom of Great Britain and Northern Ireland, but efforts to achieve independence have increased in recent years. After the referendum on Britain's exit from the European Union (EU) in 2016, in which the majority of Scottish citizens voted to remain in the EU, calls for independence in Scotland have become louder again.

There is a clear south-north divide in the country of 5.5 million. In the south, there are metropolitan areas including Edinburgh and Glasgow, while there is a low population density in the north. Very few people live on the west coast, where the famous Scottish Highlands are located.

Around three-quarters of Scotland's total land area is used for agriculture. Barley, wheat, and oats are mainly grown here, particularly for the production of one of the country's main exports, Scottish whisky. All over Scotland, distilleries produce whisky under strict conditions. A tour through one of the facilities should not be missed.

When it comes to biking in Scotland, you are in good hands. With the 7stanes project, so-called trail centers were set up at seven locations in the south, which invite you to hike and bike in the woods. The award-winning trails are now among the best in Europe and are viewed as models for developing centers all over the world. Next to this, there are of course countless opportunities for cycling in the great outdoors, and due to progressive access rights you really can get into the wild.

FACTS	Ø Temperature (Trip): 15 °C (59 °F)	Elevation (Trip): 780 m (2,559 ft.)	National Cuisine: fish and chips, haggis, mussels
DESTINATION: Isle of Skye	Trail Distance: 13 km (8 mi.)	Passability: difficult, unpaved parts and a very steep uphill segment	Don't forget: waterproof pants
TRAVEL TIME: June–July	Trail Duration: ½ day		

16

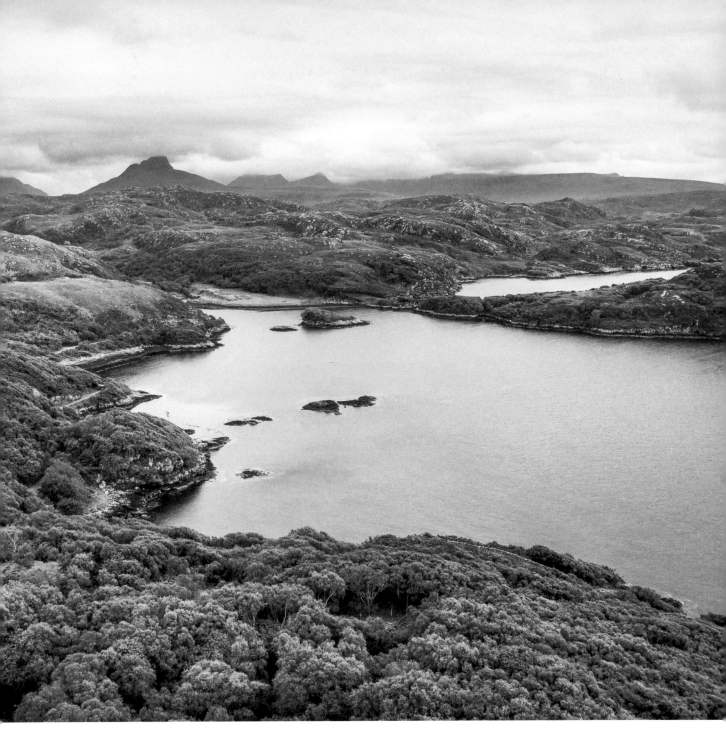

Before riding through the rough Scottish landscape, make yourself familiar with the customs on the paths, ride and act responsibly, and expect unexpected weather.

The most famous trail center of 7stanes is Glentress in Peebles, located about 30 minutes from Edinburgh. There are not only five trails ranging in level of difficulty, which can be combined in different ways, but also Freeride Park, a bike school for children, campsites, and restaurants. A huge bike community has been established around the trail center, and local cyclists have created and maintain hundreds of paths away from the official routes. This makes the area one of the largest contiguous trail areas outside of the Alps. ◆

Watching the Weather and the Wilderness

When I first came to Scotland, I didn't know much about the country. I only knew the common stereotypes: the Scots play bagpipes, the guys run around in skirts wearing nothing underneath, and it rains all the time. I never expected to fall madly in love with the country.

Since then I have returned several times and it has become kind of a ritual to visit Scotland at least once a year. For me, Scotland is the perfect mix of great nature, trails, and the changing weather that I love so much in the north. I keep trying to convey my enthusiasm for Scotland to other people with varying success. If one steps into wet bike shoes for the third day in a row, their face will immediately show whether they would rather be lying on a Caribbean beach. I would never claim that Scotland is easy to travel to or perfect for a mellow bike trip.

To be honest, Scotland does not make it easy for you, and that is what I find so fascinating about this country. The more you get involved with the country, the more you enjoy its rough and tough sides. The best examples are the weather changes that turn up faster than you can put on or take off your jacket. This spontaneity and unpredictability make Scotland one of the most beautiful countries in the world for me, and I just can't get enough of the Highlands, the trails, and especially the Isle of Skye.

With these words, I persuaded Markus to accompany us on this trip to Scotland. He would have actually wanted to travel to the Italian island of Sardinia to spend summer vacation with his family. But, somehow my stories convinced him because, in the end, we travel north together.

The culinary aspect of our trip begins on the ferry with the all-you-can-eat buffet where you »»»

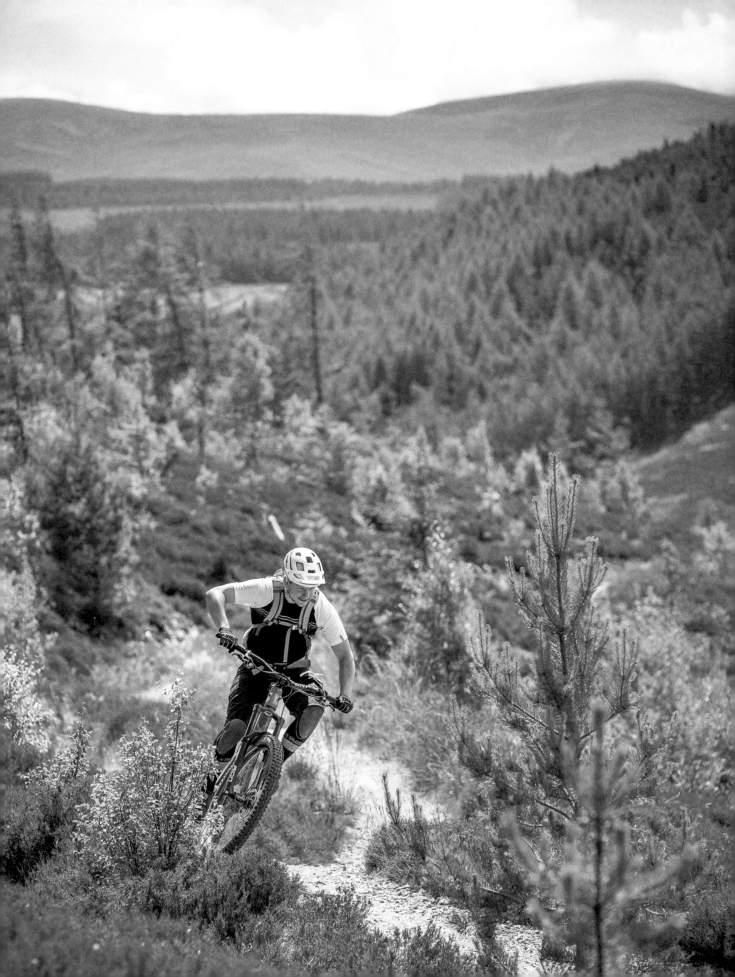

>>> can eat around the world: mini burgers, small pizzas, curry, and also classic Scottish dishes like fish and chips, and steak and ale pie. I would not consider any of these a culinary marvel, but I expect we'll be eating tastier meals during our trip.

A Ride on "Magic Mushroom" in Front of *Braveheart* Scenery

Our first stop is Tweed Valley, situated a little east of Edinburgh and home to Glentress, one of the trail centers Scotland is famous for. Located across the country, these trail centers offer signposted and specially-designed trail circuits that are suitable for riders of all experience levels. Whether a beginner or a professional biker, everyone will find what they are looking for here.

We park our cars at Buzzard's Nest and make our way toward the trails. Since Markus has not biked that much this year, I lend him my e-bike to race the trails. Big mistake! I have been cycling quite a bit this year and felt fit, but I cannot keep up with Markus. After a short time, I have to make sure that my tongue does not get tangled up in the spokes because I am completely exhausted. I am constantly looking forward to the small river crossings because on the one hand, the cold water cools my legs, and on the other hand, it gives Markus a reason to wait at least briefly for me.

Our plan for today is to do the red lap, a succession of trails that have names like "Britney Spears," "Magic Mushroom," and "Spooky Woods." The trails here are extremely fun when you go downhill and when you go uphill, the local residents cheer and wave. After hours of ups and downs and thousands of turns, the trail spits us out at our car. Exhausted but happy, we load our bikes into the car and make our way to the No1 Peebles Road coffee house in Innerleithen. The café has been the meeting point of the bike scene in >>>

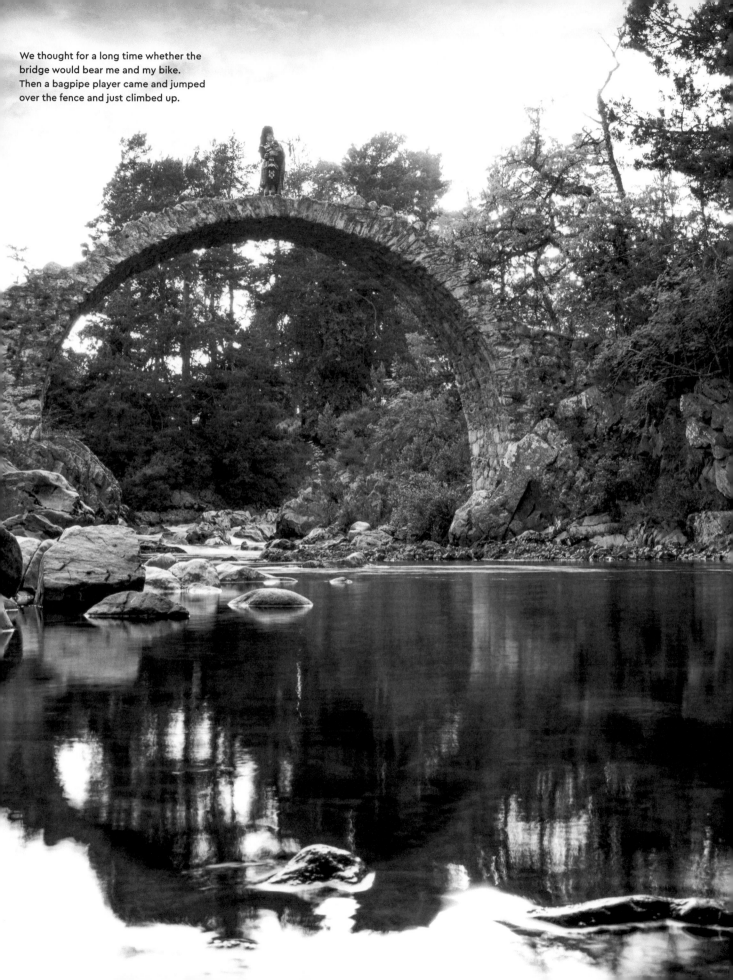

We thought for a long time whether the bridge would bear me and my bike. Then a bagpipe player came and jumped over the fence and just climbed up.

>>> the area for years. While the tourist bikers stop at the trail center café, the locals can always be found at No1. That is why this is the perfect place to find out about the new trails springing up all over the area. Yet, we come here not only for trail recommendations but also for the coffee.

Everywhere in Scotland, there is a culture of small, but fine cafés that either roast their beans themselves or buy them from small roasters in the region. There is usually also a small selection of delicious snacks such as toast with halloumi, chorizo and blueberry jelly, or the Full Breakfast Mess, a breakfast plate with mushrooms, scrambled eggs, and spinach. Whether before or after hitting the trail, every local biker comes here and gets a coffee or quickly eats a scone. You could say that No1 is for the local younger generation what the tea room is for the older generation.

Freshly strengthened, our journey continues to the north. Over the next few days, we will visit other trail centers, camping along the way, until we finally reach the destination of our trip: the Isle of Skye. The island is located northwest of Fort William and can either be reached by ferry from Mallaig or via the Skye Bridge in the north at Kyle of Lochalsh.

The trip there alone is worthwhile: the road winds wildly through the mountains and then along the banks of the fjord. If you are traveling by car, you have to be careful not to be distracted by the magnificent landscape. You feel transported to the thirteenth century, like the setting of *Braveheart*.

Riding on Skye

Wild camping is allowed in the Highlands and it is more than recommended to include at least one or two overnight stays in remote places. You cannot get closer to nature.

This time we decided to try something new as we heard about a traditional bothy that was renovated by a young couple.

So after arriving in Skye, we meet with our hosts Jane and Paul, who moved to the island from the Southeast a few years ago. >>>

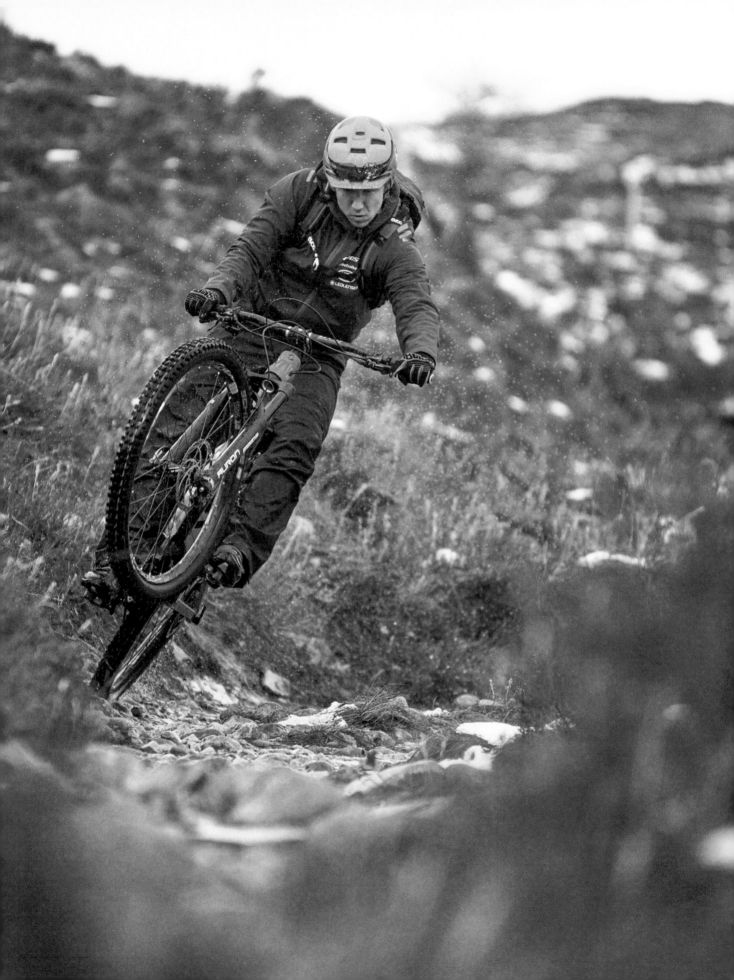

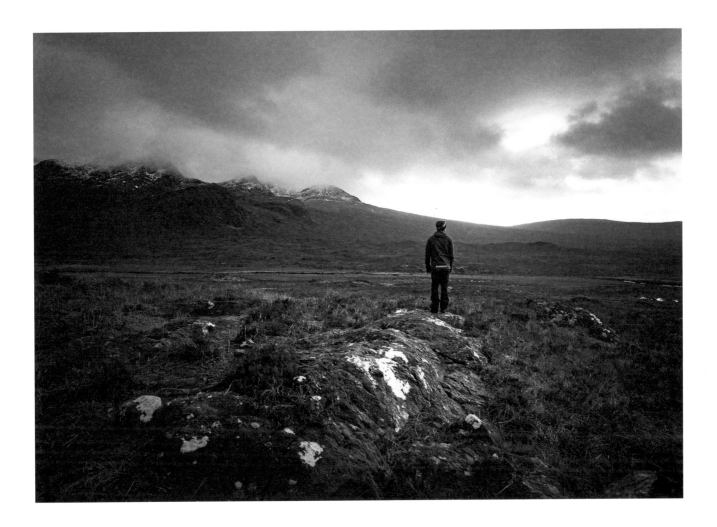

>>> Normally a bothy is a basic hut that offers hikers shelter and protection in the middle of nowhere. Jane and Paul's bothy does exactly this, but in the most comfortable way you can imagine.

The two belong to a new generation of Scots who are moving back to the Highlands to start their own business and spend their lives in close relation to nature. We took the long way up north because of the Cuillin, a massif that is located on the southwest coast of the island that not only offers an incredible mountain panorama but also has a great trail at its feet. This trail asks for skilled mountain bikers and requires good physical condition. Some parts of the path are unpaved and difficult to ride, and you might even have to push your bike. But, being surrounded by an amazing landscape rewards you for your efforts.

From the Sligachan Hotel, the trail winds through a valley from which the mountains rise majestically to just over 900 meters (2,953 ft.) on both sides. The path continues over countless river crossings, and while it's relatively flat, the trail is still quite technically demanding. Again and again, you have to choose your route cleverly and jump stones or go down steps. At the only crossing on the trail, we take the right branch, which leads us first on a challenging uphill ride and then on a bumpy downhill towards Loch Coruisk. Here we take a small ferry to the village of Elgol, where the trail leads us back to the Sligachan Hotel.

The hotel and its pub are renowned for serving over 400 different types of whisky produced around Scotland. One of the most famous distilleries, Talisker, is just five kilometers (3 mi.) away. There is hardly anything better than ending a day on the bike by a fire with a game burger and a glass of whisky. ◆

NIALL

In the early 1990s, Niall Rowantree learned about a hunting ground for sale on Ardnamurchan, a peninsula in western Scotland, from a friend he was working with on a reforestation project. He got in touch with the owner, arranged a deal, and step-by-step turned this area with a deer population of around a thousand, including some fallow deer, into one of the most famous hunting grounds in Scotland.

How did he do it? First, by observing. "You have to keep an eye on the animals' habitat," says Niall. "The local landscape is an indication of the red deer population. The animals eat the vegetation and thus keep it low. If it becomes denser or higher, that means there are too few animals. If it thins out, there is overpopulation that needs to be reduced."

When Niall took over the hunting ground, he first paid attention to harmonizing the ratio of female to male animals and returning to a natural age structure. As a result, more young animals were born after a short time that were healthier and, therefore, more stable. The older animals also had positive developments. Their higher average weight made them less susceptible to illness.

Niall is convinced that all people and all cultures that draw their resources from nature must have a deep understanding of the changing seasons and the cycle of nature. In his limited area, he sees it as his task to keep everything at the same level so that the different species find ideal habitats.

With his company West Highland Hunting, Niall combines the pleasant with the useful. "My job is not just hunting," he says. "I also take people on tours so that they can experience nature and wildlife. We have one of the largest otter populations in all of Europe

here. And this morning we saw a sea eagle. It is a special feeling to see a bird with a wingspan of over two meters (6.5 ft.) circling above yourself."

Niall gazes over the peninsula. His work here has not gone unnoticed. He temporarily worked for the government, was a former board member of the Deer Commission for Scotland, and was a member of the Scottish Natural Heritage Transitional Deer Panel.

But over the past 25 years, he has always looked after his herd in Ardnamurchan. "Working with animals is a privilege. Anyone who hunts and thus kills animals, should think carefully about what they do and how they do it. For me, full respect for the animals is essential. The deer are part of my life." ◆

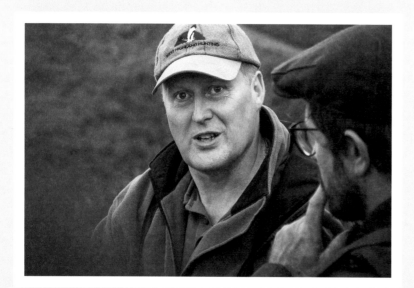

Right side top: **Markus aiming.** / Right side bottom: **A day for observation and no hunting. Niall pays close attention to the population in his hunting area.**

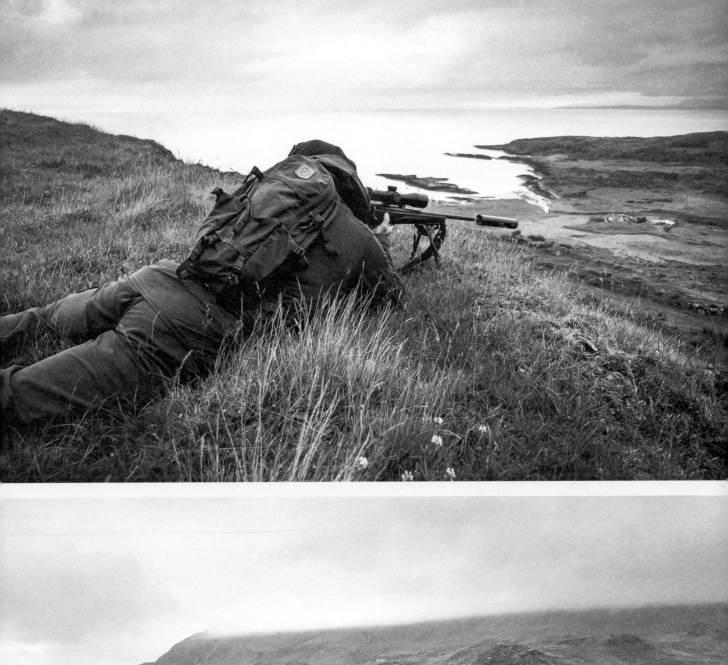

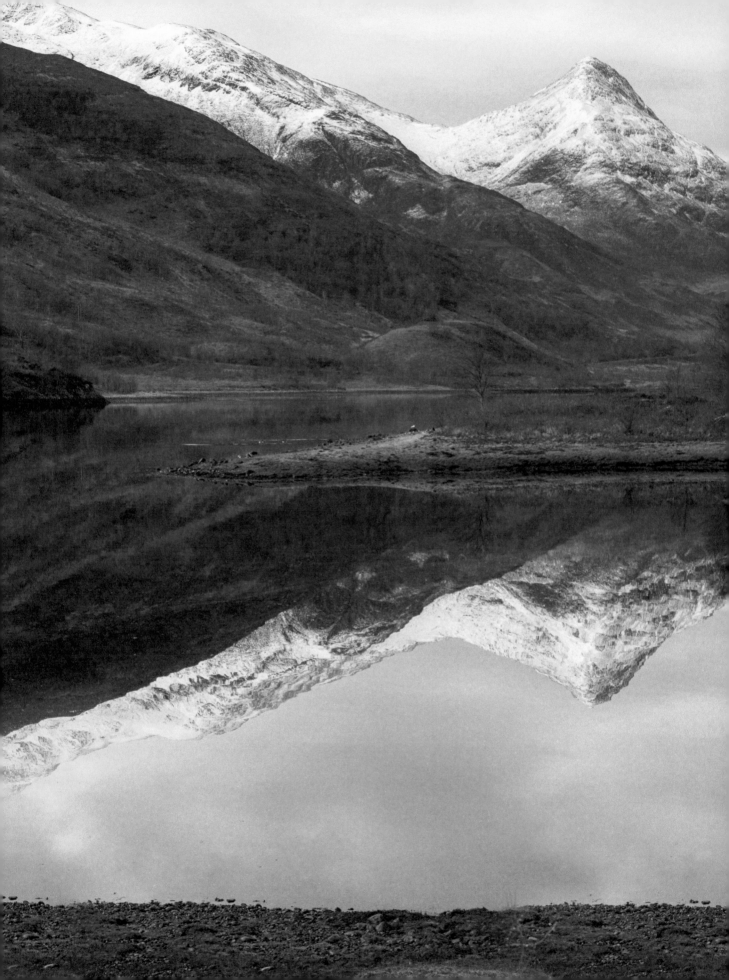

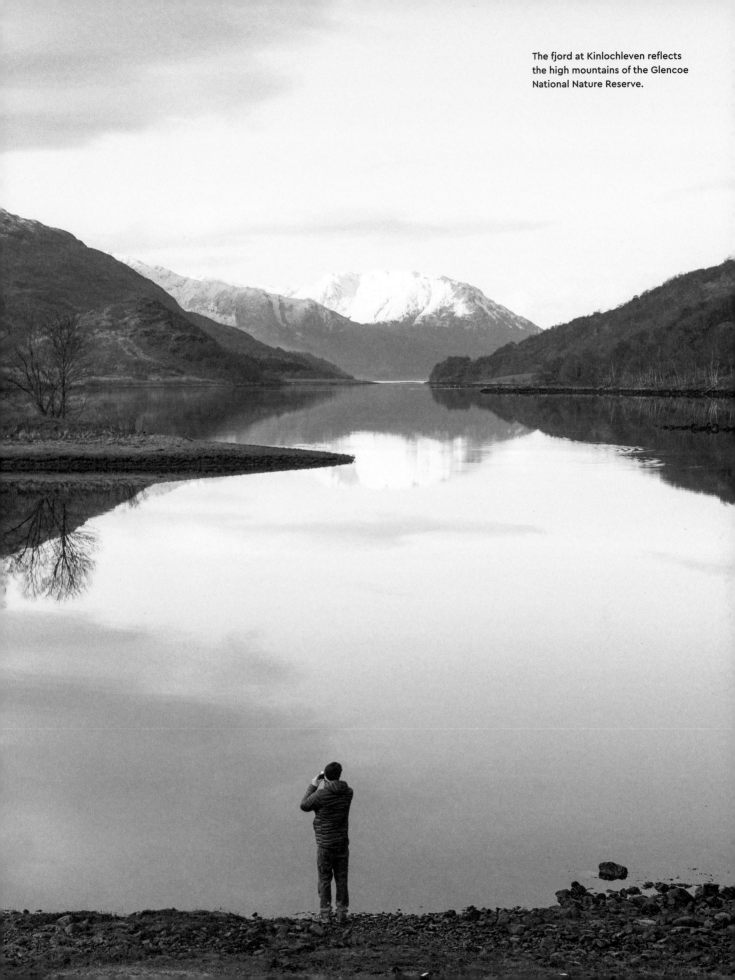

The fjord at Kinlochleven reflects the high mountains of the Glencoe National Nature Reserve.

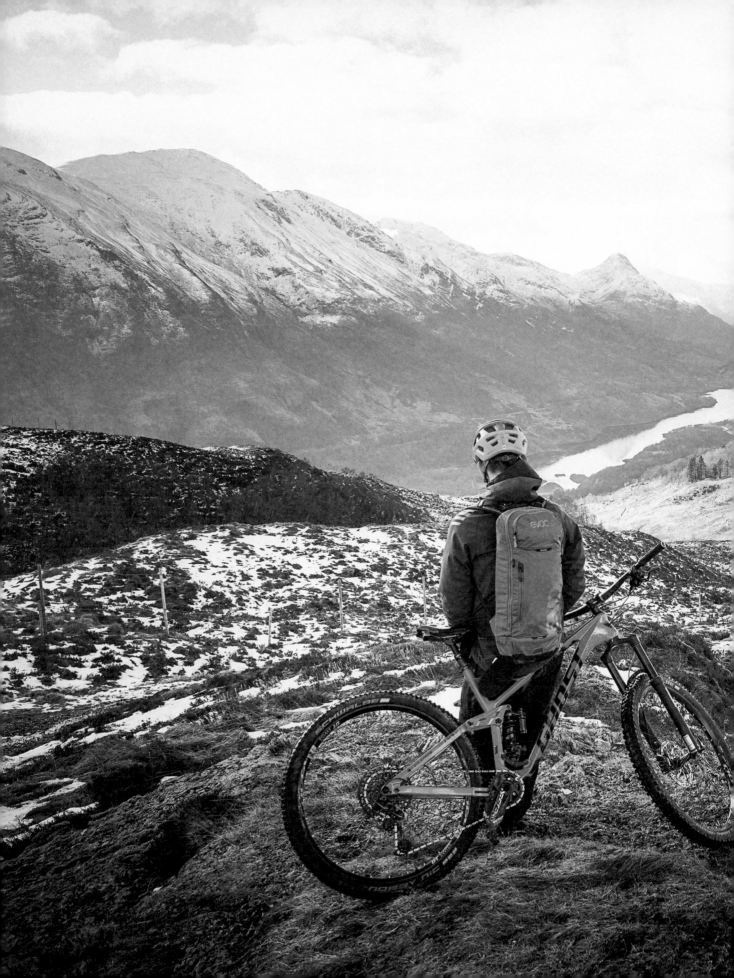

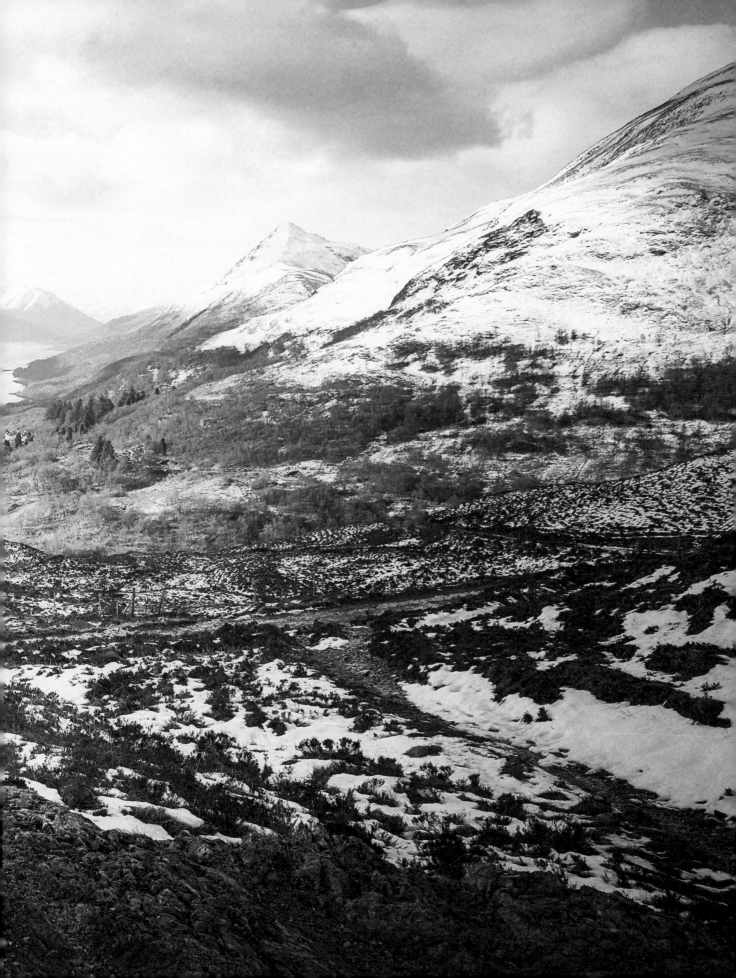

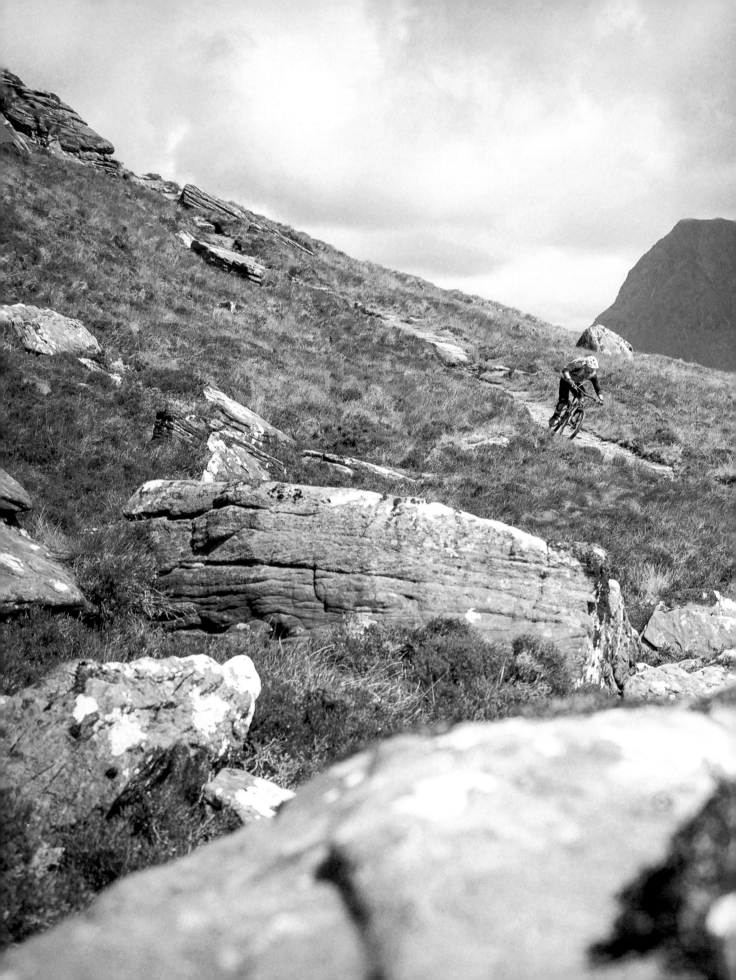

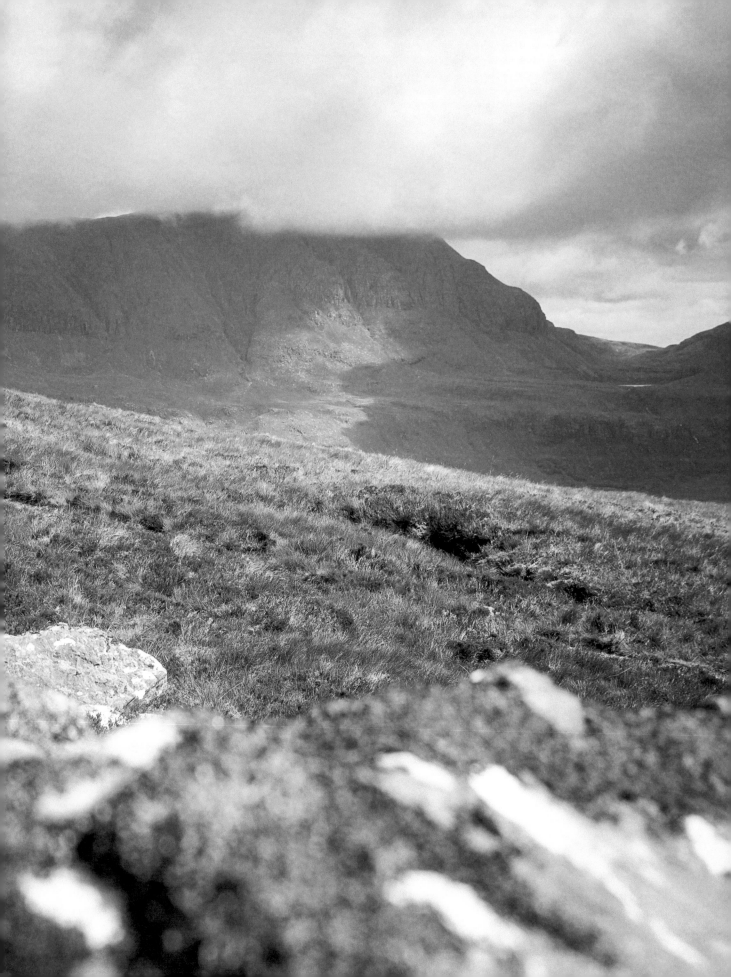

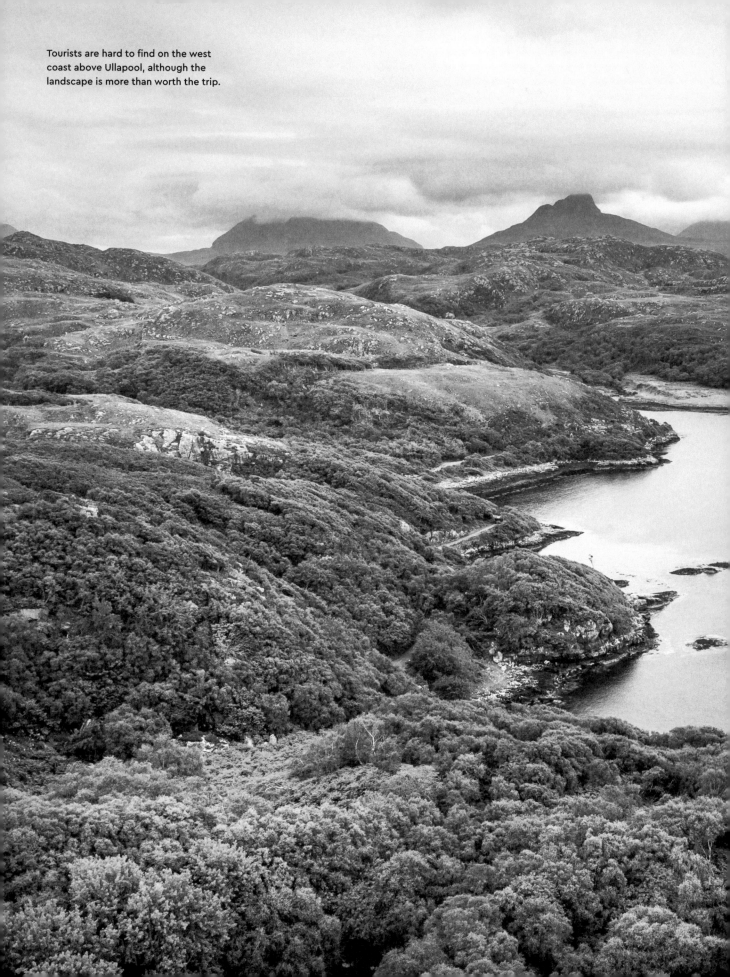

Tourists are hard to find on the west coast above Ullapool, although the landscape is more than worth the trip.

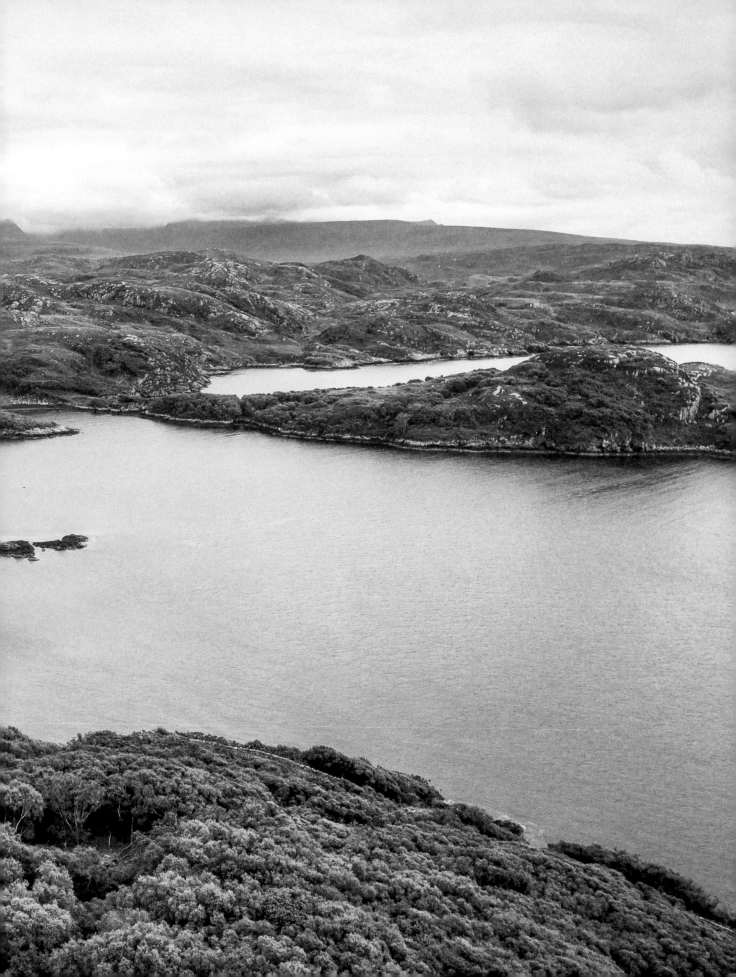

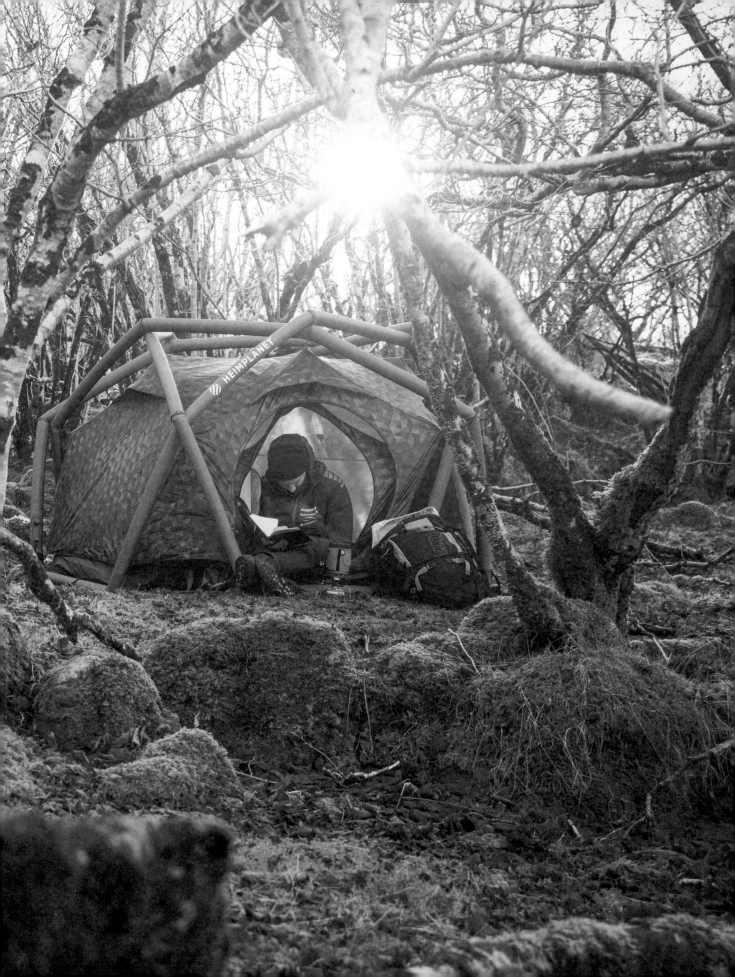

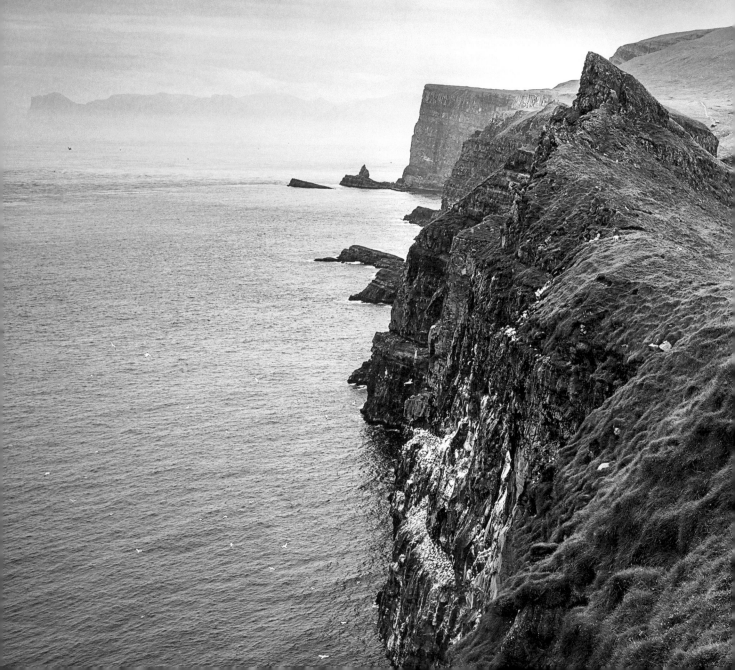

REMOTE ISLANDS
IN THE
NORTH ATLANTIC

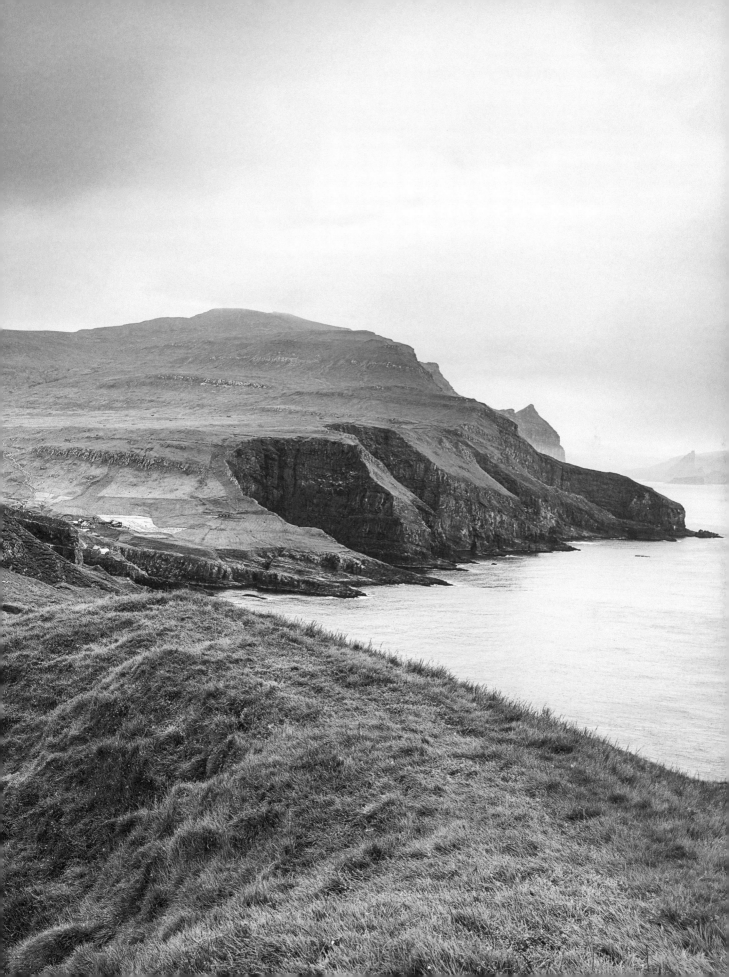

No spot on the Faroe Islands is further than 5 km (3 mi.) from the sea. Accordingly, the climate is rough and challenging, which needs to be considered when planning a trip.

The Faroe Islands, also known as the Sheep Islands, are located between Norway, Scotland, and Iceland. The scenic archipelago consists of 18 islands with steep cliffs, towering from the dark waters of the Atlantic Ocean.

Although the archipelago belongs to Denmark, it enjoys extensive autonomy as a self-governing nation with its own currency, flag, and language. The inhabitants have also voted against joining the EU. This is due to fishing being the major source of industry for the Faroe Islands. However, the EU has concerns about overfishing in the surrounding waters, which is why deliveries to the EU have been sanctioned.

Tórshavn is the capital of the Faroe Islands. The micro capital is one of the smallest cities in the world with a population of around 20,000. It is located on the east coast of the largest island, Streymoy.

Since the 6th century, there has been a mixed heritage of people hailing from different ethnic communities, from Irish monks to Norwegian Vikings who have settled on the island. Today, there are about 52,000 citizens and twice as many sheep, hence the nickname Sheep Islands.

Holistically, sport is an integral part of island life. Apart from the many indoor sports and rowing, football is also a serious topic on the islands.

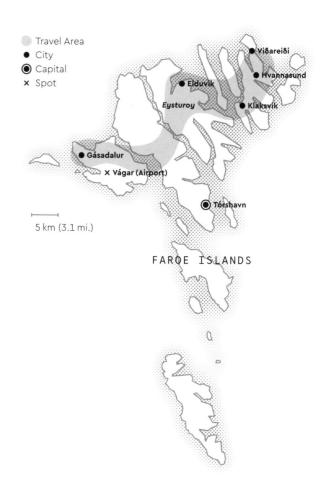

Travel Area
● City
◎ Capital
✕ Spot

Viðareiði
Hvannasund
Elduvik
Eysturoy
Klaksvík
Gásadalur
✕ Vágar (Airport)
Tórshavn

5 km (3.1 mi.)

FAROE ISLANDS

The country has its own national team, which has also proudly hosted the German national team as international qualifiers.

FACTS

DESTINATION:
Gásadalur

TRAVEL TIME:
May

Ø Temperature (Trip):
8 °C (45 °F)

Trail Distance:
181 km (113 mi.)

Trail Duration:
3 – 4 days

Elevation (Trip):
530 m (1,738 ft.)

Passability:
easy, almost entire
trail on asphalt,
depending on wind

National Cuisine:
cod, grindabúffur,
lamb

Don't forget:
rain jacket

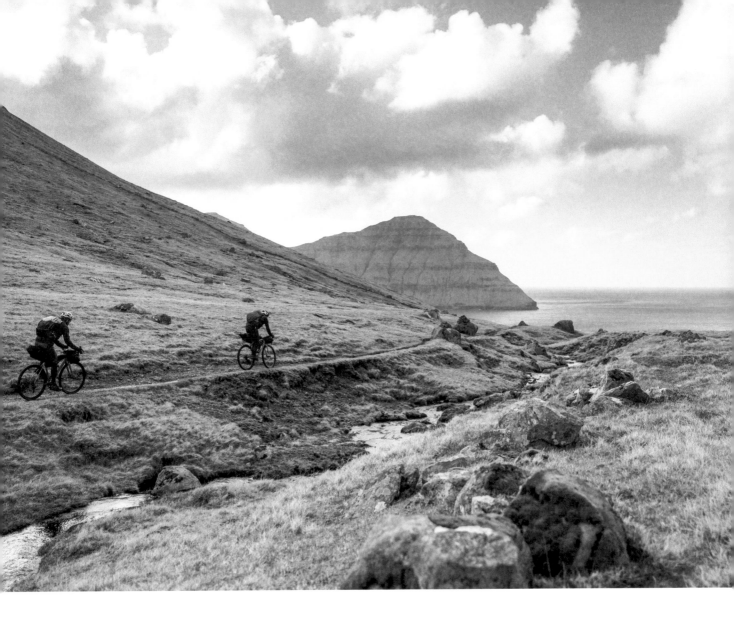

Regarding wildlife, the most famous animals on the islands, apart from the vast volumes of sheep, are the puffins. These small birds are very difficult to spot in other places; however, here they run and fly around by the hundreds.

The Faroe Islands consist of five main islands: Vágar, Streymoy, Eysturoy, Borðoy, and Viðoy. This chain of islands is connected by tunnels and bridges. The rest of the islands can only be reached by more remote forms of transportation, such as boat or helicopter.

Firstly, we began our backpacking tour on Viðoy, the easternmost island. Within the course of the tour, we crossed all five main islands. Our trip's destination was the village Gásadalur, which is home to one of the most famous waterfall of the Faroe Islands. Only in 2006 was the village connected to the traffic network via a new tunnel. Before this time, the only access to the island was by helicopter, boat, or on foot via the "Old Postman's Trail."

The climate on the islands is irrespective to it's northern location, as it is relatively mild, ranging between 0 and 15 degrees Celsius (32–59 °F) all year round. Nevertheless, the weather there can be quite unpredictable by changing within minutes. This makes planning exact tours and times a real challenge. It is advisable to always allow extra time to buffer in consideration of fluctuating weather patterns. ◆

Far Away in the Faroes

Whenever people have asked me what is the most beautiful place on Earth that I have ever set foot on, the words "Faroe Islands" fire from my mouth like a bullet from a gun. The archipelago in the North Atlantic has held my fascination since my backpacking trip there. The isles are a natural jewel in the vast sea with a rugged, sometimes barren, but always breathtaking landscape—bravely presenting itself with harshness but also warmth. In late Spring, I set off with my friends Max and Philip to cross the islands from west to east. A Trans-Faroe Islands quasi—anyone can do Alpencross.

In the beginning, I first heard about the Faroe Islands during the solar eclipse in 2005. This natural spectacle could only be admired completely from two places on Earth: on the Spitsbergen and the Faroe Islands.

My companion and photographer, Philip, was on location in Faroe to capture the eclipse. When he returned, he spoke vividly of his trip; he was eager to visit this unknown place once again. My wanderlust was aroused: Maybe the Faroe Islands are an undiscovered mountain bike spot? After he had shown me the first few pictures, it was clear to me it was a destination where we absolutely had to go! These green islands, embedded in the dark North Atlantic Ocean, fuelled a fascination of wonder to both of us.

I immediately threw myself into the research. Unfortunately, I was quickly disappointed to discover that off-road biking is prohibited on the Faroe Islands. Excitedly, I dug deeper into the topic more thoroughly, as my understanding of the situation grew. The islands have only about fifty thousand inhabitants. Most of them earn their money through hard work at sea or on farms. Only a few go hiking on their own land. The Faroese (local citizens) regard their land as useful, however, not particularly beautiful. Therefore, there's a handful of hiking trails where you're officially allowed to walk and only on foot.

Ask the Sheep for the Route

Fortunately, the bike ban didn't deter us from planning a bike trip to the Faroe Islands. However, we chose gravel bikes because there are no bike trails, just a few trails that are reserved for hikers. The plan evolved to cross the Faroe Islands from the furthest west to the easternmost tip on the official trails. Normally, I would prepare the trip with Google Earth and look at the most important ⟫⟫

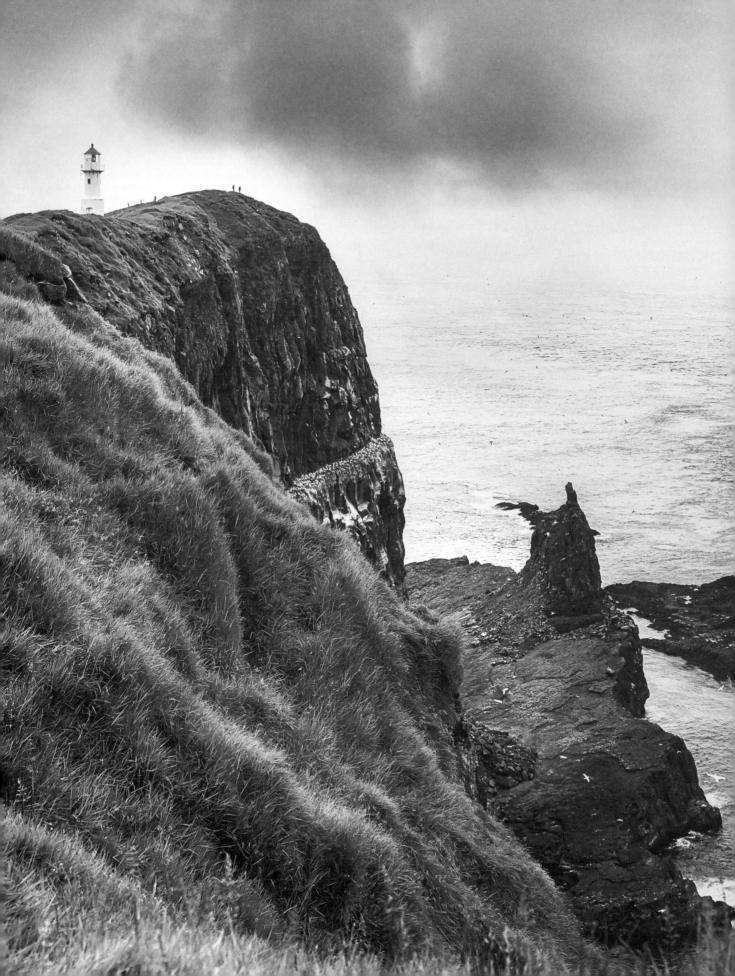

routes in advance. Unfortunately, there are no street-view pictures of the Faroes only "sheep-view" pictures. Yes, you read that correctly: sheep equipped with 360-degree cameras created the pictures available on the internet. This initiative was launched in 2017, by Durita Dahl Andreassen, a resident of the Faroe Islands. She wanted to draw Google's attention to the small archipelago that had fallen into oblivion. Low and behold, the US company was thrilled. Since then, you can explore the Faroe Islands on sheep-back via Google Street View. In reality, however, I would prefer the views to be seen from a bicycle saddle.

Navigating Turbulences

After a short while, barely two hours had passed sitting in the plane from Copenhagen to the Faroe Islands. Interesting, that even for a small group of islands, which look quiet and inconspicuous when viewed from the air, at the last minute we learned during the turbulent landing approach that appearances can be deceiving. In any case, we didn't recognise the narrow concrete strip adjacent to a fjord as our landing zone. Fortunately, the Faroese pilot was highly skilled and safely dropped us and our bikes on this minuscule landing strip.

Between the sky and the sea, I mused—here we are—in In the middle of the North Atlantic, between Norway, Scotland, and Iceland. It's May. Of course, we didn't expect to ride our bikes in shorts. However, the weather beyond the airport exit was different than expected, with a heavy storm raging over the islands.

We were sitting in the bus heading for Klaksvík, the easternmost town of the Faroe Islands. It is the fishing center of the islands and the starting point of our route. We spent the evening attaching our bags to our bikes in a way to ensure they would remain as waterproof as possible. Inevitably, bad weather was predicted for the next few days. Waiting was not an option, so the next day we grabbed our bikes and ventured out into the wind.

The first stage led us around a big road loop from Klaksvík, heading north to the northernmost town of the islands—Viðareiði. Again and again, »»

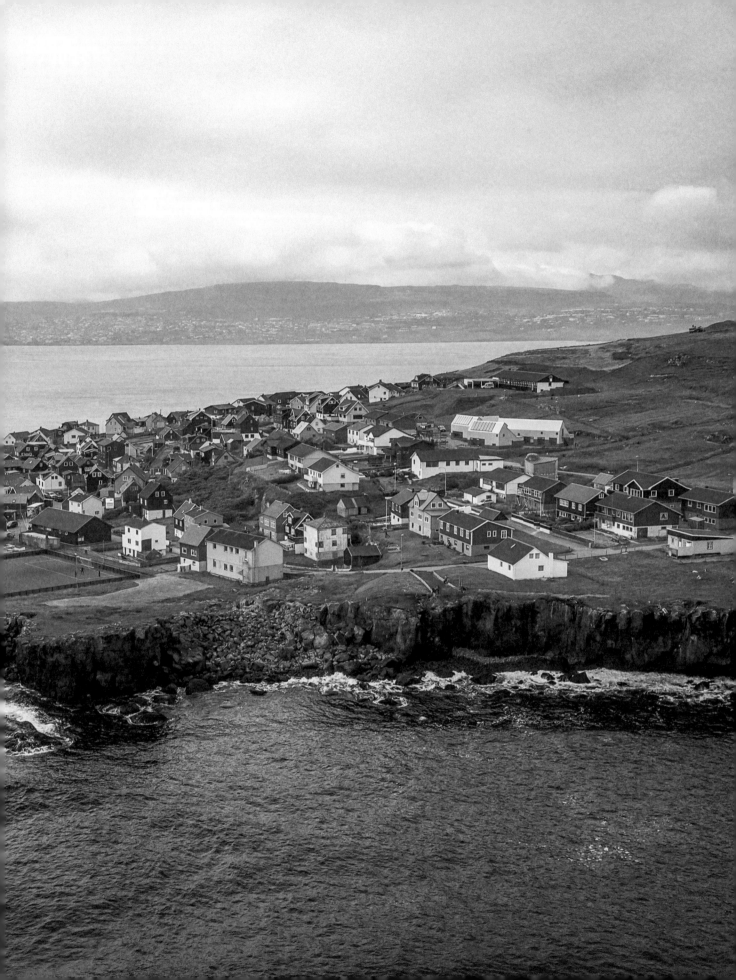

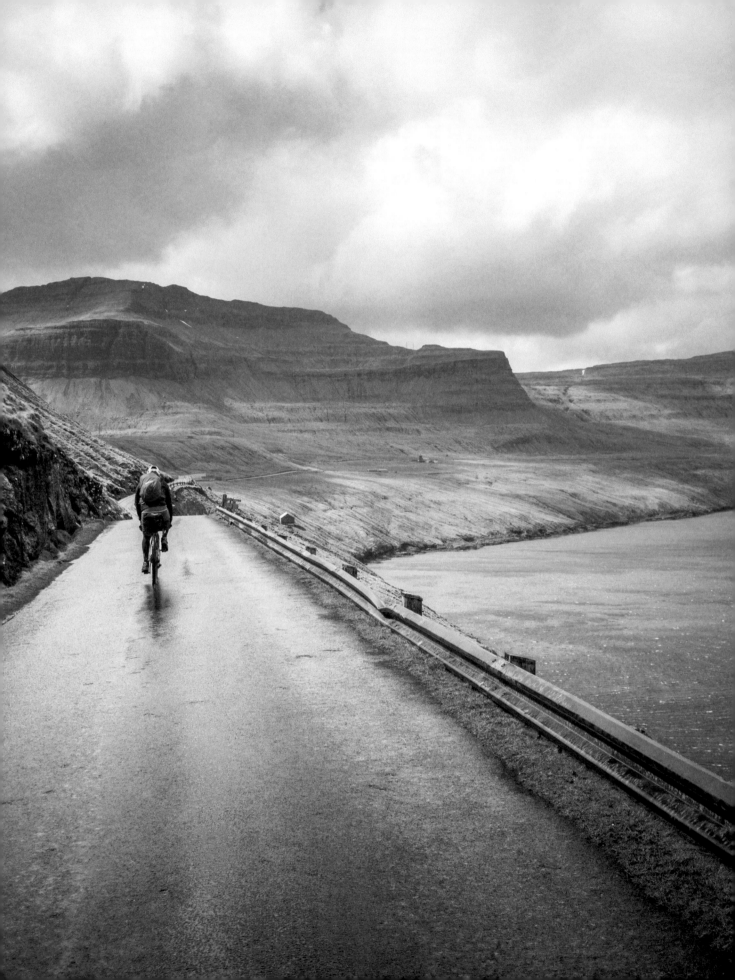

>>> the wind whipped our faces, throwing rain-drops that popped painfully against our skin like little water bombs, drawing our bikes along like sails flinging us to the left and right. Fortunately, the roads in the southwest of the islands were quiet, and we could meander across them.

Emerging from a tunnel shortly before the little village Hvannasund, we could hardly steer the bike due to the billowing strength of the tyrannical wind. Even breathing was difficult. Next to us, water cascaded as it fell down the rock face. However, water does not strike the ground as it's caught by the wind and thrown back up into the air with full force. Seemingly, the waterfall defies gravity at halfway in its majesty.

Finally, we reached our destination for the day in the evening, deciding against spending the night in the tent. Instead, we dry our soaked clothes in front of the warm heater. The wind was due to remain strong over the next few days, but less rain was predicted. A little spark of hope we were elated to hear! Therefore, the next day we made our way to the biggest island—Eysturoy.

Travelling to the next island, we discovered the main Faroe Islands are connected by huge tunnels. We rolled onwards on our bikes through these pathways, which had been laid under the seafloor. Eight kilometers (5 mi.) of sheer darkness. Occasionally a car passed by, illuminating the black walls for a few moments before the darkness engulfed us again in an echoing chamber of metallic clinks and clatters, as we pedalled through the abyss. Water dripped from the ceiling—a troublesome thought. I wondered about the volume of water directly above our heads within the fjords, so we inevitably pedalled harder and faster.

Soon afterwards, we left the tunnel, after what felt like an eternity. We prepared to emerge in a protective stance against the weather that we had left behind at the entrance of the tunnel. Exactly the opposite awaited us: blue skies, warm sun rays fell onto our skin and the feeling of our high spirits returned. On a high, even pushing our bikes up the long passage at the steep coast of Elduvík didn't bother us. When we reached our sleeping destination, we could finally best utilize our travel >>>

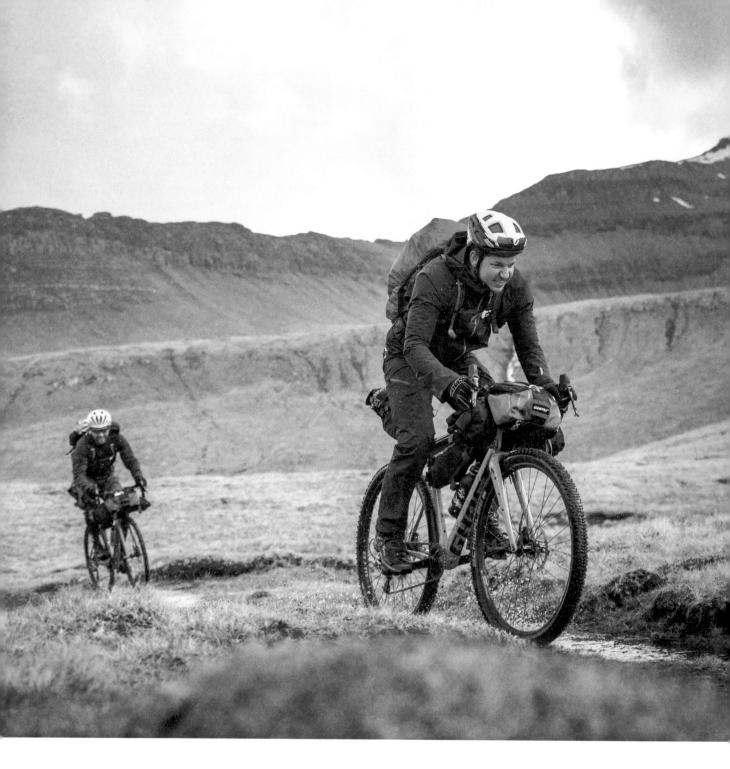

provisions—spaghetti carbonara from a bag. Culinarily not very pleasing, but the easiest way to have a warm meal quickly. If you are in the middle of a tour, you are usually so exhausted in the evening that you are grateful for every extra minute of sleep. So we finally climbed into our sleeping bag to rehab for the next day.

Soaking Wet Nightmares

Slap...Max turns over grumbling in his sleeping bag. Slap...Half asleep and confused I asked myself what has just hit my face? I arose to the completely soaked flapping tent canvas, that whipped across my face again. Being attacked from my own

I wonder what the next day would look like for me. I thought to myself, what you would imagine a day riding into a headwind after a sleepless night would look like. The sound of the wind roared so loudly through my ears, through my head, that it didn't take long before the pain began to set in. In addition, my legs were still asleep from a turbulent night in the tent. The next day, no matter how hard I pedalled, I couldn't move forward. Although it was mostly flat along the fjord, it felt as if I was grinding up a mountain all day long. The rescue? A gas station at the roadside, where we arrive exhausted, to quite literally fill up our tanks: never had a soggy hot dog tasted so good.

After a whole day of headwinds, even a hot dog from a gas station tastes like star cuisine.

In the End, Everything Will Be Fine

On the last day, we crawled out of our tent greeted by the warm sun. The wind had calmed and the clouds had cleared; this is what a rare beautiful spring day on the Faroe Islands looked like. Despite being shaken by the weather, what we experienced on that day was more than just a welcomed reward for all the hardships of the past few days.

We soared on our bikes through green valleys, from whose steep slopes, small rivulets flowed down towards the sea. We spotted the famous puffins, that fired through the air like little rockets, diving into the water and just as quickly »»

tent! On my travels, I have been through many uncomfortable weather situations. I have never been afraid for myself or my tent. However, storm gusts had affected us greatly. They whipped the tent relentlessly, which meant rain did not bounce off anymore. Rain then came through the tent. Max grumbled on once again and slept on!

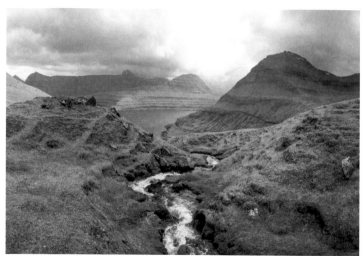

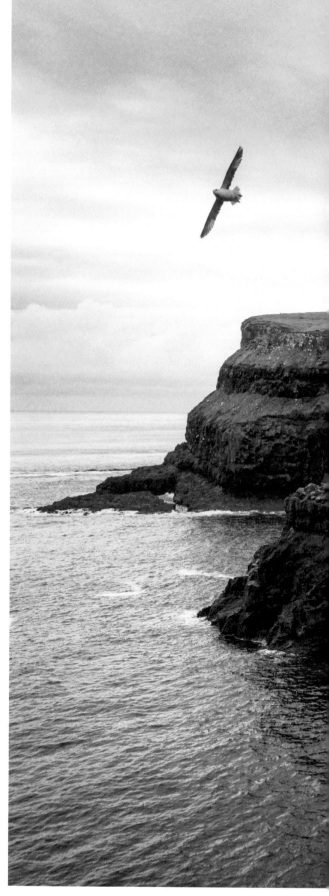

>>> fluttering away again with beaks full of fish. The Faroe Islands arguably know exactly how to win someone's heart with their diverse and extreme landscapes.

Finally: the Selfie Waterfall

We travelled to our last island. We rolled the bikes through the last tunnel of our trip down to Gásadalur, where probably the most famous waterfall of the islands is located. Under the hashtag #gásadalur, this natural spectacle can be found online. The small village, which shares the same name, which was almost cut off from civilization until 2005. Now it receives a lot of attention as a place of natural beauty. Only since the completion of the tunnel, has it been possible to drive here by car. Before that, everything had to be brought to the rugged coastline via an arduous mountain path or by boat. An unimaginably steep staircase leads up to the village from the dock. Since then, many things have changed there, but the inhabitants have kept their manners open and welcoming. On the last day of our trip, we didn't know where to stay overnight and asked a local where we could pitch our tent. The warmth and sincerity the man showed us was heartwarming, as he graciously invited us to camp directly in his yard. Of course, he asked us if we wanted a coffee in the morning. This is how we experienced the Faroe Islands: wind, weather, and boundless hospitality. ◆

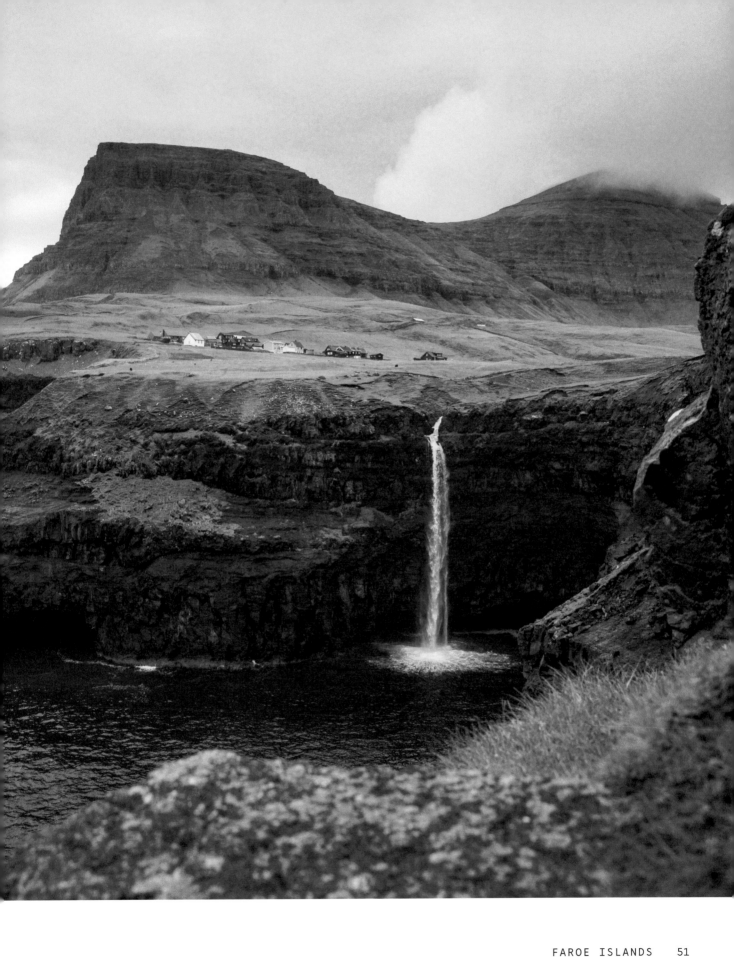

JOHANNES

Johannes is sitting in an archaic armchair that suggests it is as old as the house. The spirited man looks out the window with a serious expression on his face, lit from an outside shining light, which brightens only half of his face. Johannes is a sheep farmer and runs the oldest farm in the Faroe Islands.

"In 1557 my ancestors came to this place, built the farm and started to cultivate the land," says Johannes. He is a living testimony of heritage, as he is the seventeenth consecutive livestock farmer.

Johannes is surprised by us, suggesting that we didn't exactly choose the warmest island to go on a bike trip. Without the Gulf Stream, which brings warm water from Mexico to the north, the islands would be frozen and uninhabitable. The influence of climate change has had an effect directly felt here.

The rocky island outcrops are so small and isolated out in the Atlantic, the weather can be interchangeable. Providing a multitude of conditions from minute to minute; sun, wind, snow, and rain can all be experienced within hours. The weather is often a challenge for farmers, yet Johannes says that you have to follow what nature dictates. "When the weather is very bad and the lambs are still small, we don't feed the sheep. We don't want to disturb them unnecessarily and endanger the lambs."

As an experienced farmer, Johannes' land also includes a small island 10 kilometers (6.2 mi.) away, where he has a flock of sheep. Unfortunately, if the weather is bad, there is no way for him to get there because he cannot moor his boat. Normally, the sheep are brought to the "mainland" in mid-September. However, this is not always successful. Johannes remembers a year in which the sea was calm enough only for a short time in mid-November, to dare take a boat to the island and collect the sheep.

On the other hand, it can still become surprisingly cold in late spring. Last year, there was a big snowstorm at the end of May, which many lambs did not survive. It is arguably difficult to plan in the face of such meteorological fluctuation. Or as Johannes puts it: "You can't even rely on grass growing enough to feed the sheep." Yet, he also sees a real advantage in this unpredictability. "If you learn to live with what nature gives you, it makes you strong," he states. "That also applies to our lambs, because the weather here is so cold and the grass grows very slowly. However, it is full of taste and nutrients. This makes our lambs the best in the world." ◆

Johannes takes care of the breeding of the little lambs. Sometimes he has to assist with vitamins and food pellets.

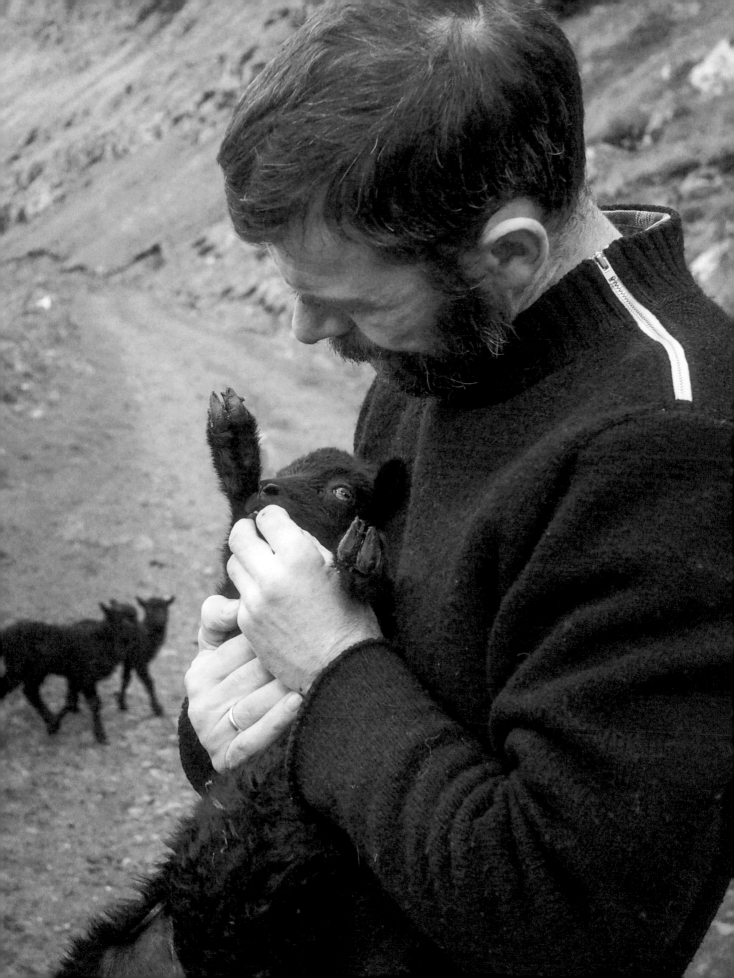

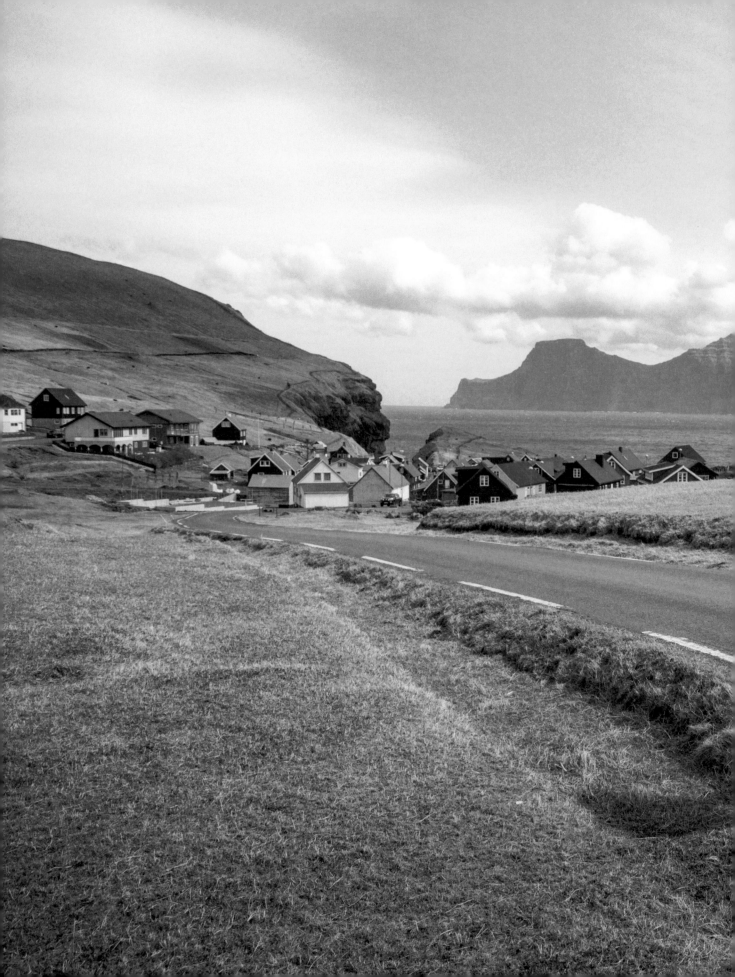

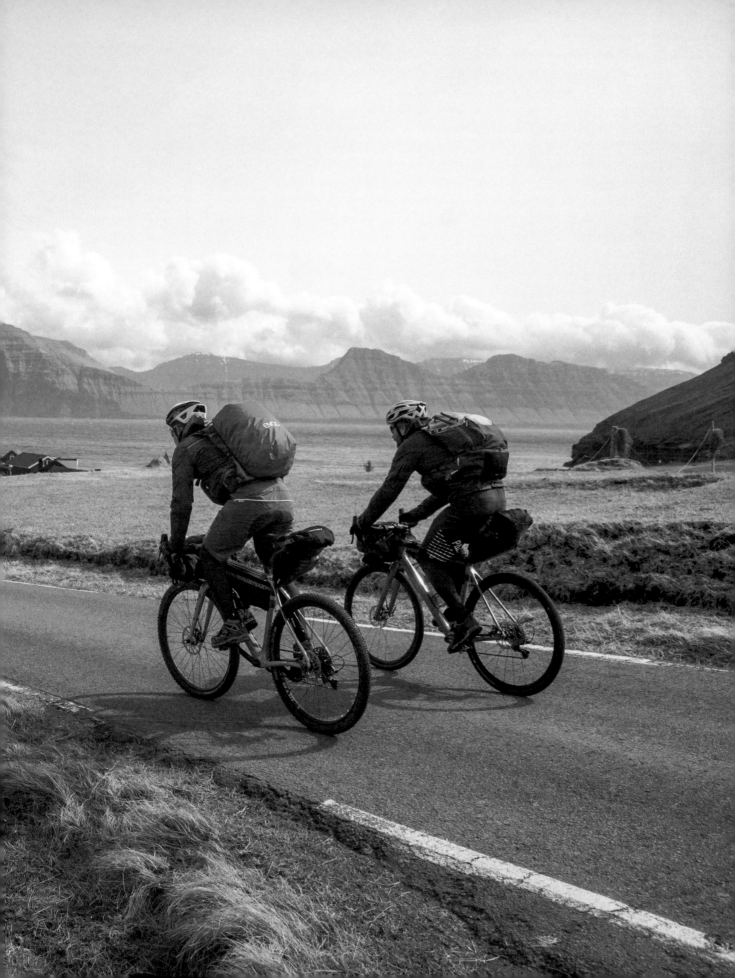

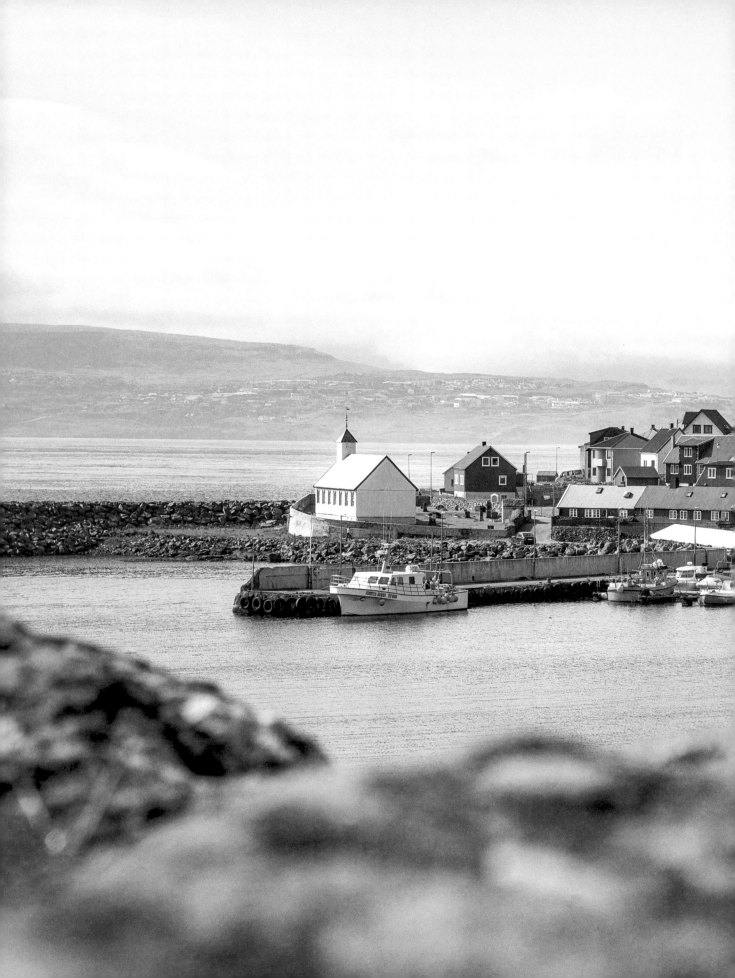

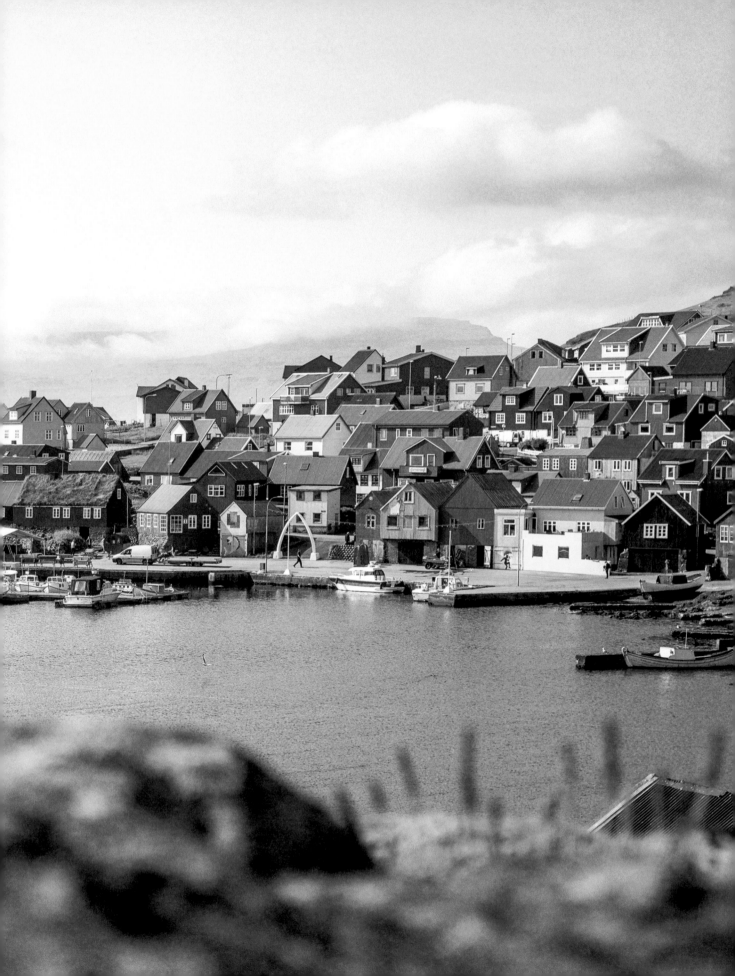

According to legend, the two sea stacks called Risin and Kellingin are petrified trolls that were supposed to pull the Faroes to Iceland.

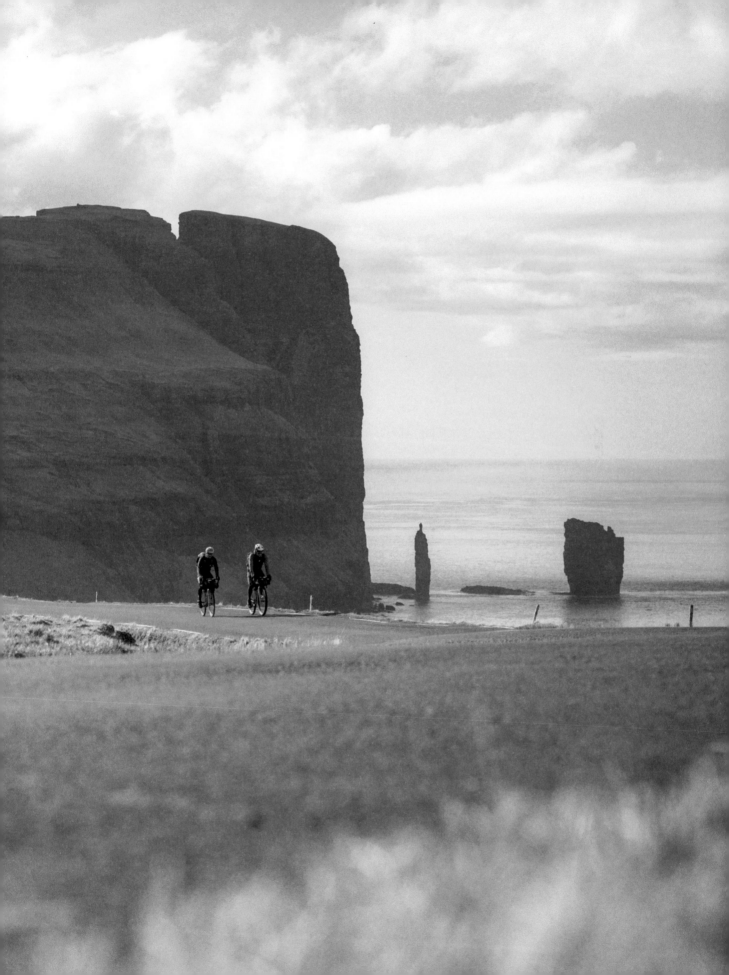

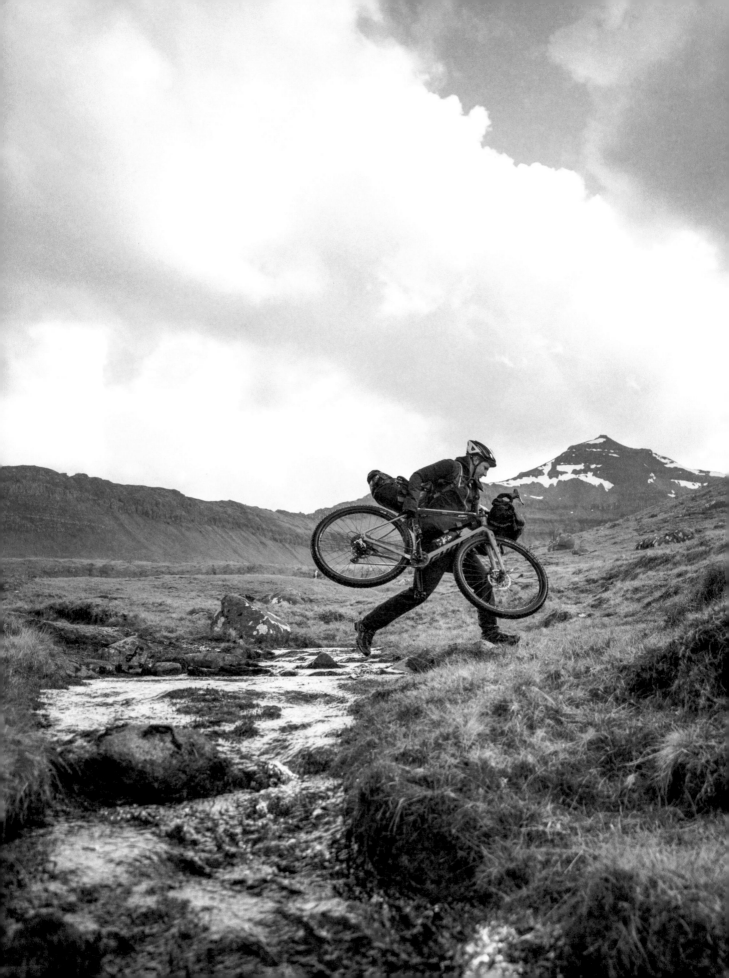

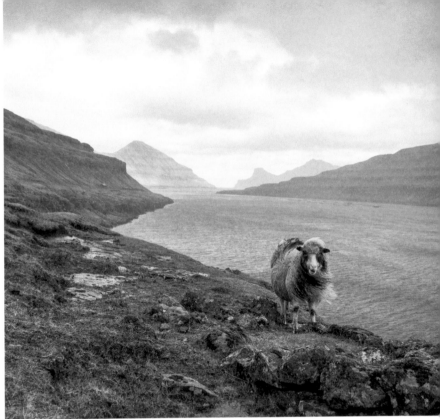

Inevitably, bad weather was predicted for the next few days. Waiting was not an option.

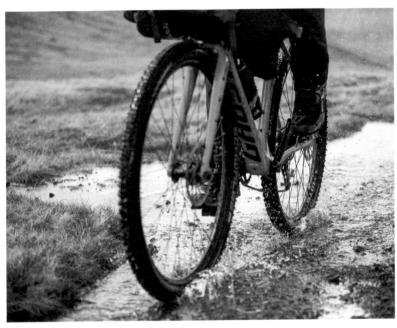

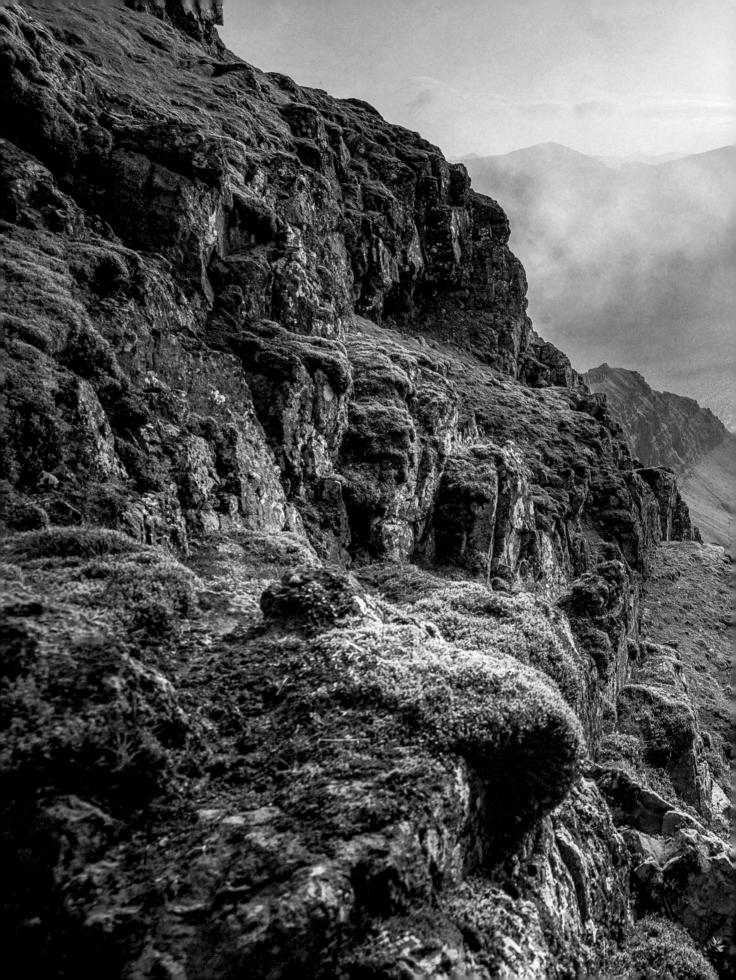

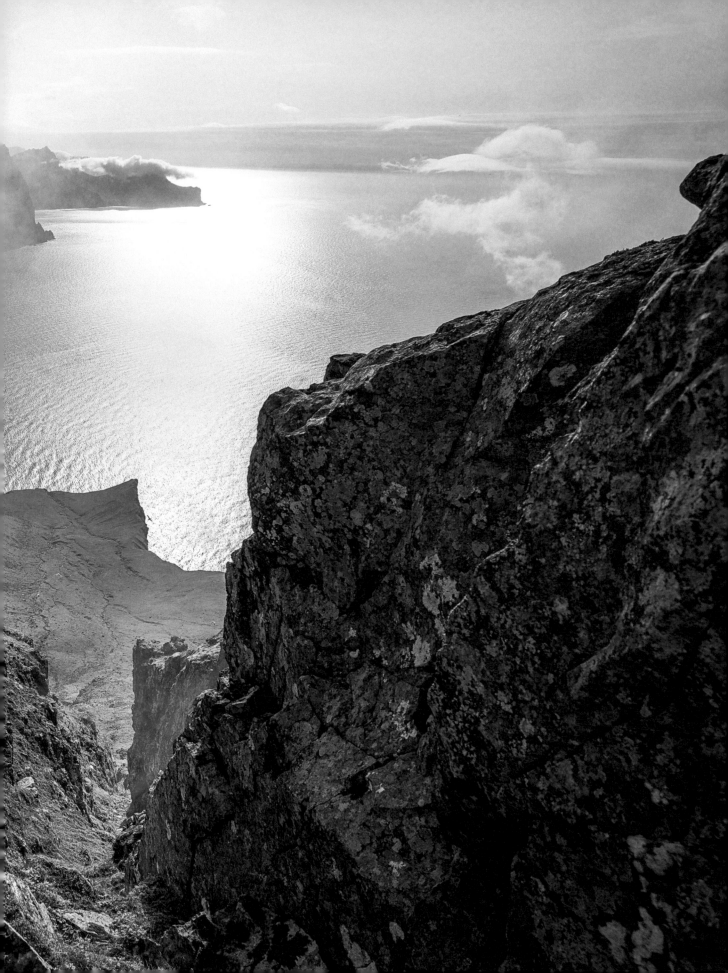

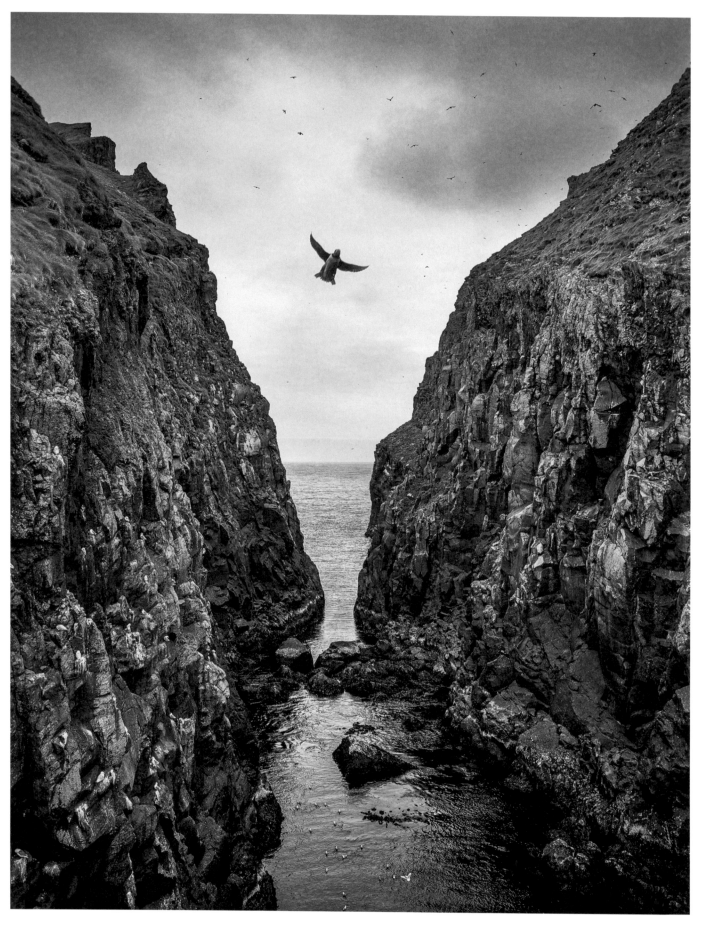

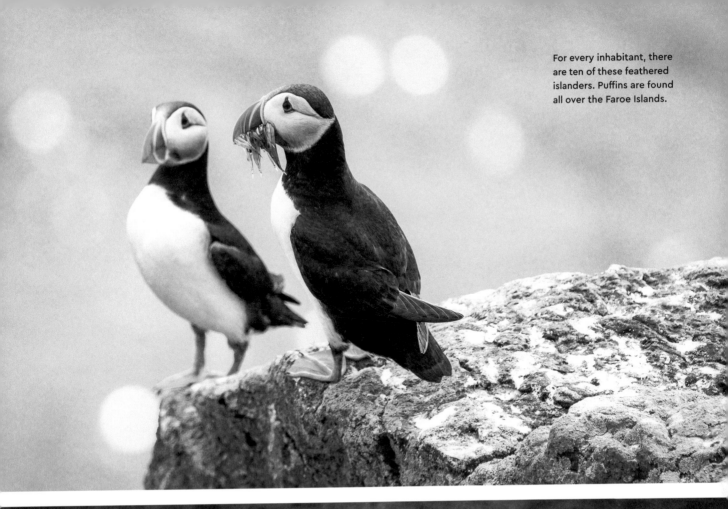

For every inhabitant, there are ten of these feathered islanders. Puffins are found all over the Faroe Islands.

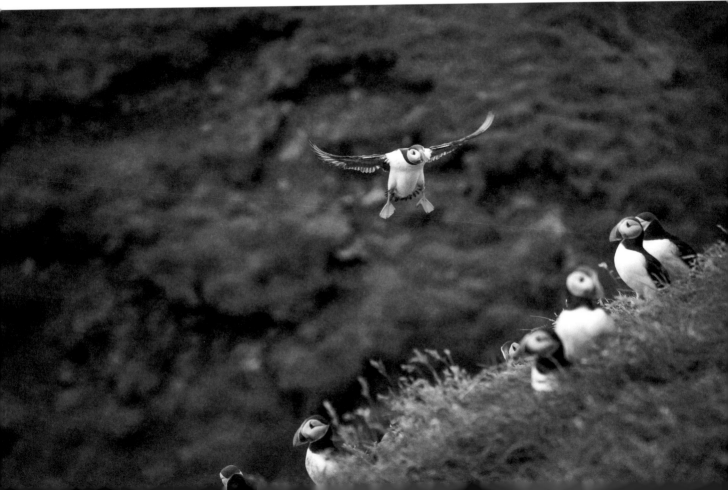

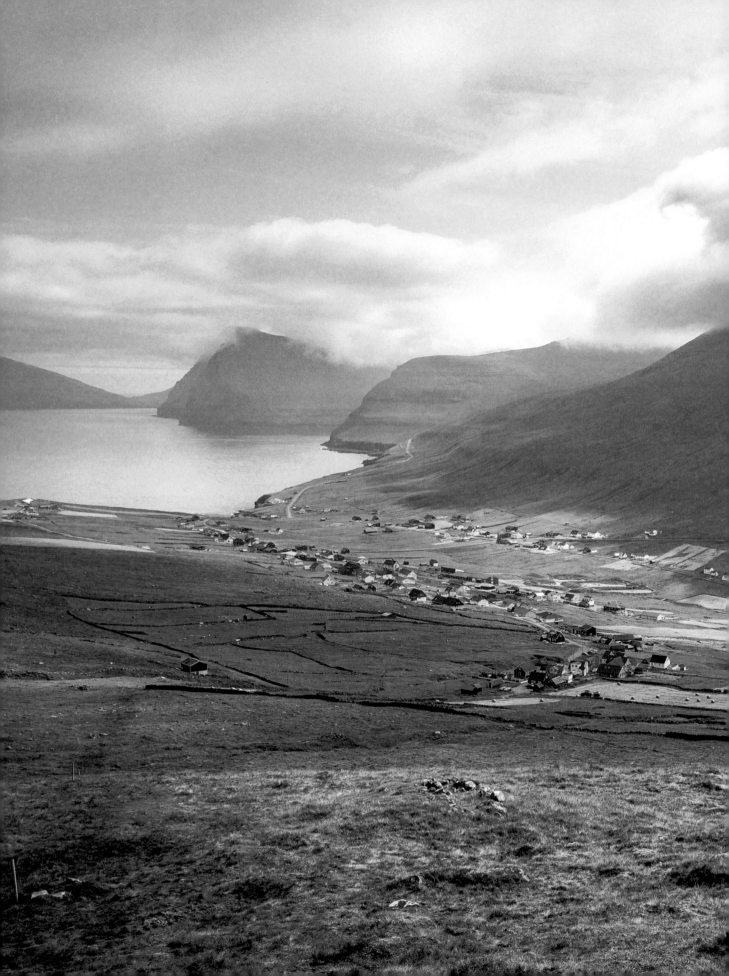

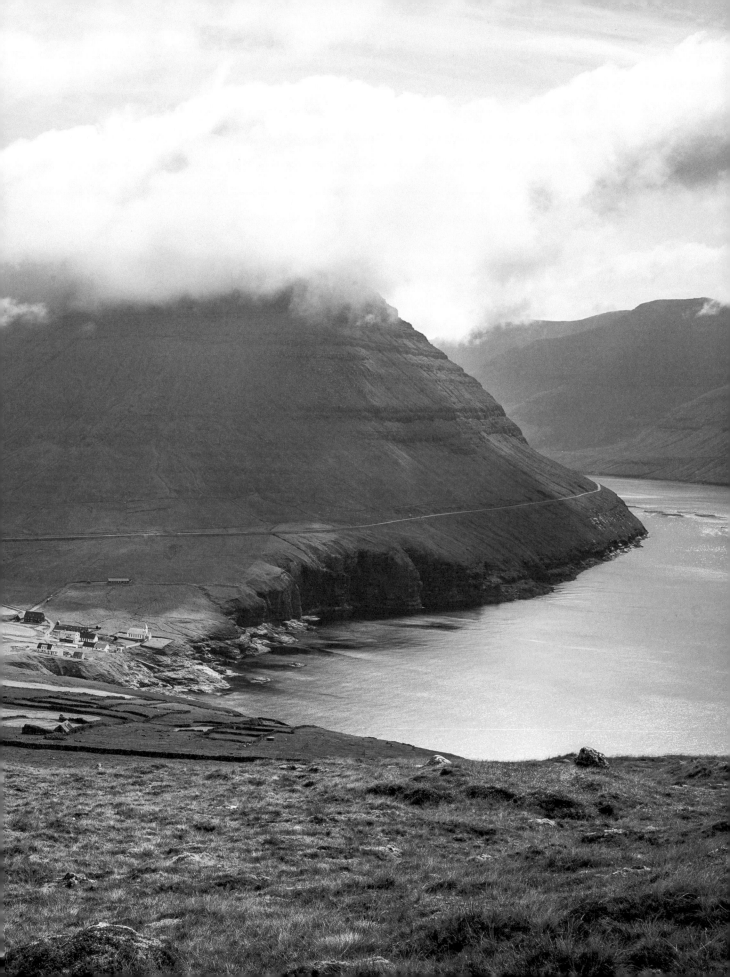

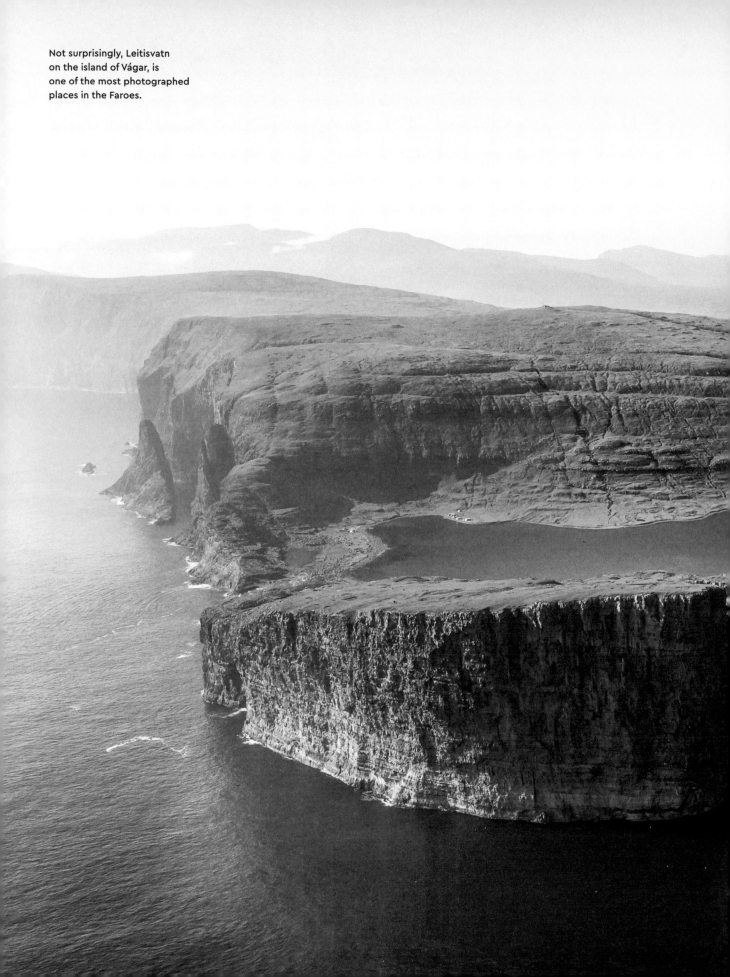

Not surprisingly, Leitisvatn
on the island of Vágar, is
one of the most photographed
places in the Faroes.

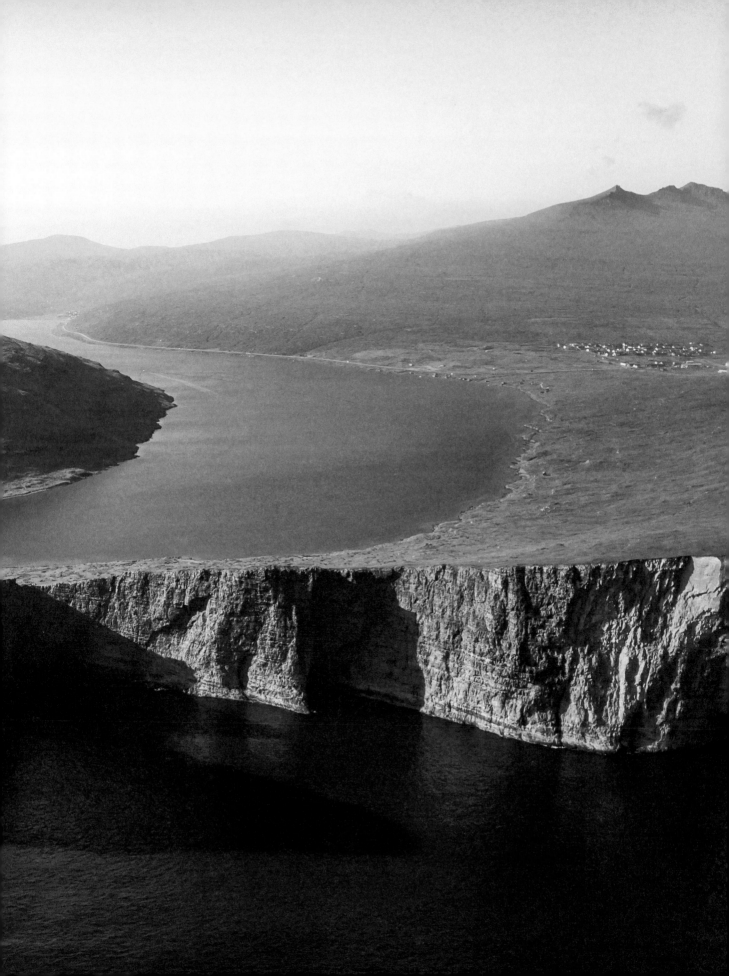

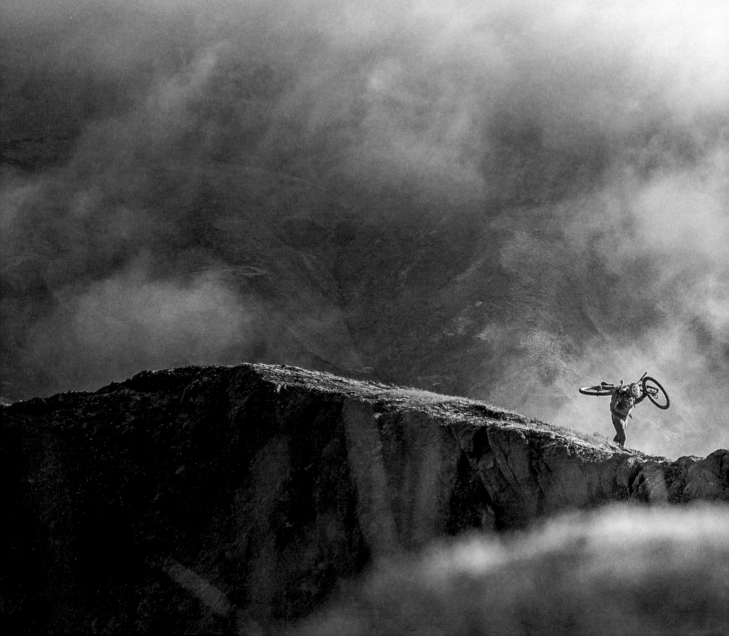

ISLAND OF FIRE AND ICE

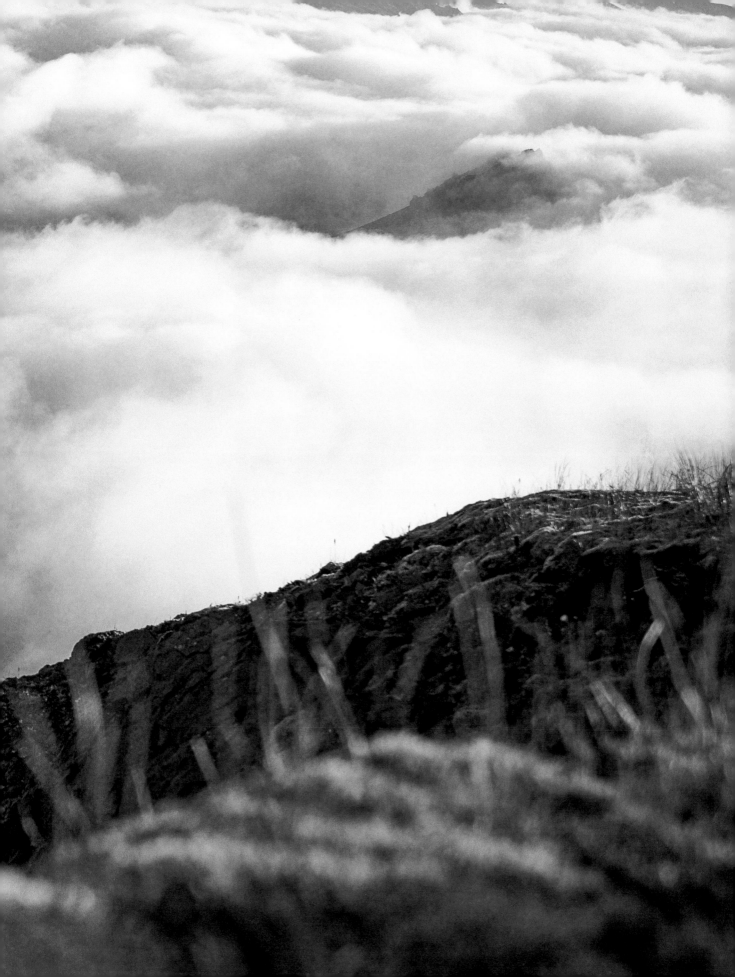

Active volcanoes, hot springs, gigantic waterfalls, geysers, fjords, bright green valleys, and black sandy beaches—everything you want of wild nature, *Iceland* has to offer.

Iceland is an island country in the North Atlantic between Norway and Greenland with its own language and currency.

It's the second largest European island after Great Britain and with just 3.3 inhabitants per square kilometer, it is the most sparsely populated country in Europe. Eleven percent of the landmass is covered with glaciers and 64.5 percent consists of so-called wasteland, in which there is little to no vegetation. Strong storms and constant volcanic activity change the appearance of the island all the time.

Reykjavík, the political, cultural, and economic center of the country, is home to around 65 percent of Iceland's population and is also the world's northernmost capital of a sovereign state. With its numerous cafés and lively cultural scene, the city surprises with Mediterranean flair in the summer.

During the financial crisis of 2008, Iceland suffered the most serious banking breakdown in economic history for an economy of its size. But Iceland has weathered the crisis, and thanks to the strong growth in tourism in recent years, has returned to an economic level similar to before 2008. Marketing experts were able to promote the country's natural beauty to travelers, nature lovers, and photographers.

Iceland can be divided into seven regions, each of which has its own specific landscape features.

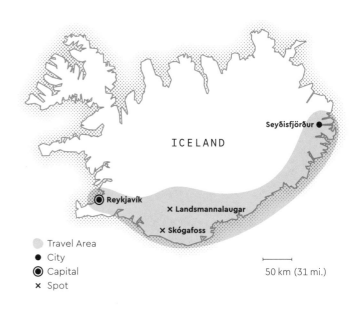

Travel Area
● City
◉ Capital
✕ Spot

50 km (31 mi.)

The south of Iceland is particularly popular with tourists. Here the Golden Circle Route connects the most important sights.

Travelers who want to explore the whole island should go on a trip along the Ring Road. The 1,341-kilometer (833 mi.) road encircles the main island of Iceland and leads past all major cities. It has only been fully paved since August 2019. Before that, particularly in the south, it was mostly a gravel path.

FACTS	Ø Temperature (Trip): 13 °C (55 °F)	Elevation (Trip): 740 m (2,460 ft.)	National Cuisine: hákarl, lamb, lobster
DESTINATION: Skógafoss	Trail Distance: 25 km (16 mi.)	Passability: medium to difficult, loose lava underground, creeks need to be crossed	Don't forget: earplugs to survive windy nights in the tent
TRAVEL TIME: July–August	Trail Duration: 1 day		

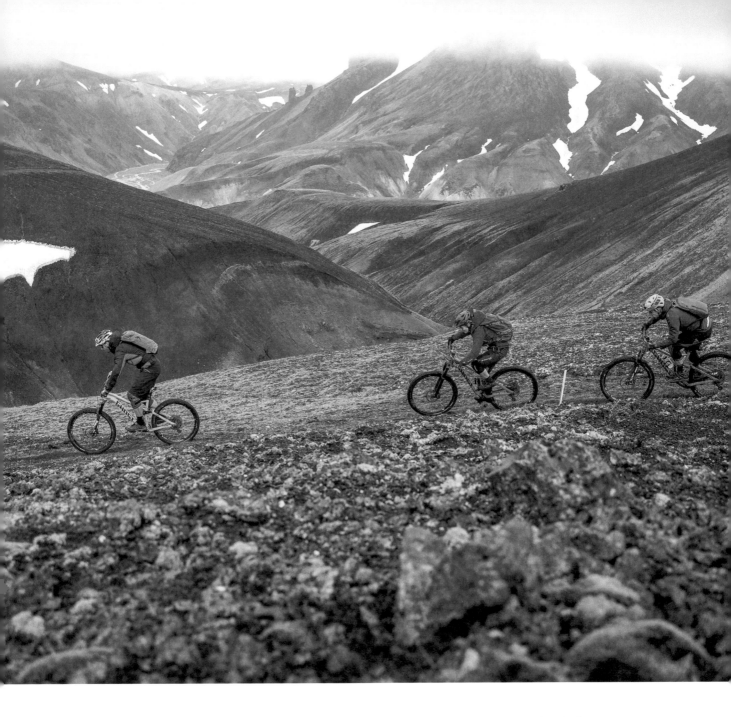

Ring Road leads to several trails that are suitable for mountain biking. However, booming tourism makes for crowded trails, especially during the tourist season.

The highlands are much more interesting and beautiful anyway. Since you have to repeatedly cross rivers by car, there are significantly fewer tourists here. The trails are scenically impressive and easily accessible. The extraordinary lava floor ensures comfortable cycling, but interior paths require a higher level of experience. As the distances between urban areas are often considerable and the weather is unpredictable, travelling alone in the Icelandic interior is not recommended.

Around the Landmannalaugar campsite, which is located within the Fjallabak Nature Reserve, there are several different routes you can ride. If you want to go deeper into the highlands, it makes sense to book a guide from Icebike Adventures. ◆

Through Rivers into Lush Green

The land of fire and ice. An attractive slogan and a really good description of Iceland—at least it was a few years ago.

A few people we meet on the ferry who have traveled the island several times claim that the rough, unspoiled Iceland no longer exists. That said, the ferry ride is long and monotonous—and happy hour at the bar is very popular—so maybe we should not believe everything that we are told.

But the frequent use of the term "overtourism" gives us mixed feelings even before we arrive in Iceland. The deck of our ship is full of outdoor enthusiasts with different interests, from fishermen to photographers to skiers. And in the belly of the ferry, there are massive vehicles that make our off-road vehicle with a roof tent look rather puny. They were certainly not just brought to attract attention in front of big city ice cream parlors. Ice cream is so popular in Iceland, that there's actually a word for ice cream road trip: ísbíltúr. Nevertheless, we also hear a few encouraging and enthusiastic reports with insider tips: "If you are here, then you definitely have to go there. Nobody knows that place."

Unfortunately, the skeptical voices are confirmed during our first few days. The Fire and Ice tourism campaign was apparently so successful that it triggered an avalanche of social media adventurers and cell phone photographers who visit the country.

As we drive west on the lower Ring Road, we are asked by bus travelers to step out of the picture at almost every attraction. There are No Entry signs on every side street and notes at every parking lot explaining that camping is prohibited. »»»

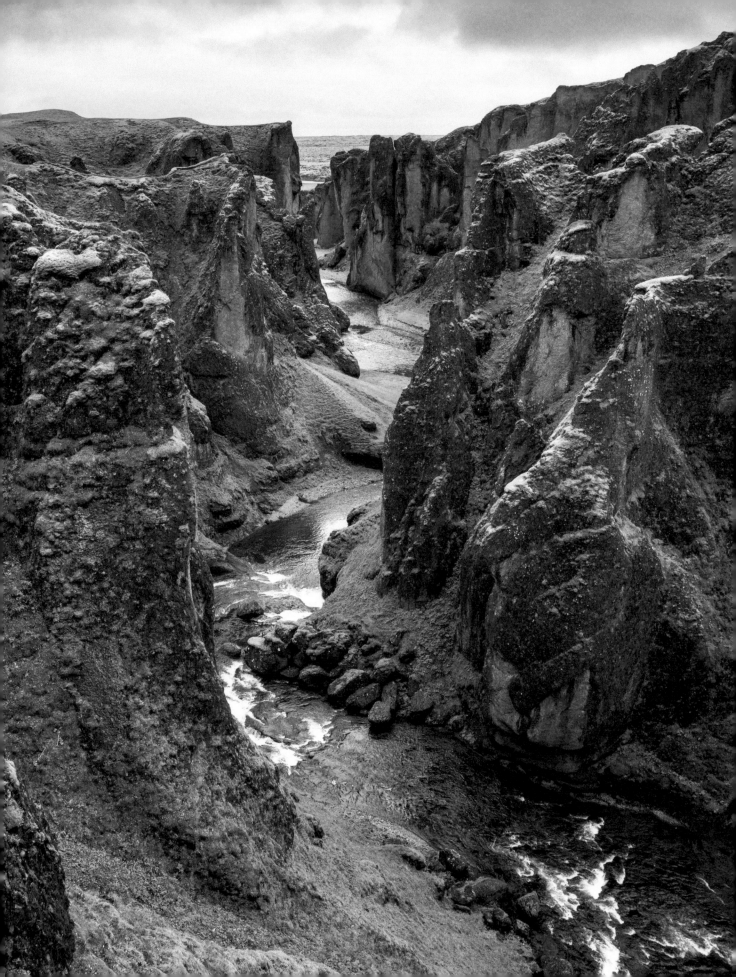

>>> Even when we are on the south coast of Iceland, we can hardly find a waterfall without hundreds of hobby adventurers with red or yellow jackets in front, trying to drive up their number of followers. Even the smallest lake or mountain is set for self-marketing. In photo ops, it appears as if the photographer hiked into the hinterland for days—while the rental car is parked fewer than 50 meters (164 ft.) away.

Is this really the Iceland everyone is talking about? The great freedom and breathtaking nature? If the south of the country is full of tourists chasing the next selfie, where do we find this Iceland that "nobody knows of" that was mentioned on the ferry?

Will We Find
the Pristine Iceland?

When we arrive in Reykjavík, we meet Magne from Icebike Adventures, a guiding company that we had already contacted from Germany. Route planning is complicated in Iceland because there are hardly any marked trails. Recommendations from local guides like Magne have helped us to find the unspoiled trails.

For many years, Magne worked as a graphic designer on important international projects when he realized that he was just staring at a computer and barely out the window. So he quit his job and set up a guiding company that leads bikers through Iceland, showing them the most beautiful trails and the best landscapes.

When we sit with him in Reykjavík in the evening, drinking the local craft beer and eating surf and turf (lobster tail with beef), we ask him where exactly the Iceland we are looking for can be found. His answer is as simple as it is obvious. What we are looking for starts in the highlands directly behind the first river crossing, where the tourists with their rental cars and big buses do not go. There it still exists—the rough and lonely Iceland.

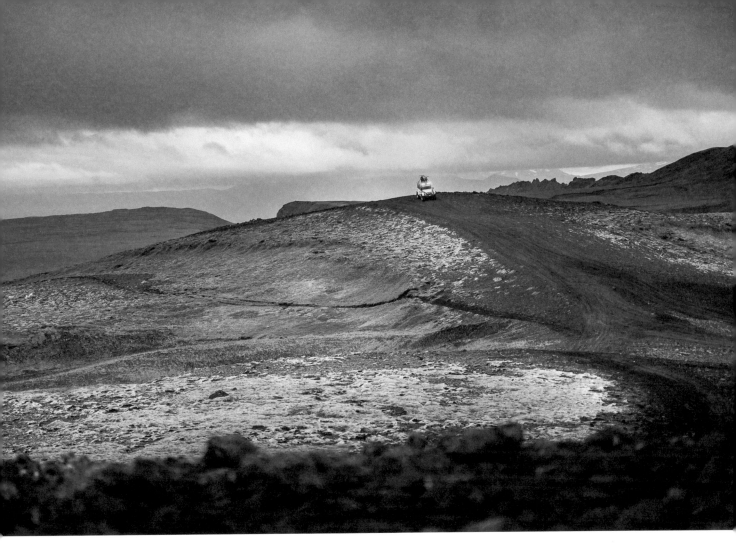

So the next day we head toward a plateau called Landmannalaugar amidst the most impressive and colorful rock and earth formations I have ever seen. Magne was right. Where the paved roads end and the gravel paths continue, suddenly you no longer see any No Entry signs, selfie sticks, or tourist crowds. Yes, you can make friends with this Iceland.

Water is Crossing Our Path

After a long drive on gravel paths and through rivers, where the landscape changes from gray to green to black and then back to green again, we arrive in Landmannalaugar. At the end of a huge valley in which meltwater rivers meander, we see many small, colorful tents already set up at the campsite.

This is where the famous Laugavegur hiking trail begins. The long-distance trail takes you over high mountain passes and deep glacier trenches to Skógafoss, a 60-meter (197 ft.) high waterfall on the south coast of Iceland.

For us there is only one last hurdle to overcome before we can pitch our tent and cook something to eat. Shortly before the campsite, there is a river crossing in which you cannot see exactly how deep it is. There are some off-roaders on the riverbank and people assessing the situation. Nobody dares to make the first attempt at driving into the river.

After talking to the other travelers for a while, I am fed up with waiting and also hungry. Without further ado, I take off my shoes, roll up my pants, and slowly wade into the water. Although it only reaches just above my knees, the river tears and pushes against my body with such force that I am unsure whether our car would simply be washed away. Yet back on land, I decide to give it a try. »»»

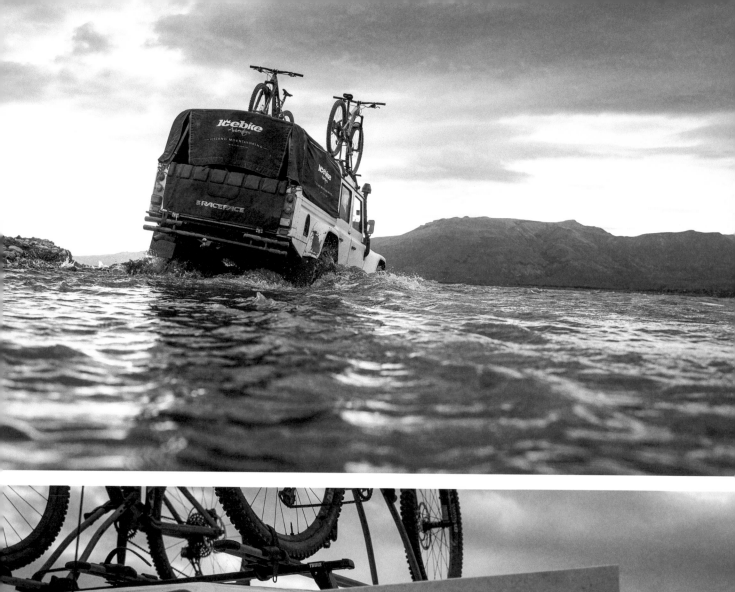
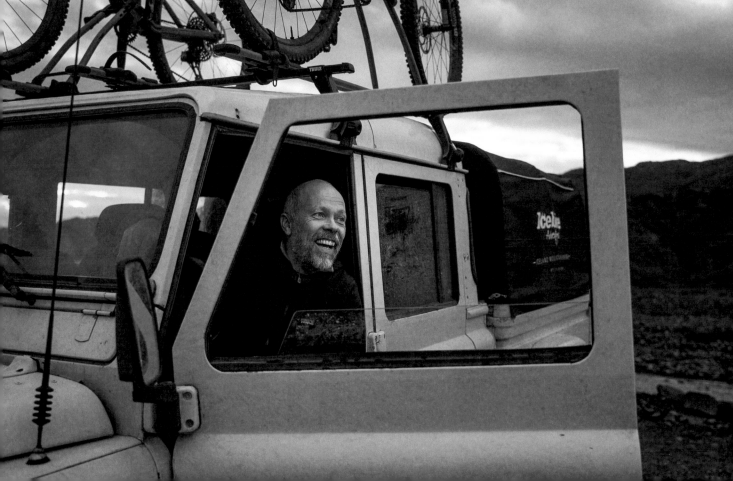

>>> Here we go. I switch on the Wade mode and slowly drive from the shore into the water. The pressure of the water on the car keeps noticeably increasing. I hope the wheels do not lose their grip and that we are washed down the valley. I think to myself, "Come on, hit the gas again, and then it should be done." Unfortunately, my foot is still very frozen and not very sensitive after my little hydrotherapy unit, so I step on the accelerator a little too hard and spill some water on the hood.

And it happened. The mistake that immediately reveals you as a fool every time you meet others. Nothing serious happened to the car, but the front license plate could not withstand the water and was washed away.

Nevertheless, we felt relieved, because we later learned that many travelers' attempts to cross the rivers had been less fortunate. For example, bad accidents are common because drivers make the mistake of trying to cross the river at the narrowest point, which is usually the deepest and hardest section to traverse.

Learn from my mistake: ask those who know the place before you act the part of the hero.

Since the whole country is teeming with geothermal activities and steaming from the ground, there are some hot springs where warm water from the interior of the earth comes to the surface and fills a natural swimming pool with hot water. After a long day in the car being thrown around all over the place, we take the opportunity to relax our muscles a bit in the warm water to be prepared for our first bike tour into the surrounding mountains on the next day.

Cycling on Lava

We experienced Iceland during the midsummer period. Since Iceland is very close to the polar circle, the sun never really sets in the summer months.

During this time, the human body is somewhat "confused" and it can be difficult to fall asleep and often hard to tell exactly what time it is. But we are sure that the new day has already begun as we crawl out of our roof tent the next morning and

Above: **In search of new trails.** / left side: **Magne from Icebike Adventures knows Iceland like no one else.**

the sun is already shining on our faces. After an extensive breakfast, we grab our bikes and make our way to the first trail.

Through a rough volcanic landscape with huge lava blocks that lie everywhere, the trail winds slightly upwards toward a large cloud of steam. The operators of the campsite told us in the morning that mountain bikers are very rare here and the route to the bubbling and smoking springs in the hinterland would certainly be perfect for cycling.

After just a few kilometers on the trail, we realize that biking in Iceland is different from most of what we have experienced so far. The mixture of soft sand and pointed lava stones on the edge always offers surprises. After several hours of pedaling and carrying our bikes through the colorful landscape of the Icelandic highlands, the last downhill of the day lies ahead. >>>

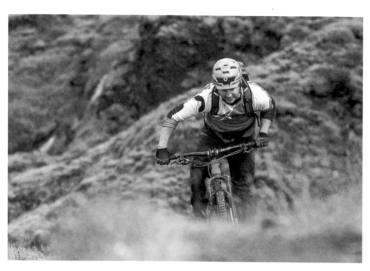

On the mountain ridge Thorsmörk you can ride for miles through an unusually green Iceland.

>>> The path meanders on a ridge in countless hair-pin bends, through the lava gravel and toward the bottom of the valley, which is partly flowing, partly narrow and blocked. In any case, one thing can be said: biking here is not easy. There are no jumps or other obstacles, but the fluidity of the trail in connection with the ground harbors some dangers.

The tour includes everything that makes a mountain bike heart beat faster: classic single track route, long cycling sections, a glacier crossing, an active volcano, and an unforgettable downhill destination.

On our trip, we always learn that there is a lot to discover off the beaten track. If you try a little, you will find exactly the Iceland you are looking for, no matter if you are a fisherman, skier, photographer, or a mountain biker like me. You just have to look for it and get involved with the country. ◆

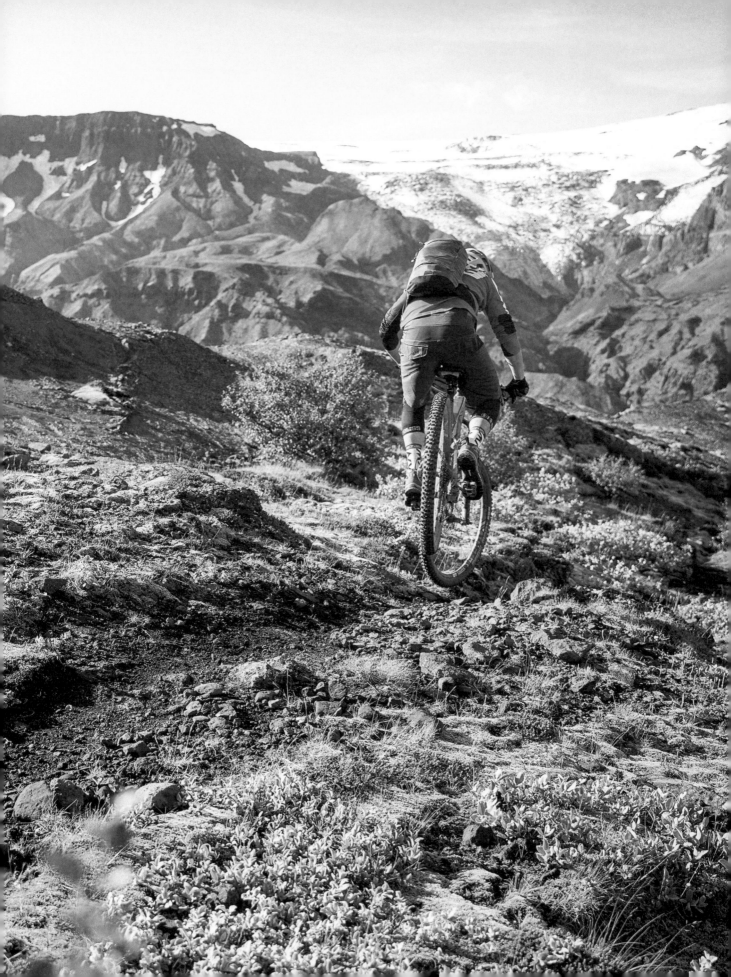

OVE

Ove sits in his spartan wooden hut next to a rusty tubular steel table and smiles at us with warm, curious eyes. He has shaggy dark blonde hair, wears blue dirty work pants, and of course, a really thick Icelandic sweater.

Ove is a fisherman. Ove narrates. He started fishing when he was 15 years old. At first, he was using his neighbor's boat. After he died, Ove says laconically, he just bought his own boat. Again he smiles kindly and somehow wisely.

He now has his fifth boat and has been fishing for 44 years. Fishing, he says, has improved significantly since then. "Really?" I wonder, and I am a little surprised. Ove thinks that today you earn more money and the work is not so hard anymore. When I look at his bear-like giant hands, I can hardly believe it.

But again he just smiles. "In the past, you had to fish every day and every night," Ove says. "Today you only have to get out once a day and the trip is shorter." He says that Iceland is a great area for fishermen and that it has improved in recent years.

I am surprised again. We all know what the oceans are like. Does that mean there are more fish today than before? So I ask him how much fish he is talking about. "This winter we caught 120,000 kilograms (220,000 lb.) of fish," he says. "On a trip it's usually between 1,000 and 3,000 kilograms (2,200 to 6,600 lb.)—the record was 6,000 kilograms (13,200 lb.) in one day." Now I am really flabbergasted. Because when Ove says "we," he really means just himself and his fishing buddy. Only two men!

Ove sells the fish to a factory. From there, around 80 percent is exported all over the world, including to Germany.

To be honest, I feel overwhelmed imagining such large quantities of fish, so I decide to change the subject and come up with a simpler question. I ask if he has children and if they have anything to do with fishing.

He has a son who works for a Norwegian oil industry—not sure if this is an easier topic—, but I ask what he thinks of the industry in the far north. "The oil industry still wants more oil and more money. They don't think about what that means when you're a fisherman," he replies. I search in vain for anger or fear on his face. He remains completely calm. "They want to drill for oil right where we fish," he continues, then says with a knowing smile. "We'll fight them when they come." I want to know how he imagines that. "The fish are very important here. Maybe there will be a revolution." Then he pauses for a moment, thinks and grins: "Yes, a revolution. That could be it."

This time my surprise is obviously written all over my face. "I have to be a fisherman," Ove says as he leans over to me. "I was born here, I have spent my whole life here and I will stay here until the end." ◆

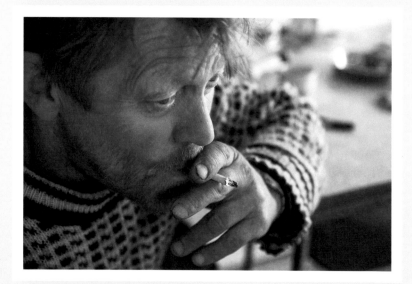

In the 40 years that Ove has worked as a fisherman, a lot has changed—for the better.

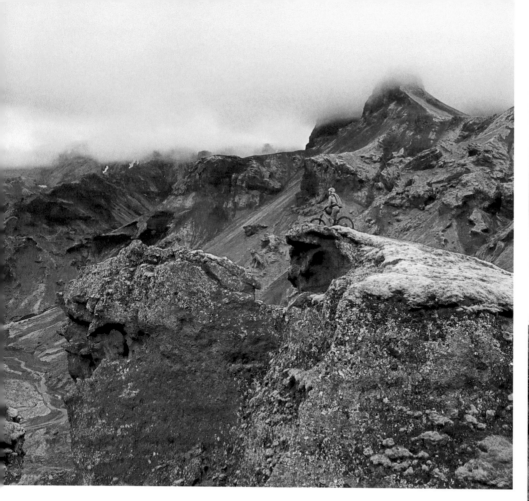

In any case, one thing can be said: biking here is not easy.

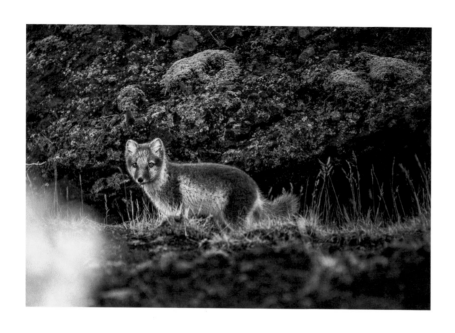

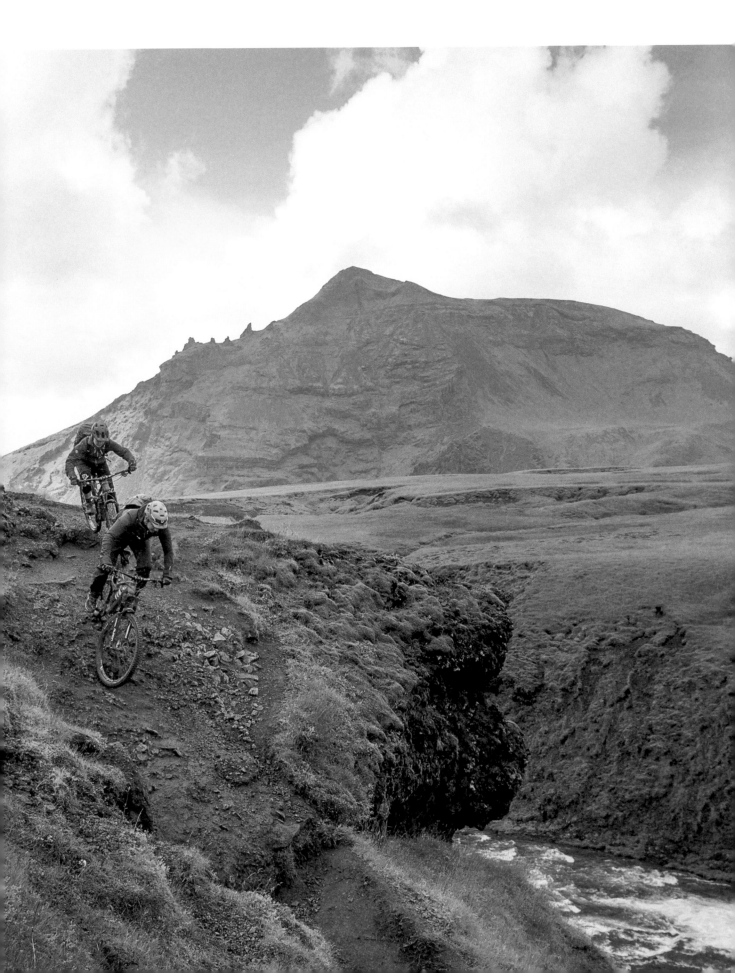

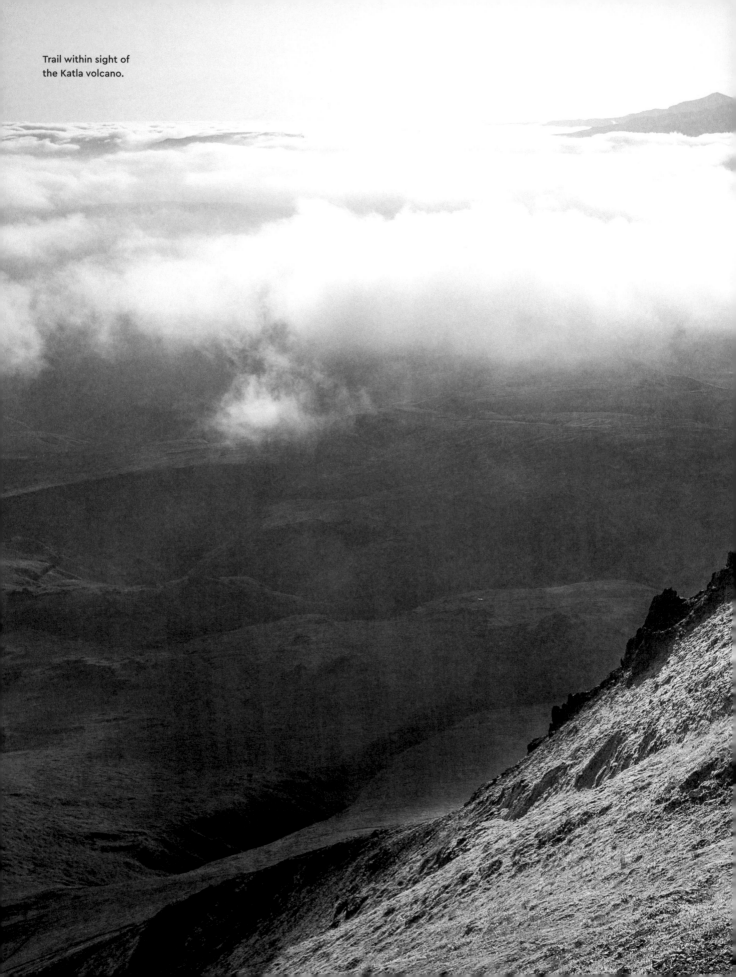

Trail within sight of
the Katla volcano.

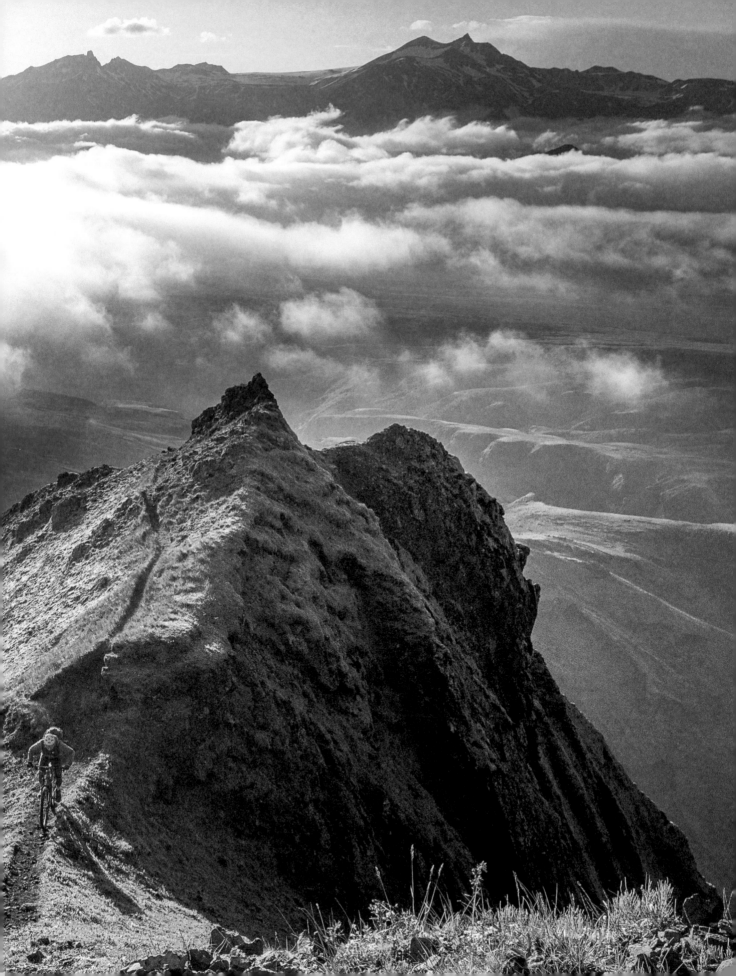

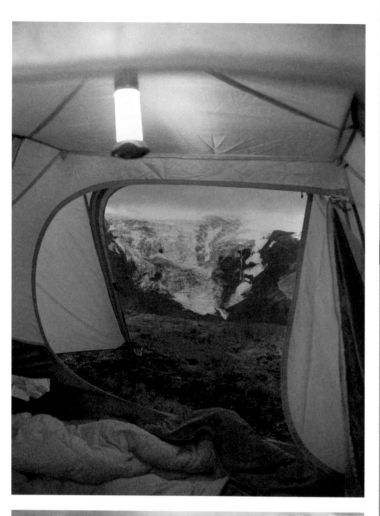

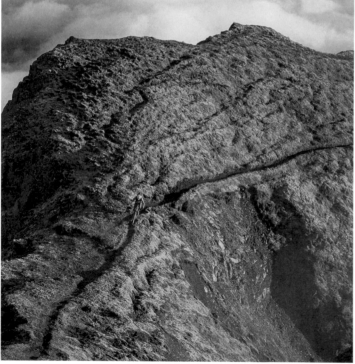

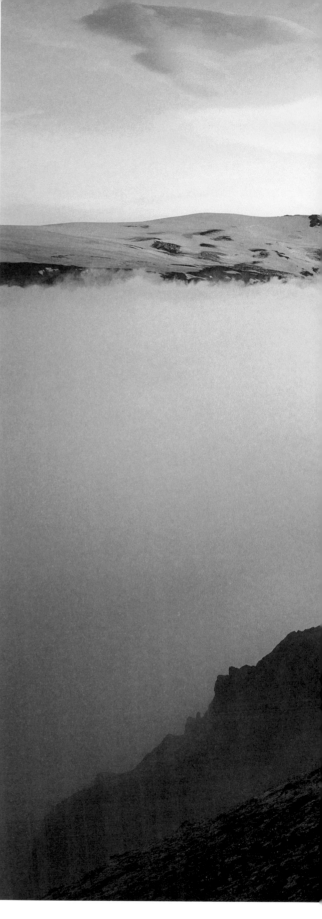

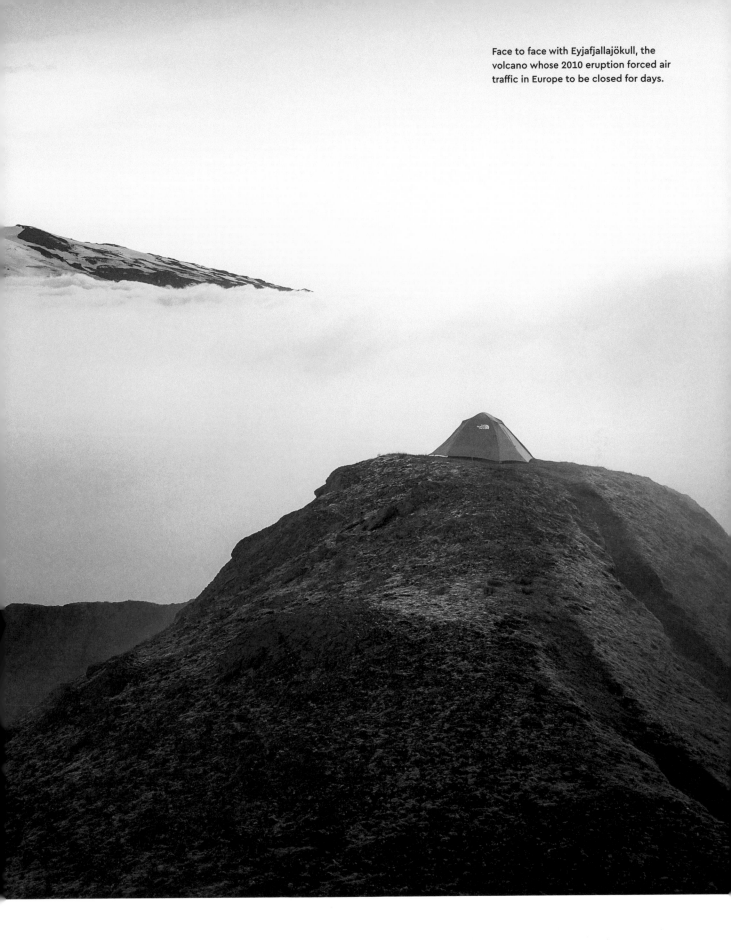

Face to face with Eyjafjallajökull, the
volcano whose 2010 eruption forced air
traffic in Europe to be closed for days.

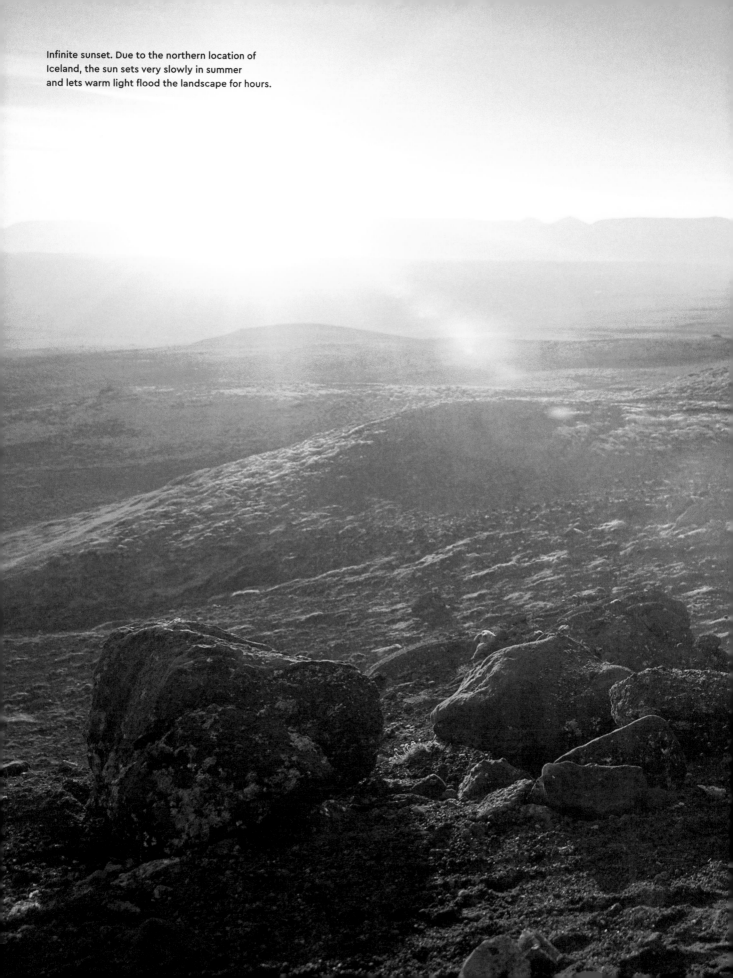

Infinite sunset. Due to the northern location of
Iceland, the sun sets very slowly in summer
and lets warm light flood the landscape for hours.

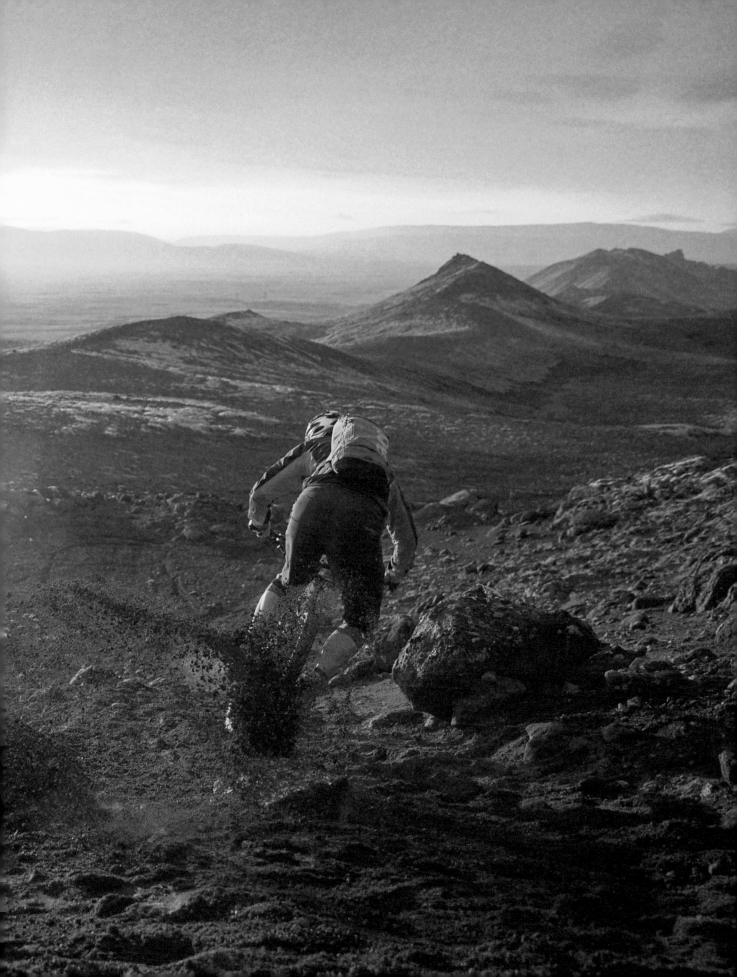

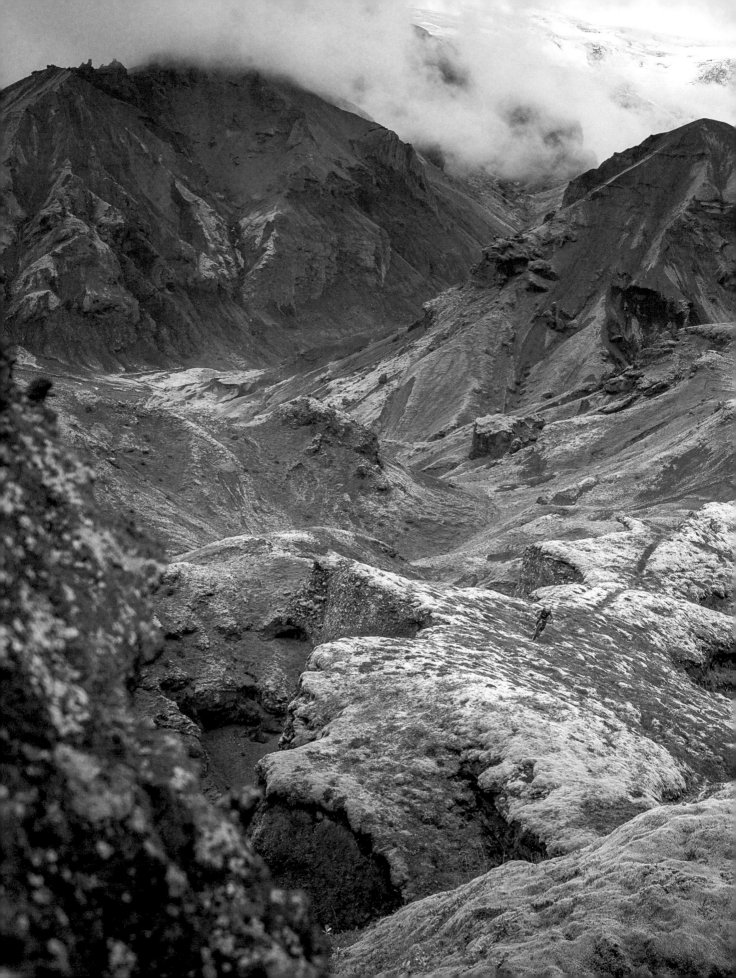

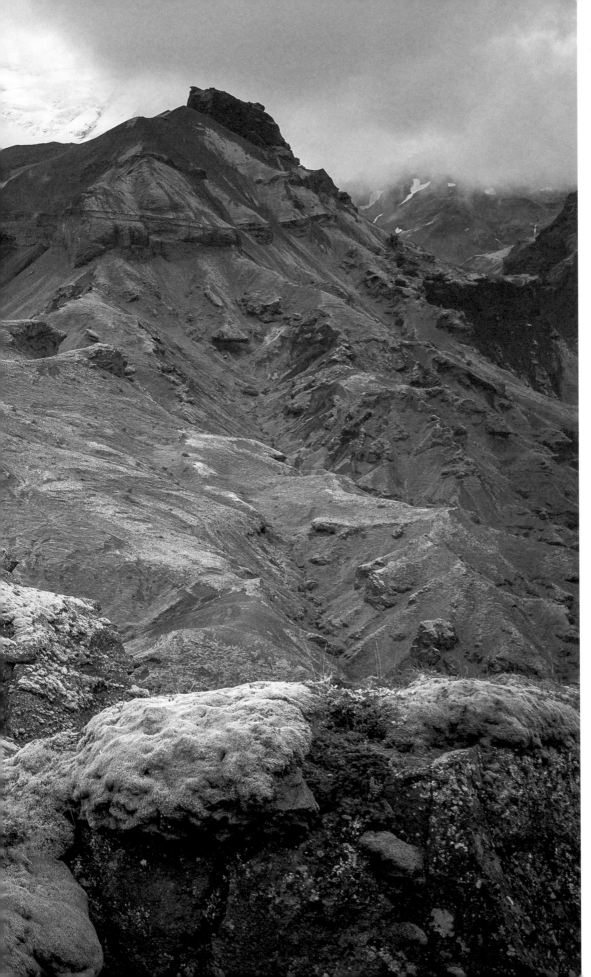

Thorsmörk the hidden valley in Iceland's hinterland. The arduous journey rarely brings tourists here.

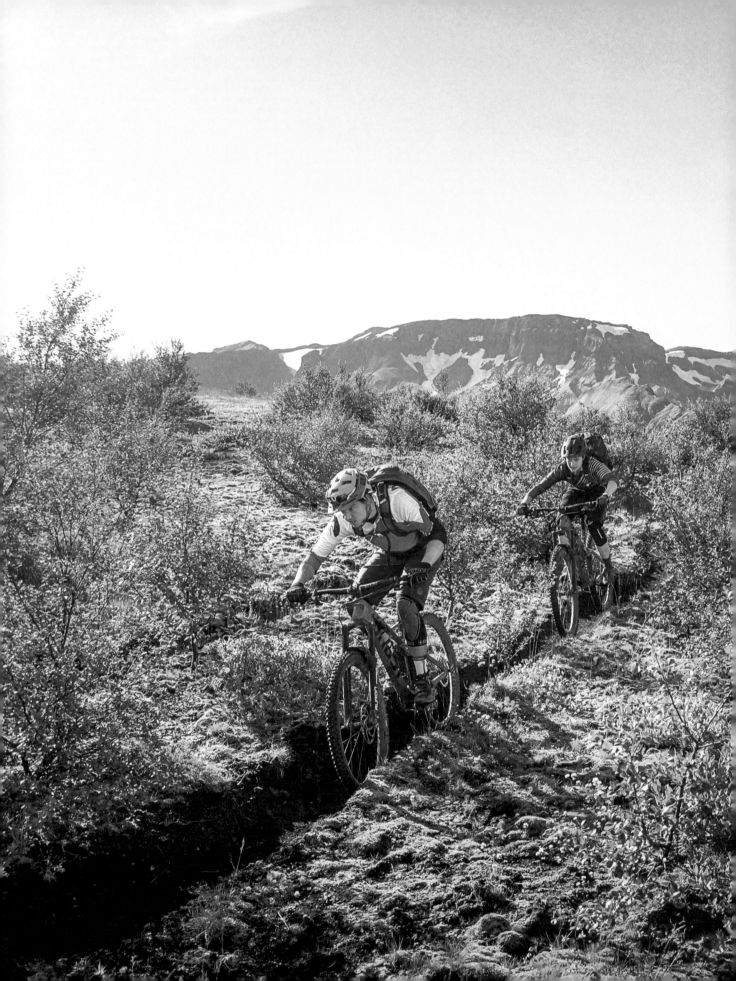

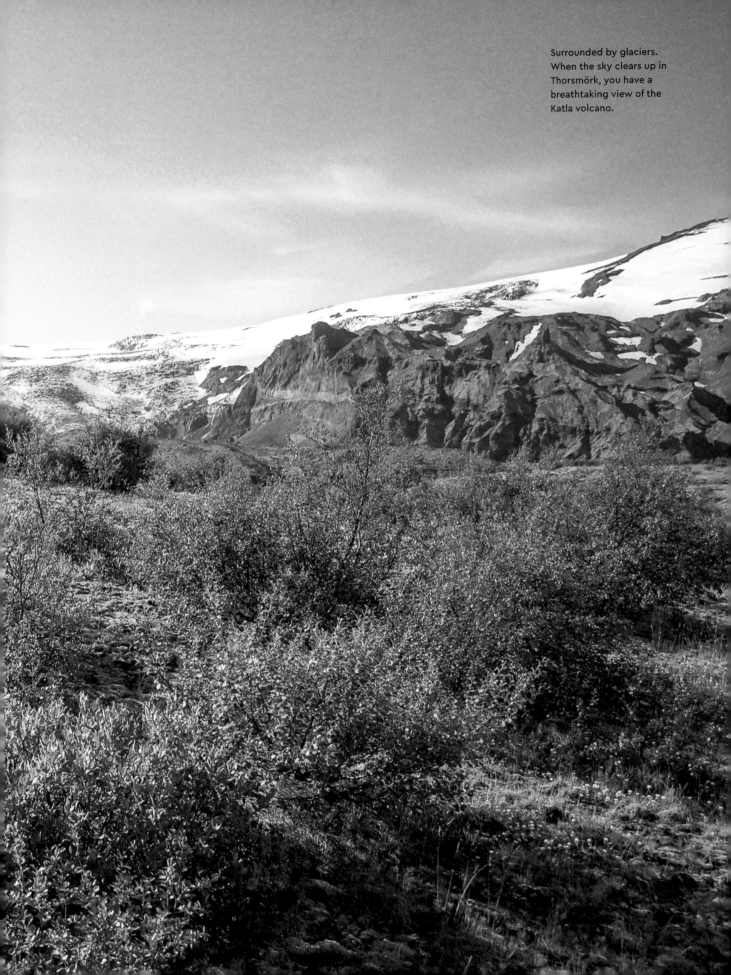

Surrounded by glaciers.
When the sky clears up in
Thorsmörk, you have a
breathtaking view of the
Katla volcano.

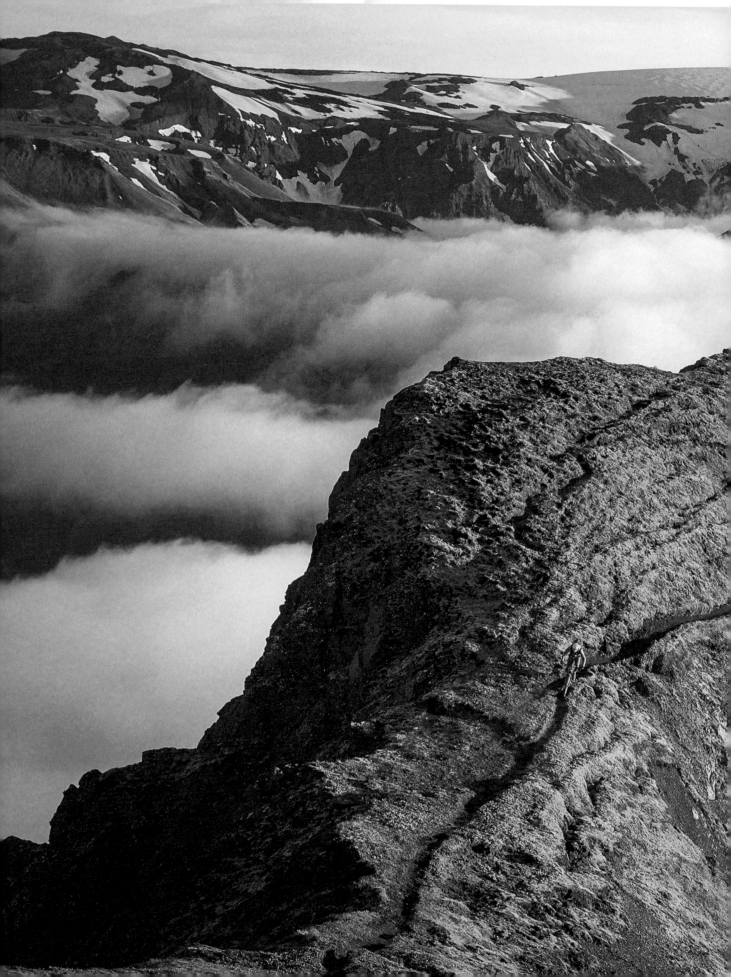

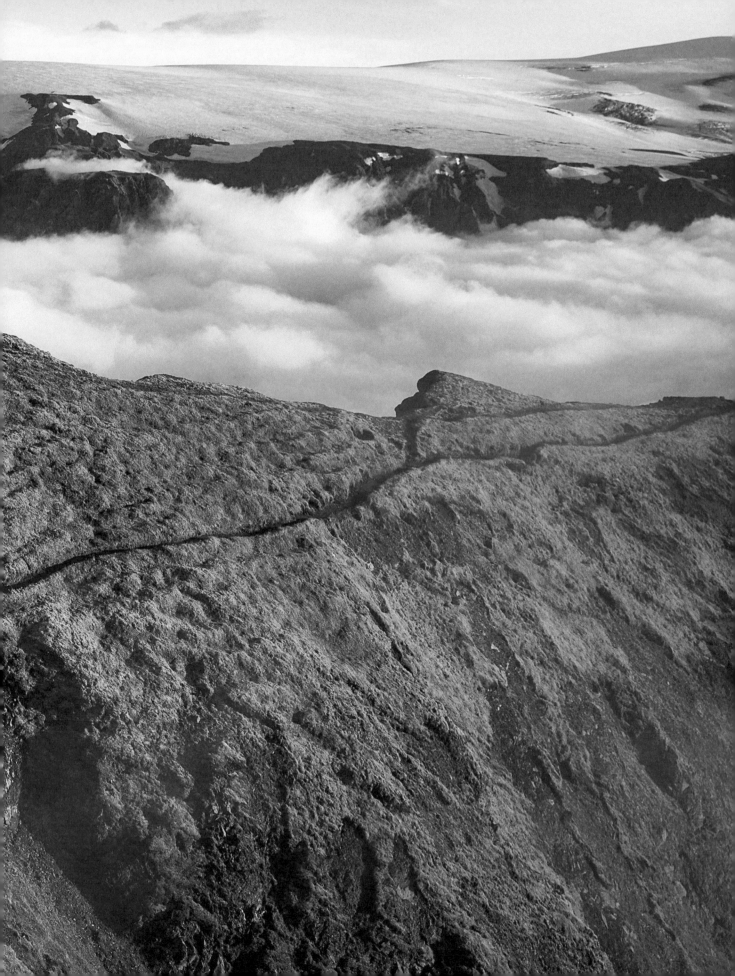

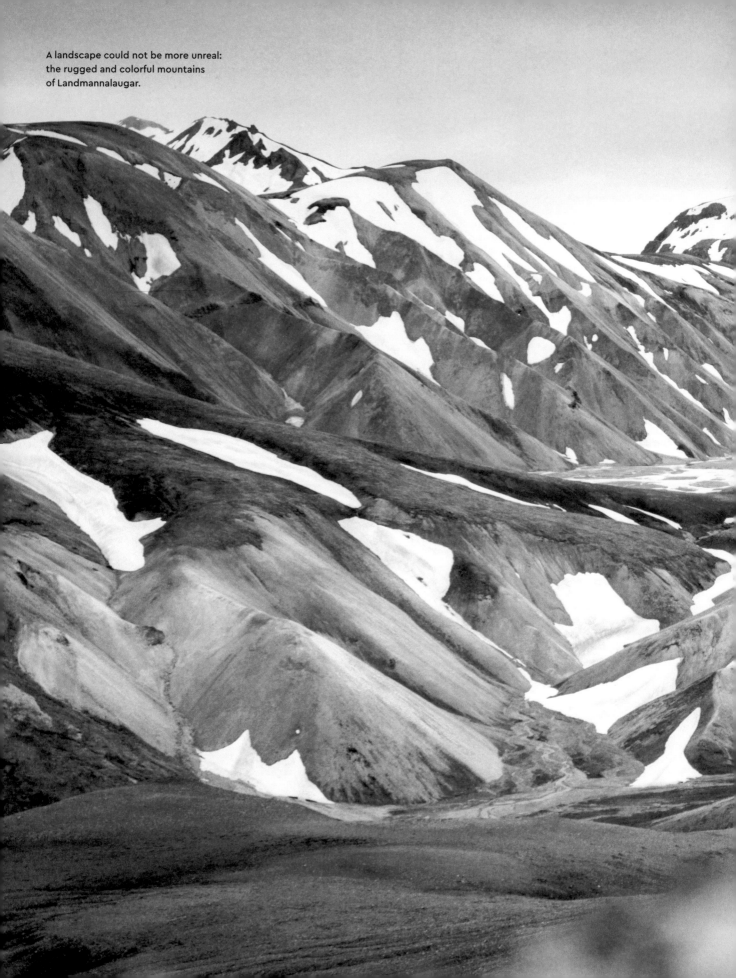

A landscape could not be more unreal:
the rugged and colorful mountains
of Landmannalaugar.

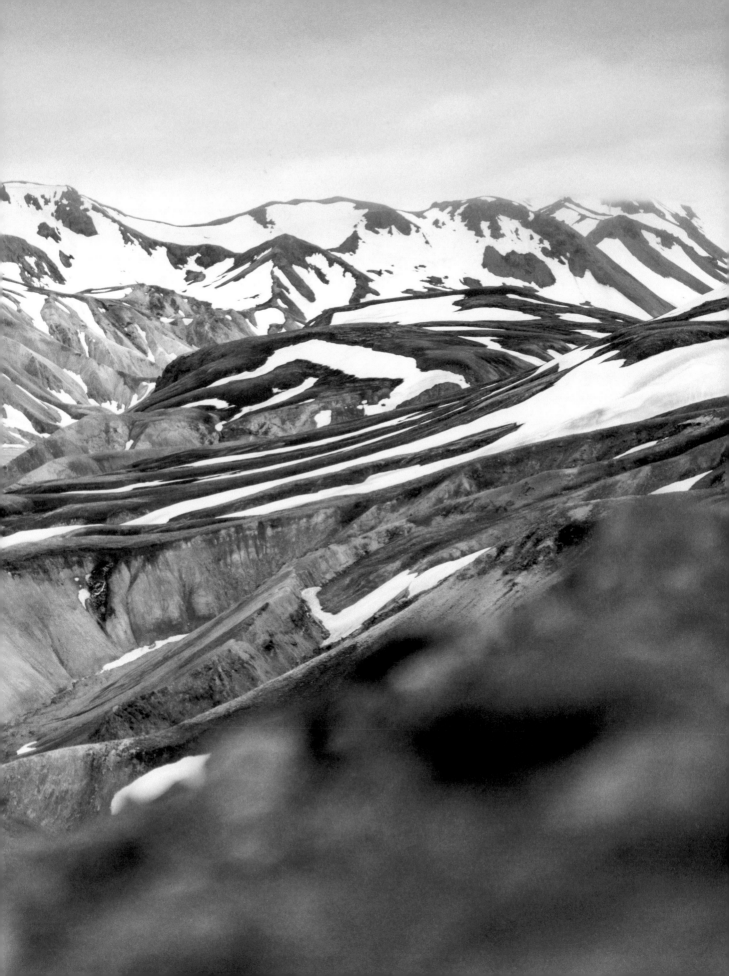

THE WORLD'S LARGEST ISLAND

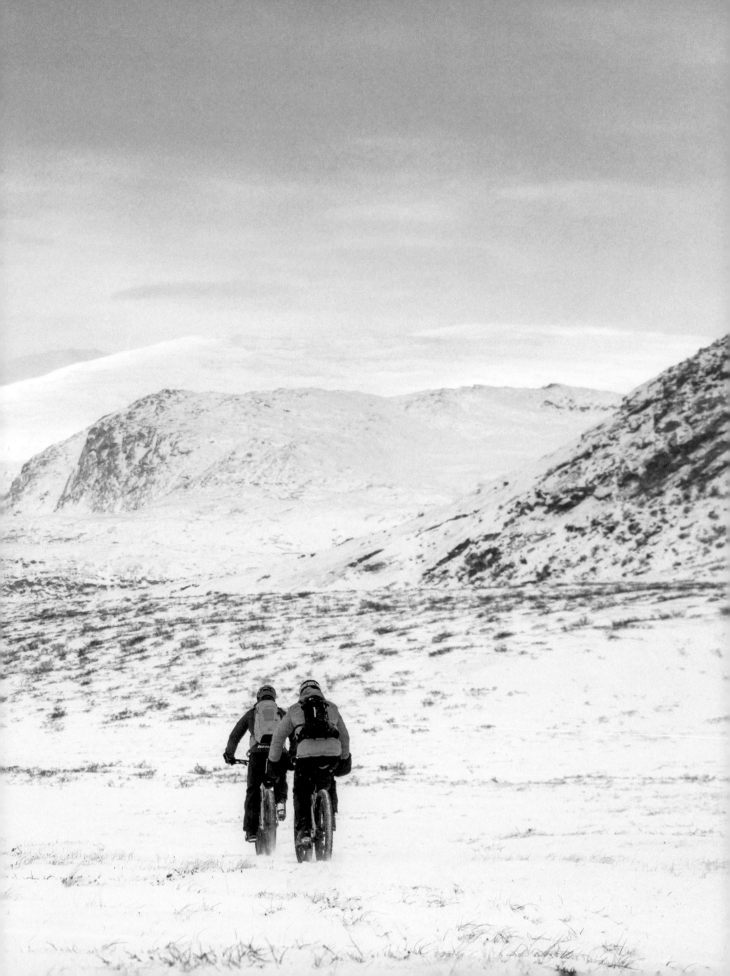

Hard to reach, freezing climate, and rough terrain— Greenland is a challenging place to travel.

Most people probably only know Greenland from stories about polar bears or as a big white spot on the in-flight screen when flying toward North America. But Greenland is so much more than just an ice-covered island in the North Atlantic.

Greenland is huge, and with more than two million square kilometers, it is the largest island in the world. It is only populated on the coasts, as the inland ice covers about 80 percent of the island even in summer. That is why people travel from A to B primarily by boat, plane, or helicopter. Some settlements are only flown to once a week, so you have to plan your stay well in advance during the winter when the private boats have to stay in the harbor.

The ice masses that cover Greenland are more than 3,000 meters (9,842 ft.) thick at their widest point and make up about 10 percent of the world's total freshwater resources.

Due to the immense load of the ice sheet, the glaciers are moving toward the coast, causing huge chunks to break off the ice mass and plunge into the North Atlantic, where they drift into the open sea as enormous icebergs. They can reach a height of up to 215 meters (705 ft.) above the water level, but 90 percent of their volume is always below the water surface.

The Arctic Circle Trail is the 160 kilometer (100 mi.) connection between the airport in Kangerlussuaq,

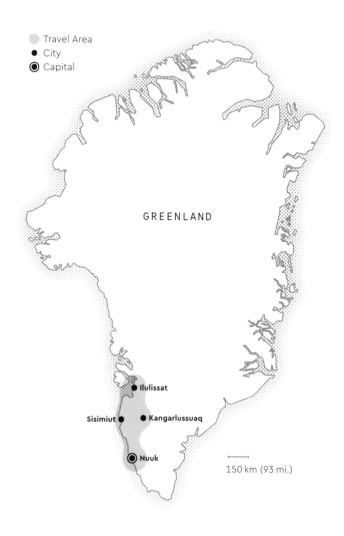

○ Travel Area
● City
◉ Capital

GREENLAND

● Ilulissat

Sisimiut ● ● Kangarlussuaq

◉ Nuuk

⊢——⊣
150 km (93 mi.)

FACTS

DESTINATION:
Arctic Circle
Trail

TRAVEL TIME:
January–February

Ø Temperature (Trip):
-11 °C (12 °F)

Trail Distance:
167 km (104 mi.)

Trail Duration:
5 days

Elevation (Trip):
2,560 m (8,399 ft.)

Passability:
easy to medium,
depending on
snow conditions

National Cuisine:
cod, karibu, suaasat

Don't forget:
ski goggles

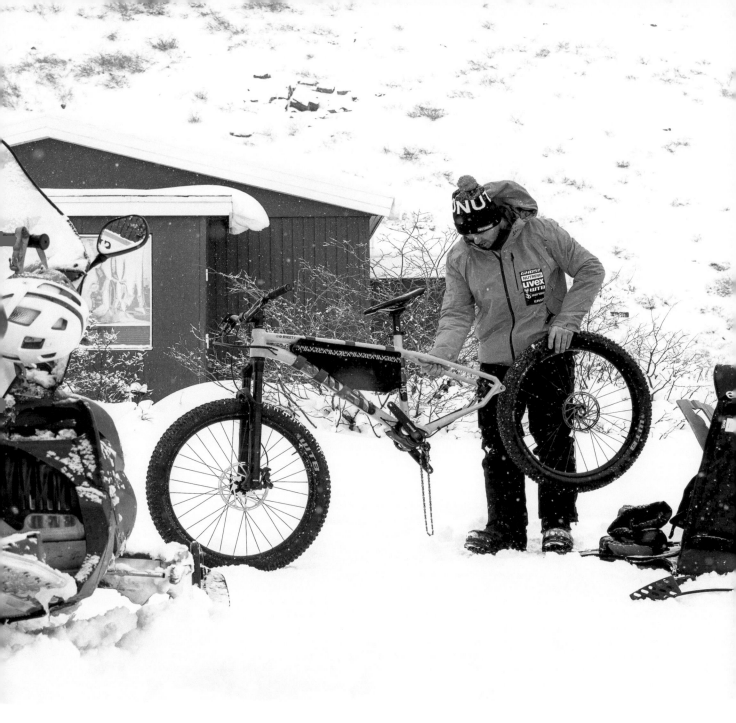

which is only 25 kilometers (16 mi.) from the ice sheet, and the coastal town of Sisimiut, which is considered Greenland's outdoor epicenter. The trail is mostly crossed by dogsleds or snowmobiles. Since it leads over frozen lakes in many places, it is not passable in summer. During winter, the trail is mainly used for hunting musk oxen and caribou, the Greenlandic reindeer, and ski hikers and cross-country skiers from the direction of Sisimiut.

From June to August, the trekking season begins and well-trained hikers and adventurers go on the track to explore the beauty of the arctic tundra. You need around eight to ten days to hike the trail, and if you do not plan to camp you find at irregular intervals—about every 20 to 60 kilometers (12 to 36 mi.)—small red huts that can be used for overnight stays. ◆

Ride On the Ice Sheet

When I first talked to Philip about the idea of going to Greenland, he was instantly hooked. I told him about my plan to ride the Arctic Circle Trail: from Kangerlussuaq—the city that is the furthest inland and situated right on the ice sheet—to the coastal town Sisimiut.

The route mostly goes over lakes and rivers, so it is practically inaccessible by bike in the summer. But in the winter, when the lakes are frozen over, you can conquer it in five days.

Since there are not many people who have already taken this tour or have experienced biking at minus 30 degrees, I consulted our friend Max. He had been riding his bike in Lapland, Finland the year before and was already experienced with the necessary technology and knew how to handle the cold.

The first piece of information he gave us was: "Try to take as few hydraulic parts on your bike as possible. The cold is not a big problem for humans as long as you keep moving, but for the bikes it is hell. The suspension will not work at all as nothing moves in the cold. The hydraulic seat post and the brakes can lead to even bigger problems. If the oil is not designed to withstand these low temperatures, the seat post, in particular, will no longer work."

The last thing you need to deal with on a five-day tour is a saddle that cannot be loaded, so we took the appropriate precautions before we left. Since I already knew from my experience with bicycle races on glaciers that the shifter and pinion would freeze when they are sprayed with snow, we looked for an alternative solution. Thus, we came up with a bike with a gearbox, where the entire shifting process is separated from external influences. Also, it is highly recommended to check the brakes for their compatibility with extremely cold weather conditions. You want them to work properly when cycling on an icy underground. »

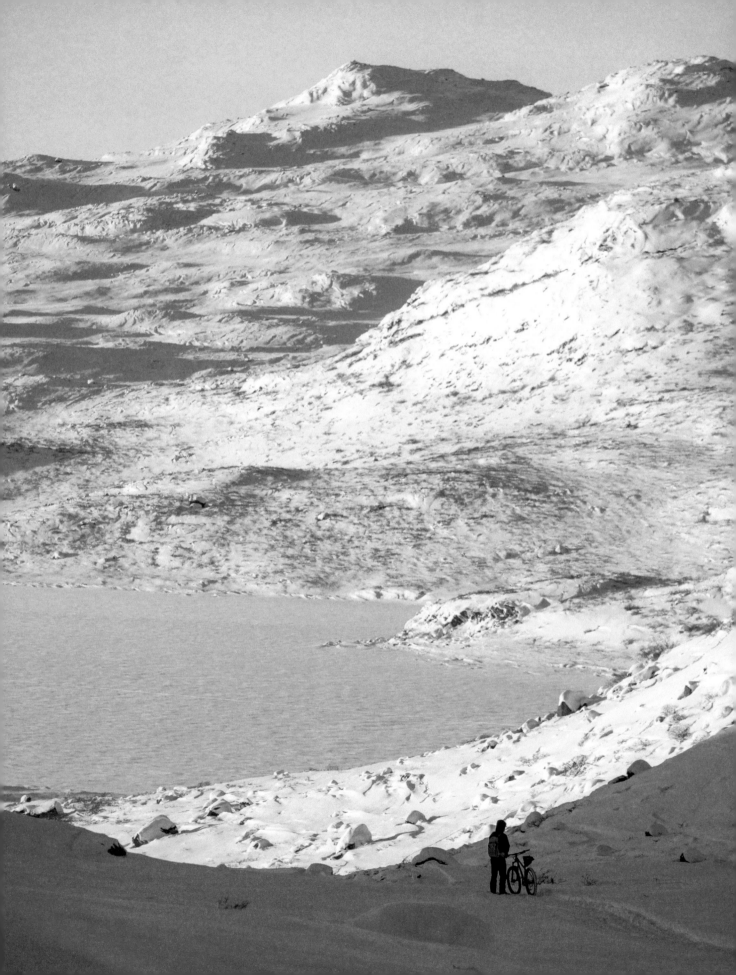

>>> You will also need to plan everything without relying on your mobile. It simply is not made for these temperatures. You might be able to switch it on, but the automatic turn off will likely switch it off a few minutes later. And be prepared to fully cover your skin. Seriously. You have to cover all parts of your skin. The harsh temperature can easily cause cold injuries.

Fully-equipped for an adventure that none of us had ever experienced before, we set off for the far north. From Copenhagen, we took the long flight to Kangerlussuaq.

Since the Greenlandic winter is basically irrelevant for tourism, only Air Greenland flies to the country at this time of year. The airline's fleet consists of a few propeller planes and only one larger aircraft capable of traveling from Copenhagen.

I only really realized how small and pristine the country is when we stand at the international airport in Greenland and are met with a confused face when we ask about the gate for the connecting flight.

After a brief moment in which I cannot assess exactly whether I said something wrong and perhaps put my foot in my mouth after only five minutes in the country, the woman at the counter grins and says: "Welcome to Greenland! We only have one gate."

First Impression: Impressive Icebergs

The first thing we do is head toward Ilulissat, the village right by Disko Bay, known for its huge icebergs floating in the fjord. We have seen icebergs in other places, but none of us have ever experienced the dimensions that await us in Disko Bay.

Since we are some of the only tourists in the village, we quickly meet the locals. Heino, an Inuit man in his mid-twenties who runs a small boat service with his family, agrees to drive us out onto the fjord to the icebergs despite the cold and the almost completely frozen bay.

Heino maneuvers the boat at close to a walking pace, past small icebergs and over plates of frozen lake water that break under the hull of the boat, loudly crackling and creaking. Not exactly the best conditions to be at sea. "If we're lucky, we can go out to sea for a week or two. After that, it's over until spring," says Heino. "This is the time of year when it gets really lonely up here."

When you can no longer drive to the icebergs, the last tourists stay away and you can hardly

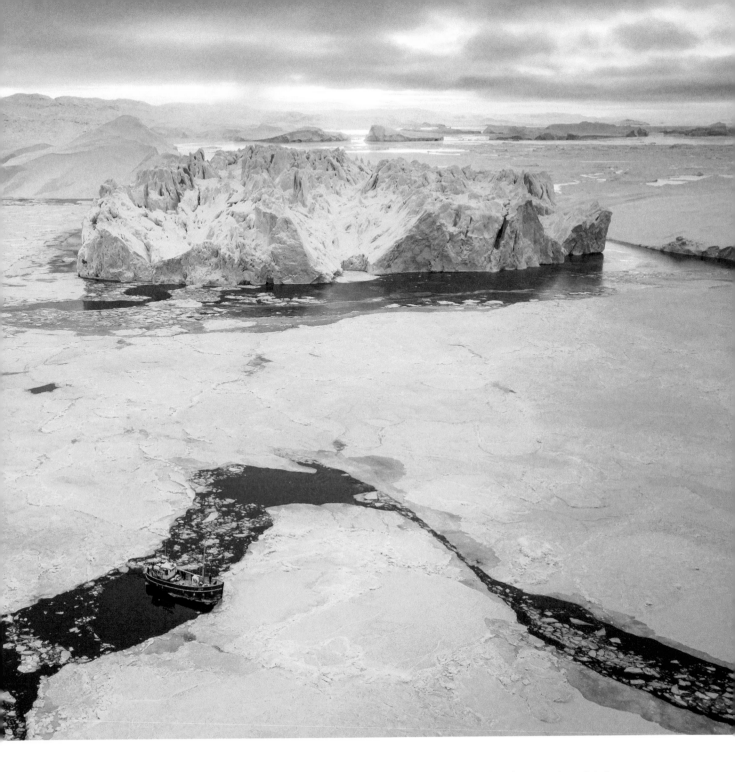

move. The longest driving distance up here is five kilometers (3 mi.). There are no more roads.

Once at the icebergs, Heino explains that this fjord produces the most and largest icebergs in the world. The iceberg that caused the Titanic to sink also came from this fjord, according to Heino. Our party proceeds from here to the south of Greenland to Nuuk. With just over 18,000 inhabitants, the capital is not only the most populous in the country, it is also where life takes place. There is no international airport that connects the city directly to the rest of the world, but there is a wide variety of museums, restaurants, and bars. »»

Meeting Greenland's Best Chef

We had heard of a restaurant where a young chef from Sweden named Simon runs the kitchen and wanted to see what Greenland's culinary scene offered in terms of local ingredients and opportunities. With local products, unusual techniques and outstanding talent, Simon tries to establish gourmet cuisine in Greenland.

Of course, fish is a priority on the list of local products, and there are many different variations. We eat pickled salmon with fennel and star anise as a starter, and an excellent halibut in musk ox butter. Another common dish is caribou, also known as Greenlandic reindeer. Simon serves us smoked reindeer tongue on a beetroot mousse.

After dinner, he sits down with us for a glass of wine and tells us about the possibilities of the country, but also about the difficulties he is facing. Fine dining is rarely found in Greenland. The locals mainly eat a variety of stews. When you go out, there is mostly one kind of food—fried food.

But this is also what makes living in Greenland so appealing to Simon. There are few places in the world where you can oversee the best restaurant in the country at the age of 24. And there is also rarely the chance to influence regional cuisine from the start. Everything he does here is new and different.

It is not easy to run a fine dining restaurant in Greenland. Although the country has incredible fish and meat, most vegetables do not grow here and have to be ordered from Copenhagen. Potatoes are sometimes on the road for a month before they arrive at Simon's kitchen. Herbs and fresh salads arrive by plane twice a week.

"If I forget to order something, or if the order doesn't have the quality I need, I can't just call another dealer and have something sent for the evening," says Simon. "I have to be creative and react to such things. That makes it difficult and unpredictable but also incredibly interesting."

After this detour to the capital, we fly back to Kangerlussuaq to cycle to Sisimiut, Greenland's unofficial outdoor epicenter. Since it was clear to us from the beginning that we could not »»

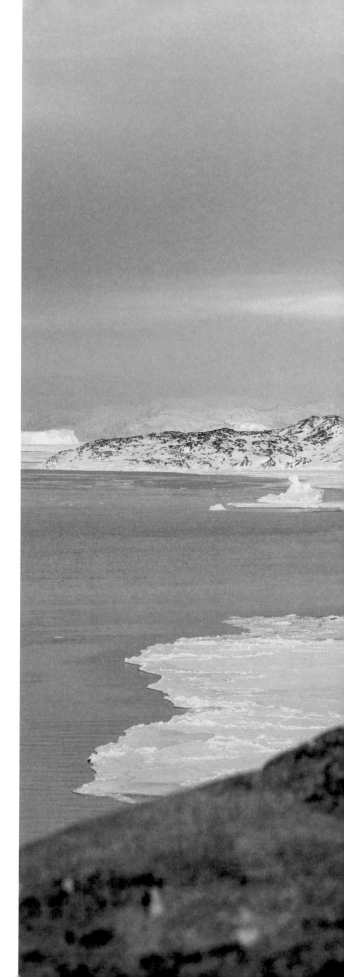

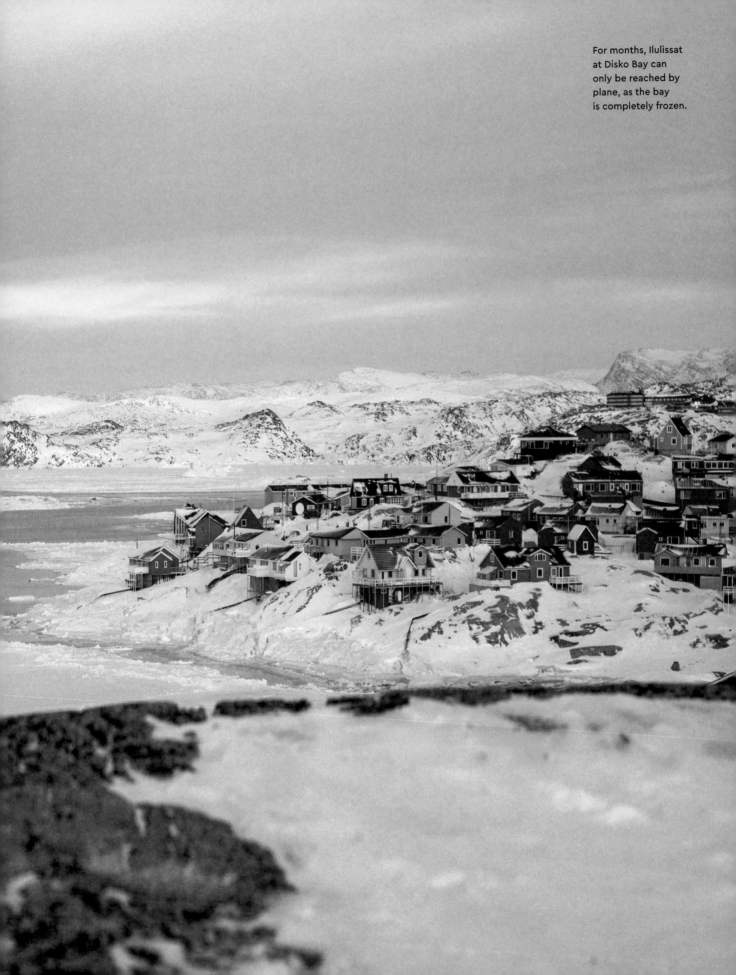

For months, Ilulissat at Disko Bay can only be reached by plane, as the bay is completely frozen.

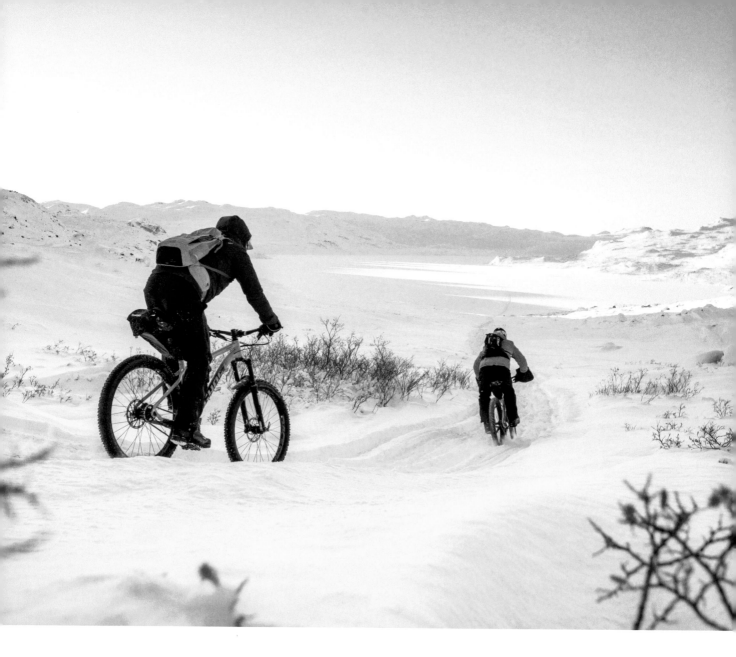

>>> just start the trip on our own, we contacted Sisimiuts's outdoor guide, Bo. He runs the Hotel Sisimiut and a guiding agency together with his wife Anette.

A few months prior to the trip, Bo advised us on what to pack for our tour: a thick sleeping bag, good gloves, and rum. A lot of rum. Sounds promising, does it not?

When we meet Bo face-to-face for the first time the night before we leave, it becomes clear why he is the best outdoor guide around. The guy is about two meters tall and about the same width, and gives off the impression that adverse

circumstances can do little to him. His bald shaved head is in the hood of a thick goose down jacket, which has probably already survived one or two snowstorms. When he shakes my hand, it completely disappears into his.

He came with his colleague Nils, who physically appears to be the exact opposite of Bo. He's small and thin, but you can also see that nothing can throw him off the track so easily. Therefore, we feel that we are in good hands with them. This should show itself not only during the tour, but even afterwards. On our return journey, we arrived too late at the airport and had to decide within

minutes whether we would continue travelling home only with hand luggage—which we finally did. Taking this option reflects that someone, in this case Bo, is around with whom you can be sure to have your luggage—including all the equipment—back in your hands. Six weeks after our trip, the ship with all our belongings reached Copenhagen.

Set Off to the Arctic Circle Trail

The large amounts of snow that fell overnight are unusual this time of year. Now we have to figure out how we can get through the snow with our bikes. Up until yesterday, the situation would have been ideal, but well, that's the weather in Greenland: simply unpredictable. Furthermore, we could not set out on a busy and thus prepared trail, because the annual musk ox hunt, which normally should have taken place at the time of our trip, was postponed.

So we pack our bags on the snowmobiles, assemble the wheels, and make the first test-drive around the airport. With a little practice and a few incidents of contact with the ground, we slowly get used to cycling in the snow. In addition to the slippery surface, the pockets on the bike are also a problem because they always push the bike in the wrong direction. But after a few extra rounds, we get that under control. Nothing stands in the way of the start of the tour. We go to bed early to start the next day fresh and rested.

Since the length of the different daily stages depends on the distance between the shelters, we have to take the longest section of the route on the first day. The Arctic Circle Trail offers ten huts as accommodations. If you decide to travel in the summer months to go for a hike, you can plan your tour more flexibly as wild camping is allowed in the area. As this is not an option for us, 60 kilometers (37 mi.) lie ahead of us.

First, the trail leads through beautiful landscapes and over small hills. Bo and Nils sometimes have to clear a path through the fresh and deep snow with their snowmobiles so that we can get through with our bikes. Although biking works

Bike clothing for extreme conditions. To prevent frostbite, the skin must be completely covered.

surprisingly well in most areas, we have to fight the resistance of the tires in the snow all the time, which makes riding more exhausting than expected. The trail leads over a frozen lake for the last 20 kilometers (12 mi.). In the distance, on the lake's bank, we can see our accommodation for the night. We finally reach it—completely exhausted.

Since Anja, the excellent cook from Bo's Hotel, is also responsible for the food on the trips, our lunch is not the usual travel meal, i.e. mush that is specially designed for outdoor trips, to which you only have to add hot water. Instead, we are served caribou meatballs in a tomato and gin sauce. What a great way to travel!

In general, we experience a refreshing hands-on mentality with everyone who accompanies us. A broken sled—no problem. Provisionally fixed and move on. A poorly-equipped kitchen in the hut—a challenge to get a great dinner on the table. It looks as if people here are used to getting quick solutions for a problem maybe because this could be lifesaving at the end of the day. >>>

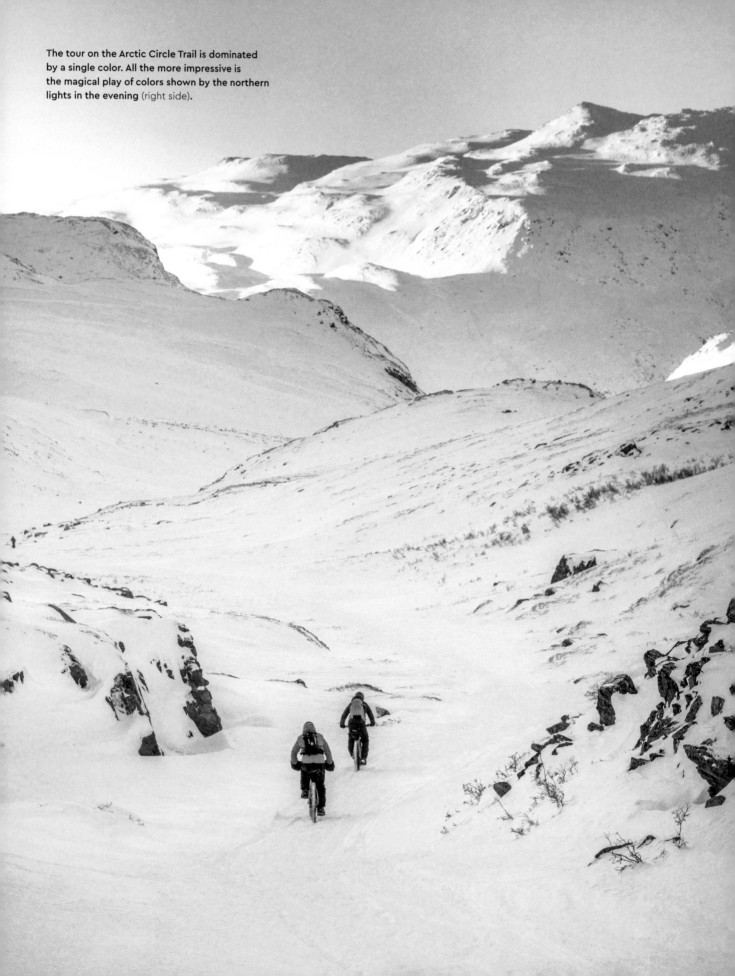

The tour on the Arctic Circle Trail is dominated by a single color. All the more impressive is the magical play of colors shown by the northern lights in the evening (right side).

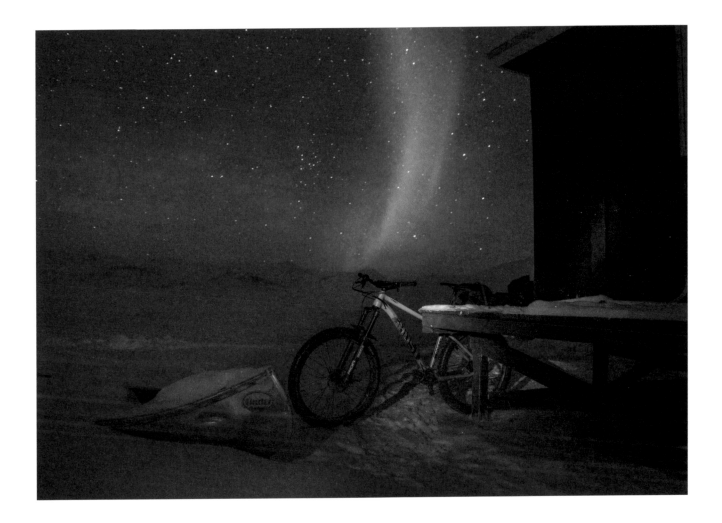

Pure White Until
Northern Lights Appear

During this time of the year, you can expect only four hours of daylight. But when the sun rises, everything is covered into a warm light and the icy landscape is colored into red, violet, and orange tones.

As the sun rises very late in the day, we can sleep in and have breakfast before heading to the next stage. The closer we get to the coast, the steeper and higher the mountains around us become. Again and again, we cross lakes and rivers and find that where the snow has been blown by the wind, we simply cannot get through with our bikes. Nothing helps and we have to load the bikes onto the snowmobiles and let Bo and Nils take us with them.

In the following days, we make good progress, especially on the frozen lakes. But when we have

to go uphill, we always have to rely on the help of the snowmobiles and have them pull us up.

When we reach the hut where we will spend our last night on the Arctic Circle Trail, we are all somewhat moved. Firstly, because this wonderful trip comes to an end in a country that can be so rough and hostile, but at the same time, so beautiful and cozy. Secondly, because the last accommodations are the nicest of the entire trip.

The little red hut is on a hill on the bank of a frozen and snowy lake. White smoke is already rising from the chimney because Bo has gone ahead and has lit the stove. On the other side of the lake, the sun is setting through an elongated valley and bathing the white surroundings in a golden pink light. After a while, it disappears behind the horizon and releases us into the cold of the dark polar night. ♦

SIMON

It is hard to believe that one of the best chefs in Greenland is also one of the youngest. Originally from Sweden, Simon Harrison is only 24 years old and the head chef at Hotel Hans Egede in the country's capital, Nuuk.

Simon has worked in large cities, including Stockholm and London, and his style of cooking is influenced by all the places he has lived. For a year he was a chef at Hedone, the London-based Michelin-starred restaurant that was rated among the top 100 in the world. "It was very, very hard, but I learned to challenge myself, and I have progressed," he says.

So what in the world is driving him to the lonely, remote, and privately-owned fjords in southwest Greenland? The new Nordic cuisine.

And he is not alone in this passion. Because the new Nordic cooking style is currently finding more fans worldwide, there are also more really good restaurants opening in the north. Many people like the idea of going back to the roots, which is why old techniques such as fermentation are becoming popular again. Simon sees the origin of this trend in restaurants like Noma in Copenhagen, which is considered the most important example of new Nordic cuisine. Noma is constantly cultivating this style of cooking and is now one of the best restaurants in the world. It is not surprising that others are following this path.

But Simon does it in his own way. Because Greenlandic cuisine does not exist, he is inventing it. The biggest challenge is the selection of products available this high up north.

"We have perhaps the best fish in the world. But there is not much else. There is musk ox and reindeer, but that's it," says Simon. Vegetables must be imported from Iceland or Denmark, and the delivery time for an order is one week.

Potatoes and carrots even need to be ordered nearly a month in advance. If it was possible, Simon would completely do without imported products. He is pleased that there are now two companies in Greenland trying to grow their own lettuce and herbs.

"And how exactly do you get the fish?" I ask. "Is there such a thing as a wholesale market in a city with a population of 18,000?"

Simon finds the idea funny. As a matter of fact, the fishermen just call and tell him what they caught and then the menu is based on that. It is similar with the hunters. For example, when musk ox season begins near the end of January, the hunters make their way north and then send Simon the meat.

The biggest difference from our way of shopping is that Simon not only knows exactly where his fish and meat come from, he even knows the people who catch the fish and kill the game.

"And what happens if the fishermen don't catch what you need? Or something you're not familiar with yet?" I ask.

"It can happen," Simon responds. "But that's the idea if you work with fresh goods. You always have to be able to make something special out of what you have." ♦

Simon at the stove at restaurant Sarfalik— which is the Greenlandic term for gathering place.

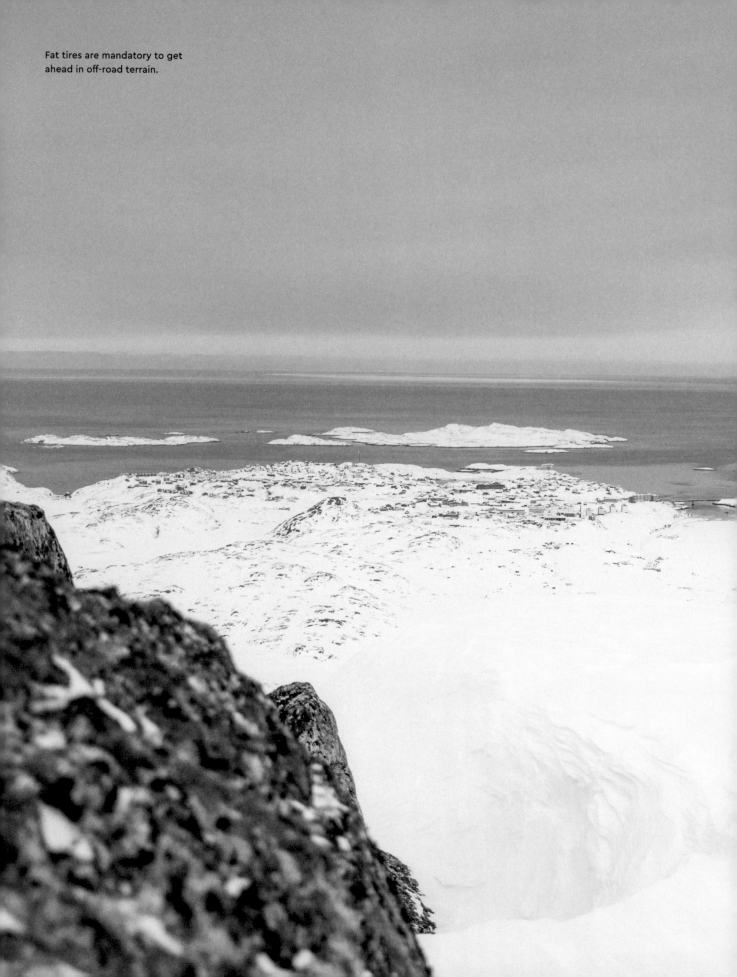

Fat tires are mandatory to get
ahead in off-road terrain.

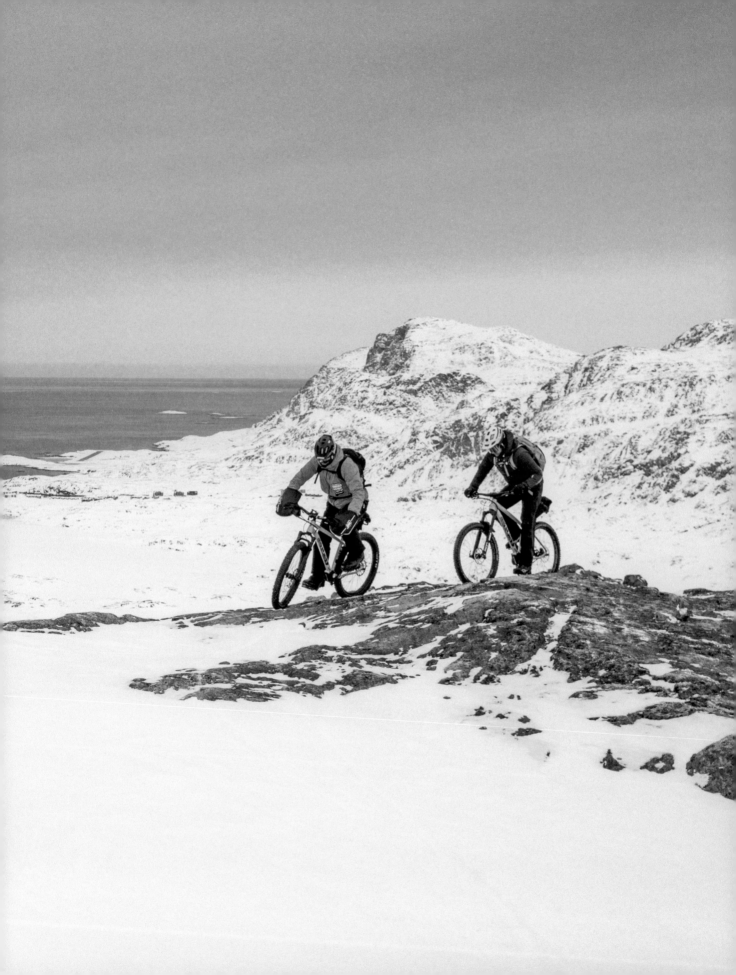

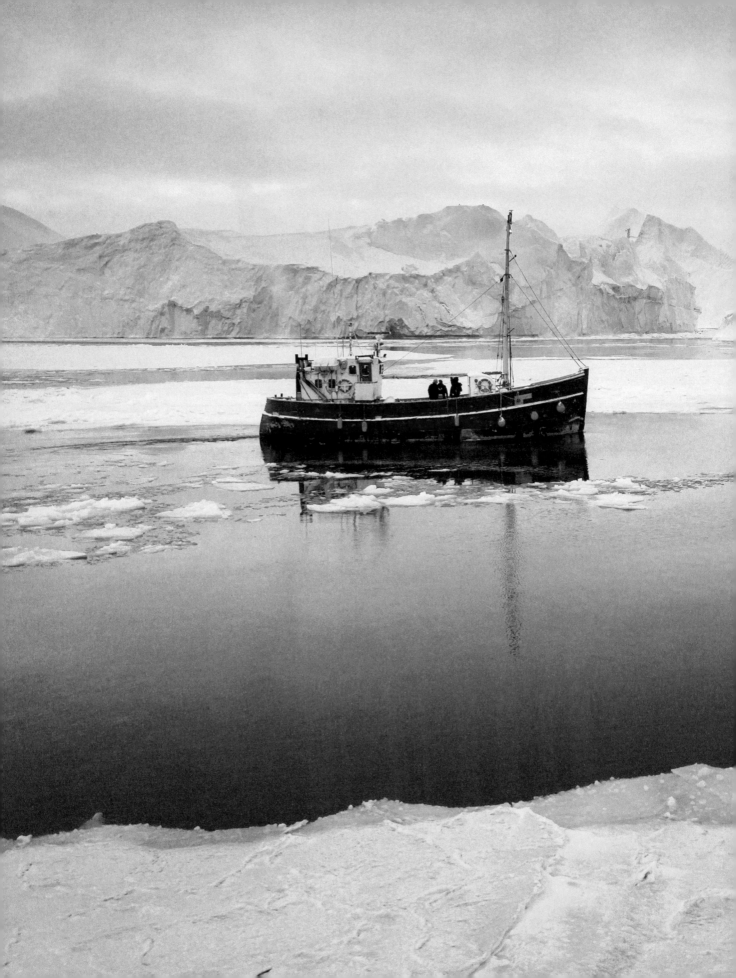

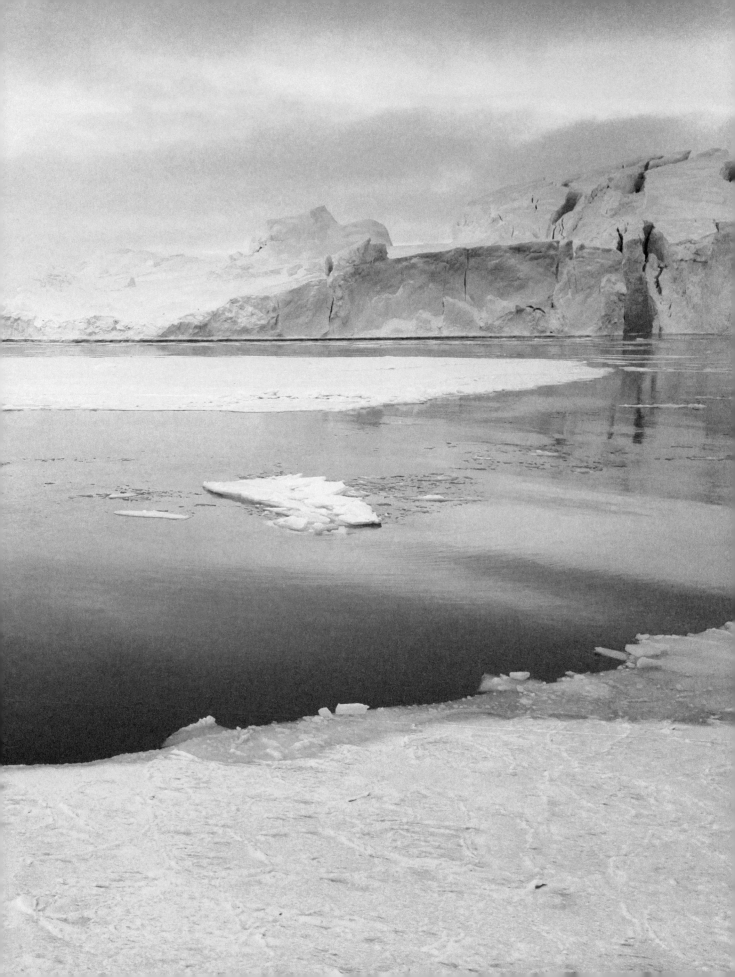

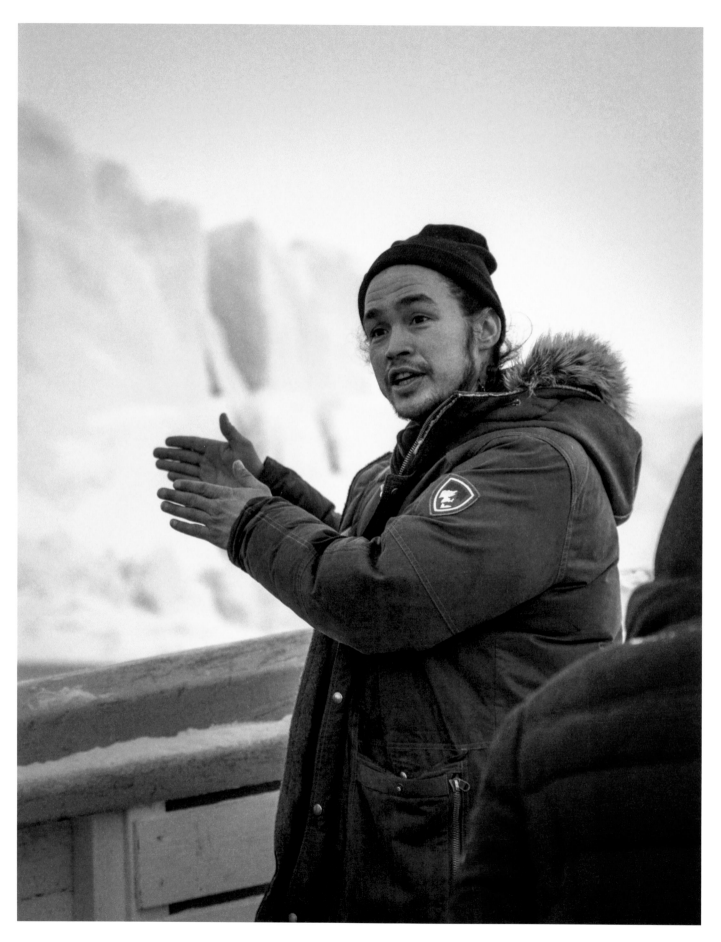

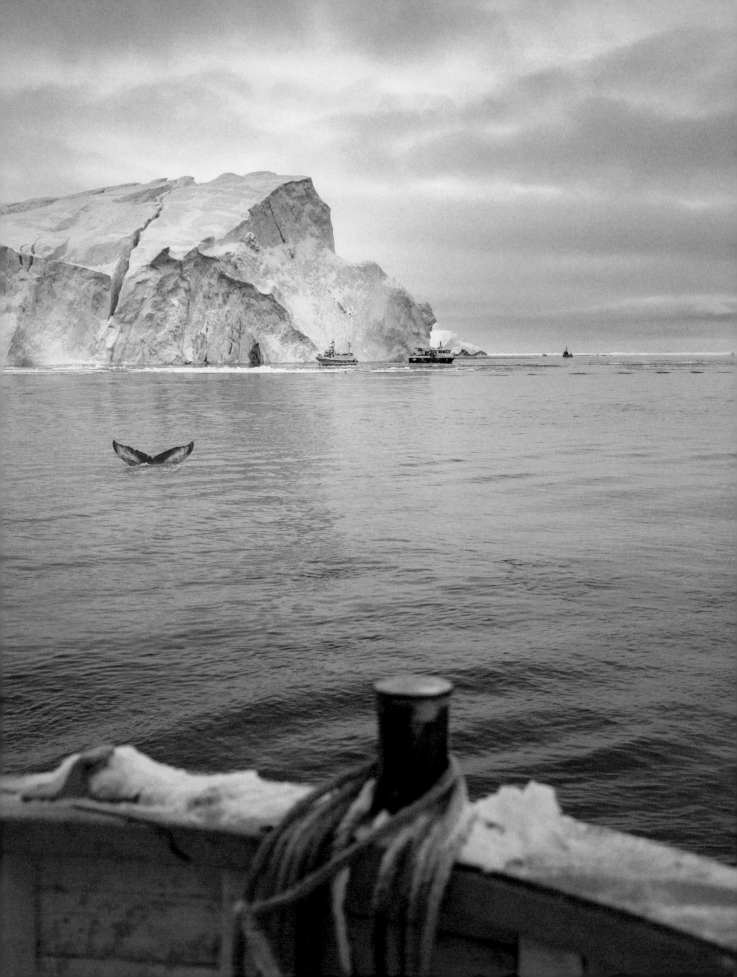

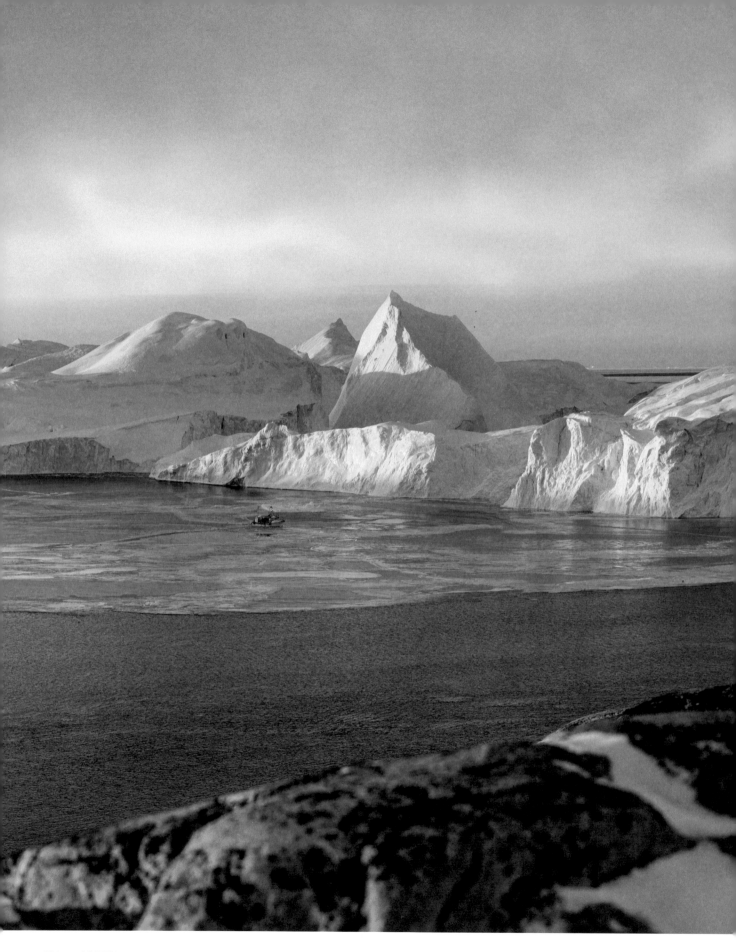

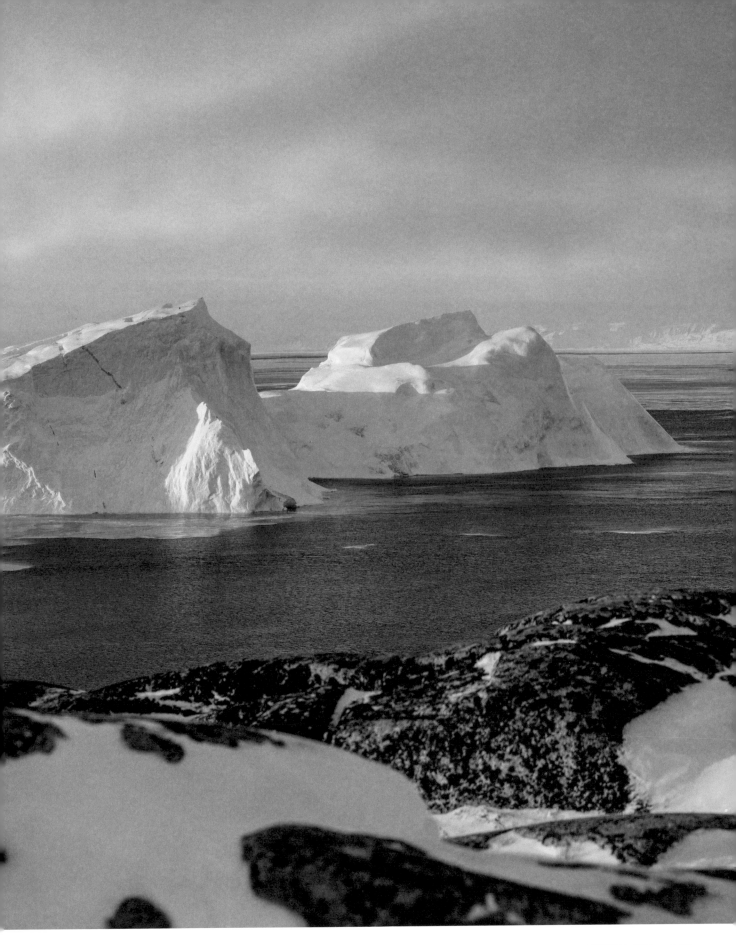

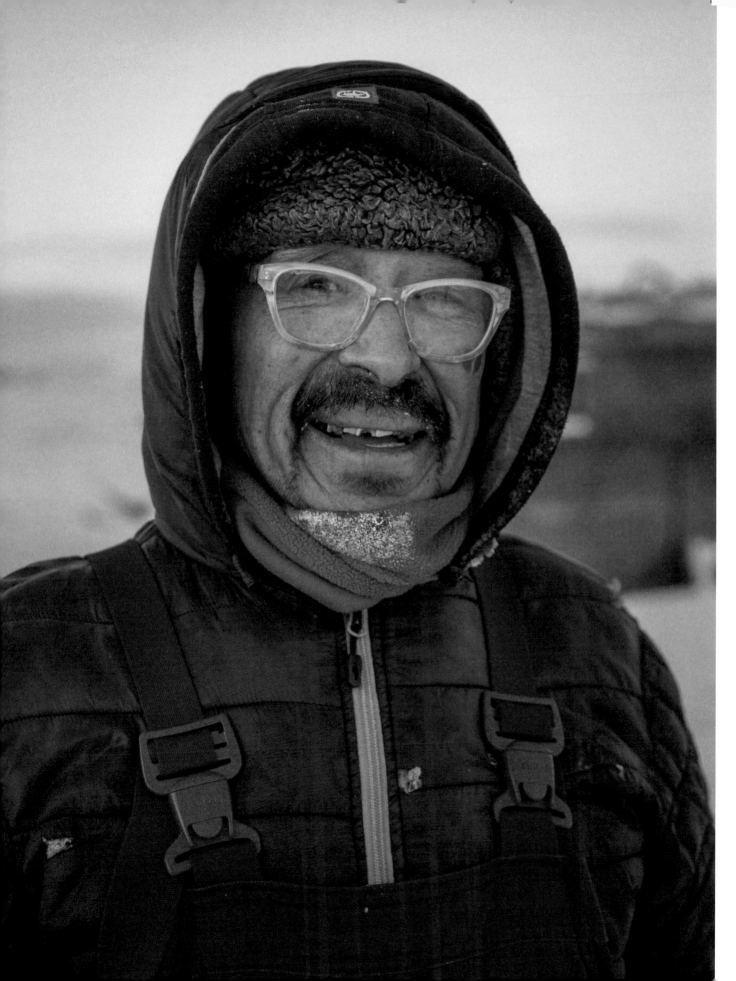

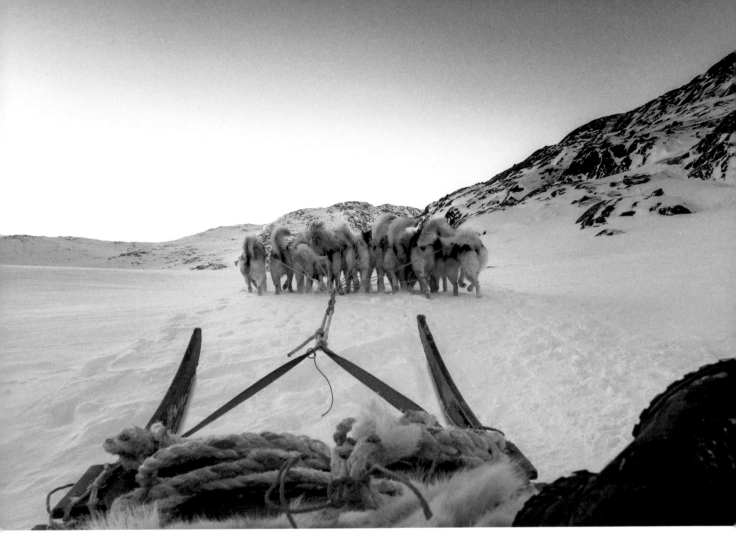

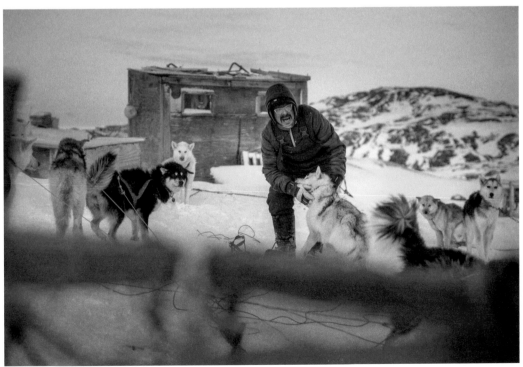

The Greenlandic sled dogs are an effective way of locomotion on the icy ground. For the locals, they are not only a means of transport but also important companions on the hunt.

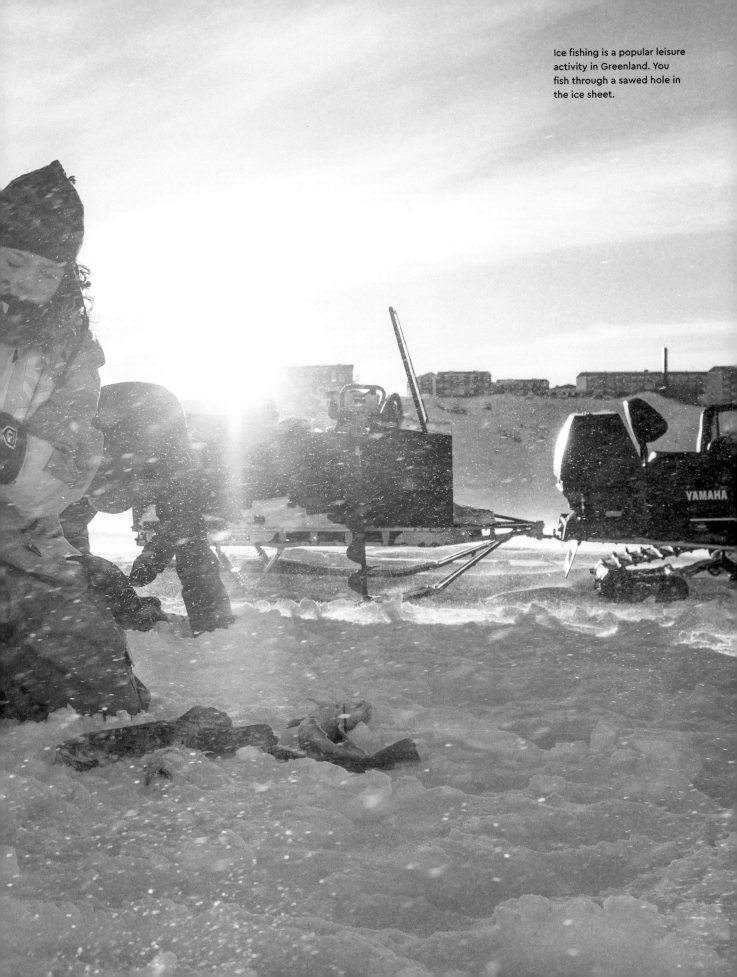

Ice fishing is a popular leisure activity in Greenland. You fish through a sawed hole in the ice sheet.

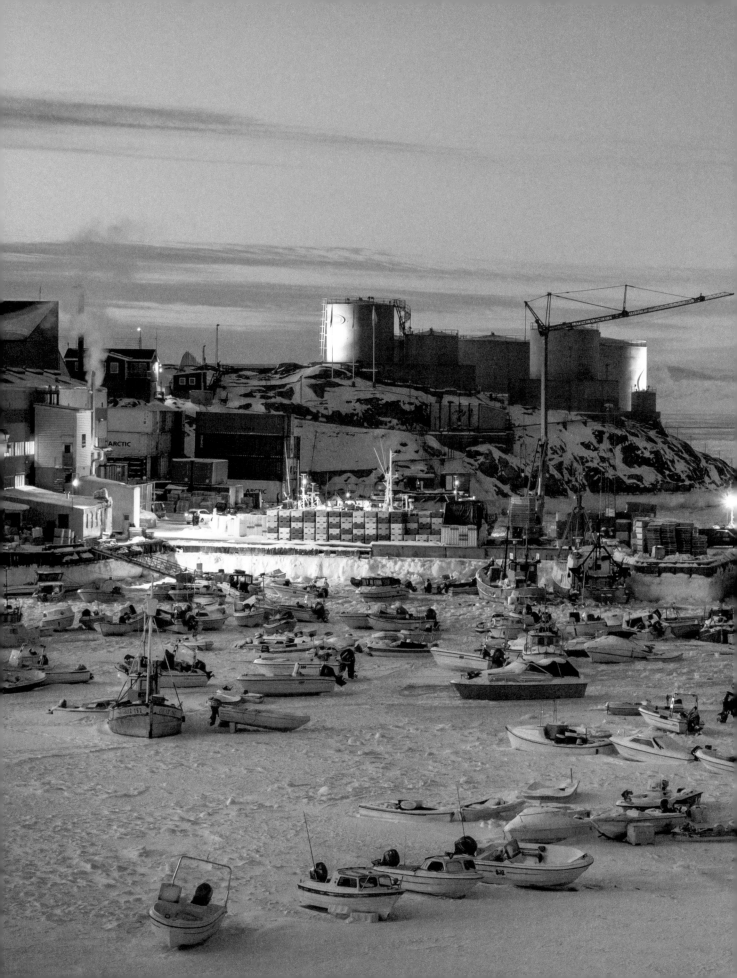

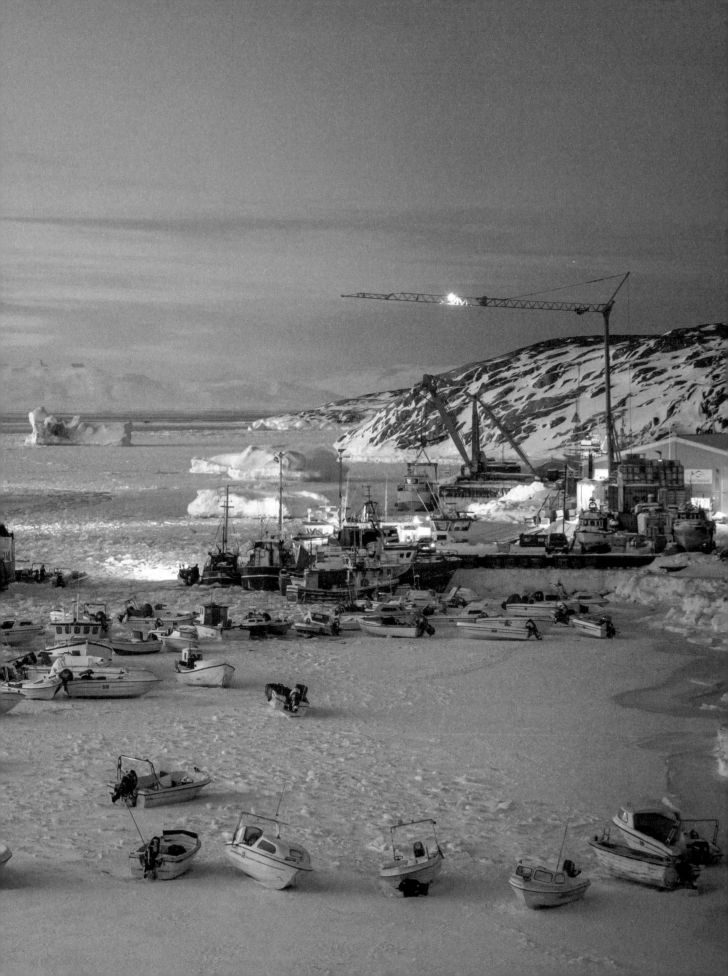

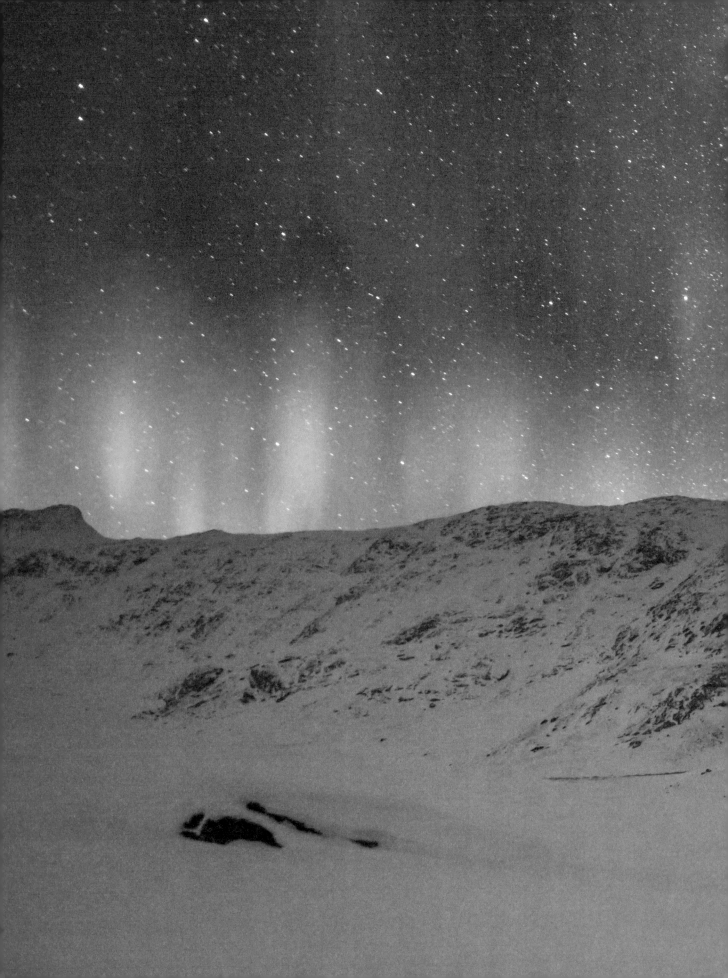

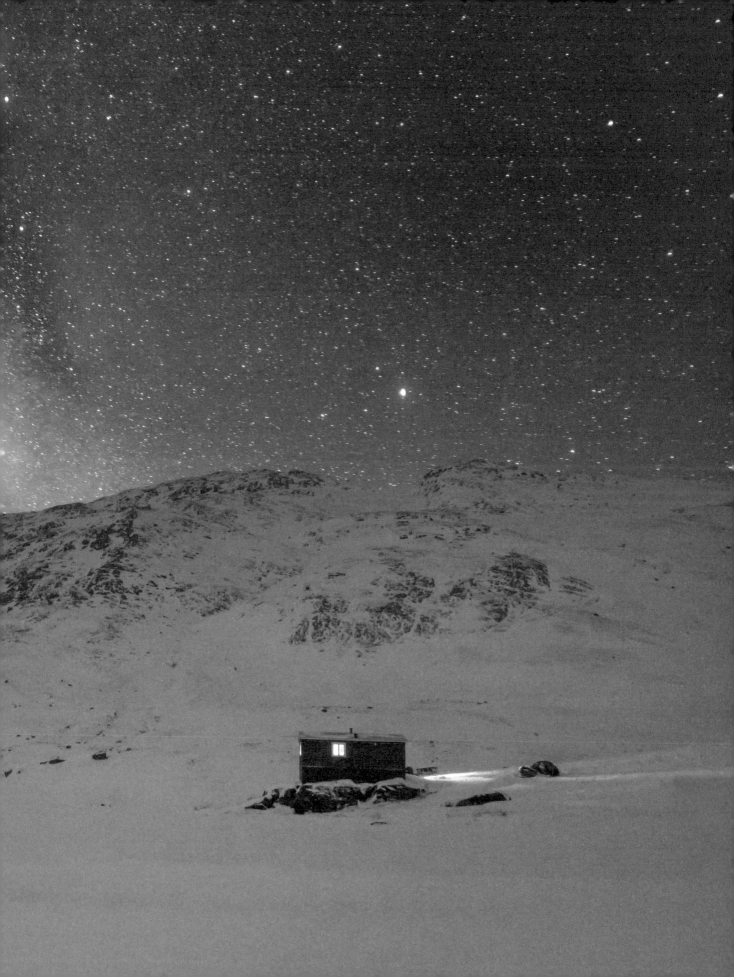

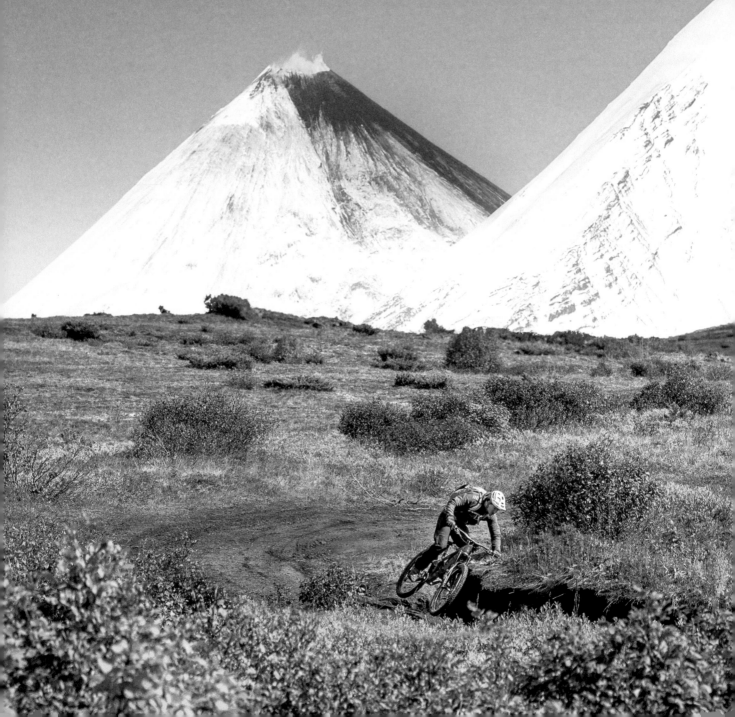

THE *SIMMERING* PENINSULA

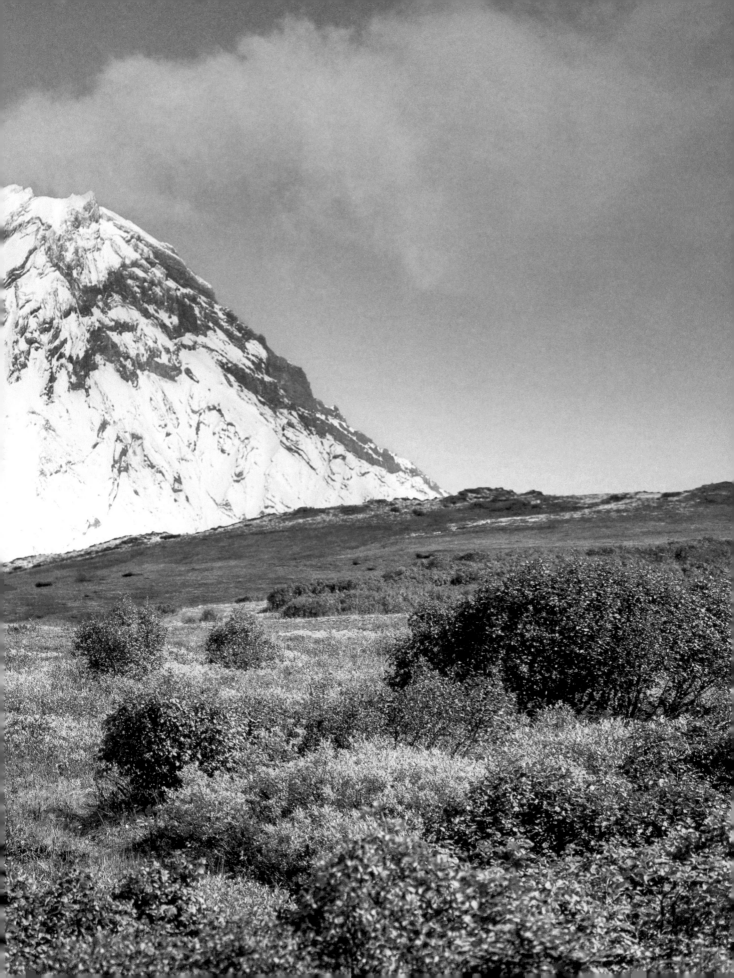

Kamchatka makes you feel like an explorer. In one of the least populated areas in the world, geysers, thermal springs, and active volcanoes can be discovered.

Kamchatka is a peninsula at the easternmost part of Russia, stretching from East Siberia to Japan, with a landmass larger than Germany. For more than 50 years, Kamchatka was a restricted military area and even Soviet citizens needed special permits to travel or live within the region. During the Cold War, the political leaders of the Soviet Union feared that the Americans could invade Russia from Alaska via the Bering Sea. It was not until 1990 that the region was opened to tourists, which is why the area has not been overly developed for tourism.

Freedom to travel is limited in the region, as there are no roads from Russia to the peninsula and, therefore, everything has to be brought in by sea. This has caused the infrastructural development of the region to be much slower than in other parts of the country. Kamchatka is known for being a diverse region, boasting a large populace of bears in a biodiverse habitat of volcanoes. There are 160 volcanoes along the peninsula, stretching a mighty 1,200 kilometers (746 mi.). Within this landscape, 28 volcanoes are active. This extremely high density of active volcanic vents cannot be found anywhere else in the world.

The highest peninsula peak is a towering 4,750 meters (15,584 ft.) high on top of Klyuchevskaya Sopka. The volcano is the eponym of the Klyuchevskaya group, a region consisting of 12 closely spaced

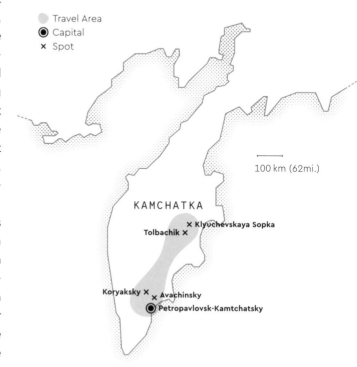

volcanoes. But the final summit destination of our trip was a different volcano. The magnificent mountain of Tolbachik is 3,682 meters (12,080 ft.) high and is one of the most active volcanoes in the world, which last erupted in 2012.

The landscape of Kamchatka is filled with natural geographic features. The rivers and lakes of

FACTS	Ø Temperature (Trip): 14 °C (57 °F)	Elevation (Trip): 1400 m (4593 ft.)	National Cuisine: borscht, king crab, salmon
DESTINATION: Tolbachik	Trail Distance: —	Passability: difficult, underground unpredictable due to loose lava rocks	Don't forget: medication to prevent motion sickness
TRAVEL TIME: September	Trail Duration: ½ day		

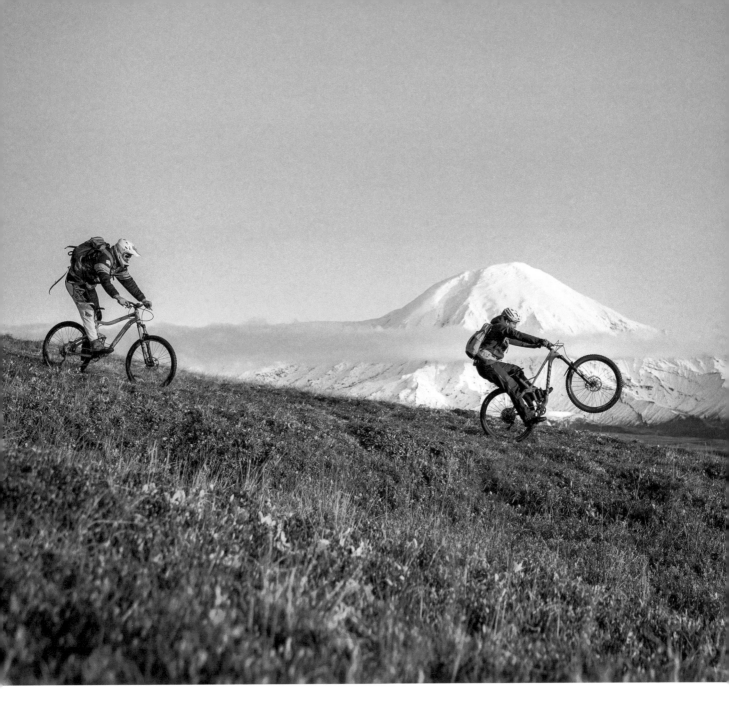

Kamchatka are a paradise for salmon, which populate the waters by the thousands. The fishing grounds are a perfect habitat for the Kamchatka brown bear, since salmon is their ideal food. The protein-rich diet allows the creatures to grow over two meters (6.5 ft.) tall and weigh over 600 kilograms (1,320 lb.), which is the weight of a large vending machine. Kamchatka is home to approximately 18,000 bears and has the largest brown bear population in the world.

Kamchatka is sparsely populated. Long and winding roads lie abandoned and neglected along the stretch of the country's volcanoes. Although there is no developed network of trails or routes, mountain bikes are allowed across the countryside. All trails suitable for biking have to be climbed, carrying the bike on your back. But after you climb the mountain, the riding possibilities are endless. The boundless gravel slopes give way to a diversity of terrain and opportunities. ◆

Mountain Biking in a Former Military Zone

My intention to travel to Russia was to explore Kamchatka, an ambitious, dangerous and exciting plan. More precisely, I wished to travel to the plateau around the Klyuchevskaya Sopka and see the sun rising behind the Tolbachik volcano. I knew this would be a difficult task when we started planning the trip.

Firstly, we required a visa to travel to Russia. Since you cannot just enter the country on a whim, we needed an official invitation from a local resident to validate our visas. Unfortunately, because we did not know of any other way to reach the region, we transferred a sum of money to the account of a Russian tour operator who allegedly could organize this for us. We were skeptical at first however, we promptly received an invitation and the visa was issued without any delays. Now nothing stood in our way to undertake what would be the bike trip of a lifetime.

At the end of August, we finally started our journey toward the east. From Stuttgart, Germany, we flew to Moscow. The city, also known as the Third Rome, was our home for the first few days as we wanted to explore the metropolis before flying farther east. Ahead of our trip, we contacted Maria, a Russian woman who originally came from Siberia and now offers guided tours in Moscow.

Maria kindly took us to one of Moscow's many food markets, which are located in every district of the vibrant city. The round buildings were crammed with small stands where smells overpowered the senses and steaming streams of smoke billowed from old sturdy-looking pots. Exquisite food sizzled and smelled so succulently delicious. We dove straight into tasting the street food and headed to a stand selling vareniki, a typical Russian dish of small dumplings floating in broth with different fillings and accompanied with a blob of sour cream. The next stand offered all kinds of fermented and pickled foods from cucumbers to garlic. Everything you could imagine is served in this little marketplace. And under the expectant eyes of the proud vendors, we politely tried everything and told them how it tasted. Eating fermented garlic puree was not necessarily a personal highlight of mine, or I imagine of anyone who had to stand close to me for the next few days. But I made a polite expression and tried to look appreciative to the little woman behind »

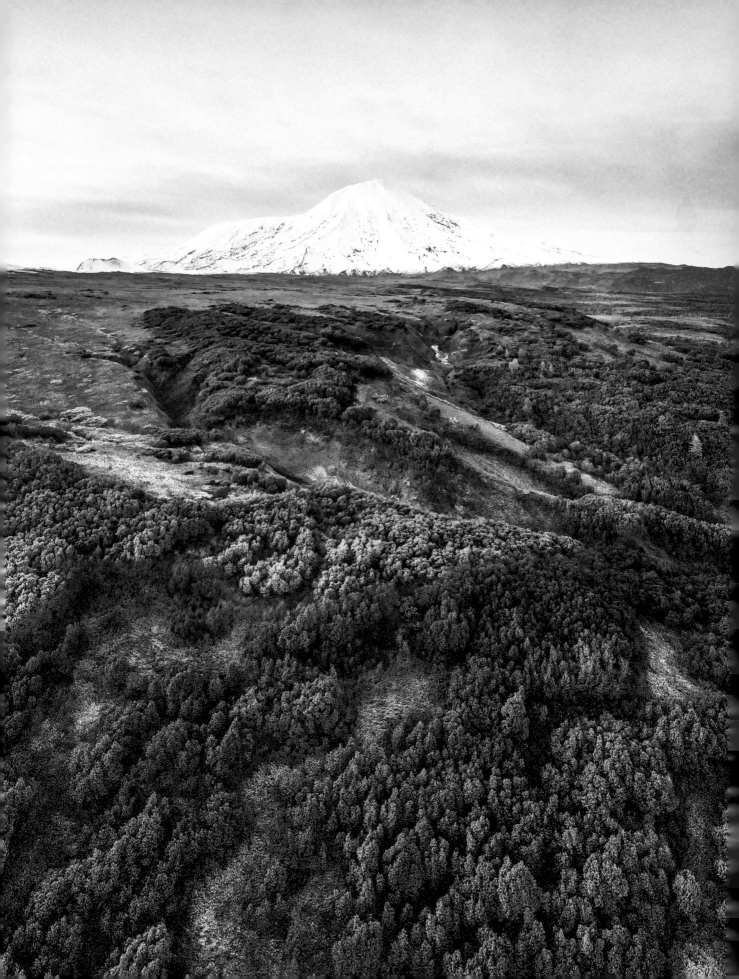

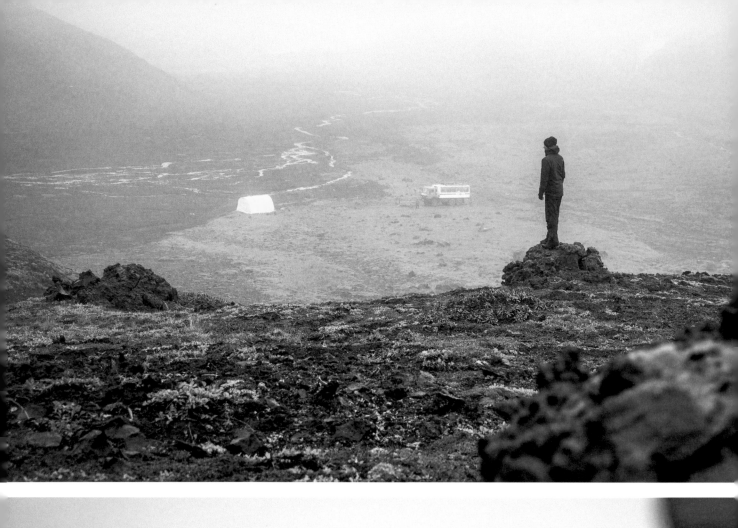

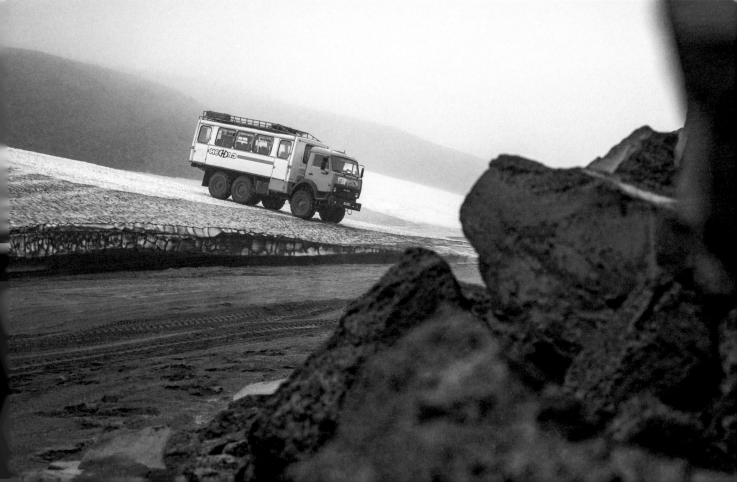

the counter. She looked so friendly, it would be absolutely impossible to not appear enthusiastic to stave off her disappointment.

After a few days in Moscow, we flew as far east as we possibly could without leaving the continent. We were on the longest domestic flight in the world, which is from Moscow to Petropavlovsk-Kamchatsky. Eight hours in the air, that I almost completely overslept. I can recommend grumpy Russian films as a sleeping pill because it had the effect of knocking me out cold for hours. When we landed, I looked out the window and suddenly realized we were now on completely different terrain. A whole new world awaited us outside the doors of the plane.

Excitedly, we load our luggage into a local taxi at the airport. We hoped we would arrive quickly at our accommodation. However, I noticed the taxi drivers all glanced at each other and exchanged disgruntled looks when they saw my big bike bag. Fortunately, we managed to find someone to take us. I am desensitized to the fact that in remote places, especially where bikers do not pass through every day, there will inevitably be questions: What is in this huge luggage? Where are you going? What bike are you using? However, the people of Russia seem to be rather stunned and either out of surprise or politeness, do not ask questions.

During the taxi ride, Philip sits in the back. A truly great friend, he generously leaves the task of communicating with the driver in whatever language or way to me. Filled with false confidence, I get in the front seat and immediately get a funny look from our driver, followed by a hearty laugh. I had inadvertently sat behind the wheel. In Moscow, the steering wheel is on the left side. Eight hours east of the capital however, I can now see it is right-hand drive. "Could it be that the people here are driving on the left side of the road?" I thought to myself. In broken English, the driver explained to us that most of the vehicles in the region are imported from Japan because the transport routes are much shorter and therefore cheaper. In Kamchatka, you drive on the right side of the road, but many cars have the steering wheel on the right side as well.

Hiking a Volcano

The next morning, we set off from Petropavlovsk to the north. We travel in a Kamaz, a huge Russian all-terrain truck with a passenger cabin. We are headed for the mighty Koryaksky and Avachinsky, which stand against the sky peering over the city below. These mountain peaks loom over the landscape like guardians of their province. The journey to the mountains is not very far, but it takes a long time because the tarred roads end shortly after leaving the city. The roads spiral into bumpy, gravel tracks, which lead north and south. Half an eternity later, we reach the foot of the volcano, and our guide immediately starts to clear out the truck.

While two people stay behind to set up camp, Philip and I set off with the other guides toward Koryaksky. Over the narrow paths on steep slopes, we hike higher and higher up the mountain. We cross snowfields and pass colorful rock faces. Somehow everything here looks a little bit like Iceland, only a more extreme version. The skyline is a patchwork of color. Yellow, gray, and red colors rise up hundreds of meters and disappear somewhere in the clouds. There is a strong smell of rotten eggs and waves of white clouds of stinking smoke roll constantly toward us. Finally, we reach the highest point of our hike and stand on a field full of steaming and bubbling mud holes, from which white columns of smoke rise into the sky. It's a truly impressive natural spectacle. After a long day, we return to the camp in the evening, where there was already fish soup on the table. Along with our tents, our guides had also built a complete traveling kitchen. It was a promising start for our trip.

Orcas Passing By

The next day we head back to Petropavlovsk and from there travel on a catamaran through the Avacha Bay. It's an expansive area home to the huge battleships of the Pacific fleet the Russian military used for their operations in the open sea. We sail for hours on rough waters along the south coast under the shadow of steep cliffs. »»

>>> Suddenly, our captain gets very excited. He turns the boat around and starts the outboard engine. My smile widens when I see why. A fin rises out of the water and then disappears again into the depths of the black sea before another one emerges after a few minutes. The orcas swim directly in front of our ship. For a while, we follow the whales, in awe of their majesty in their natural environment, and then return to our planned route towards the south. Our guides tell us our

Biking a Volcano

For me, the most important destination on our Russian sightseeing tour is Tolbachik, a picturesque and imposing 3,682-meter (12,080 ft.) high volcano in the north of the country. The destination would be the grand finale of our trip. An intrepid explorer, I had a burning desire to watch the sunrise behind this impressive mountain. While researching the trip, this wish burrowed within me and became non-negotiable.

Unfortunately, because there was poor weather in the highlands during the last few days of our journey, it made little sense for us to take the long way around to the foot of Tolbachik and then not be able to see anything. Additionally, we risked getting snowed in on top of the volcano with a snap of cold weather. This created an array of problems for us. It was mid-September and the weather was getting noticeably colder and more unpredictable. But luckily, there were a few days of good weather in the forecast, so we decided to take the chance and head towards Tolbachik.

We wanted to spend over a week in the region around the volcano. The remote location was a few hours away from the nearest supermarket and even farther away from the next hotel. Therefore, we needed to prepare holistically and bring everything including mountaineering gear, food provisions, and safety equipment. Unfortunately, not all of our guides had been so far up in the mountains. The air in our camp was filled with excitement and trepidation for all those souls who had yet to see the power of the volcano at altitude.

Just before we leave the camp, our chief guide Alex informs us the first stage of our hike would take approximately eight hours to reach the first campground. But from our journey so far, I had learned enough to always add another three hours to Alex's estimation. After hours of hiking, the forest begins to grow lighter. I smell sulfur, bitter and rotten. Through the trees, we can see the edge of the lava fields that had eaten their way down through the woods during one of the last big eruptions of 1976. »»»

destination: the final resting place of two old retired ships that were towed into a fjord in the middle of nowhere. Today they serve as markers for boats whose crews want to fish or hunt in the area.

>>> On we trek through woodland until the landscape begins to become more open, sparse, and hauntingly eerie. An hour later, we are standing in the middle of a lava field, where dead gnarled trees thrust out from blackened soil. The trees were desiccated, dried out by the hot air of the volcano that blew down into the valley during the eruption. Now, these trees serve as a fortification for our basecamp. Unfortunately, extreme weather conditions held us captive there for three days. The weather fluctuated to the extreme. It was either raining cats and dogs or it was so foggy that there was nothing to see but the volcanoes around us. Although we made small bike trips to go exploring, the rides were more for mental health and to keep spirits high. What really saved us from camp fever was the ever-satisfying kitchen that our guides set up. Somehow our cook Anna always managed to conjure up the most delicious meals with the simplest equipment. Besides fish soup, there was pelmeni and salmon in all variations for every meal. We feasted on red caviar, which is eaten like jam in Kamchatka.

Our trusted guide Alex called Petropavlovsk every evening on the satellite phone to find out the latest weather forecast and finally, good prospects for the next day were reported. We desperately wanted to climb up the volcano nearest the camp to get a good view of Tolbachik. The downhill ride from there by bike was going to be difficult but not impossible. That night, we were full of hope and went to bed early in order to get up before sunrise

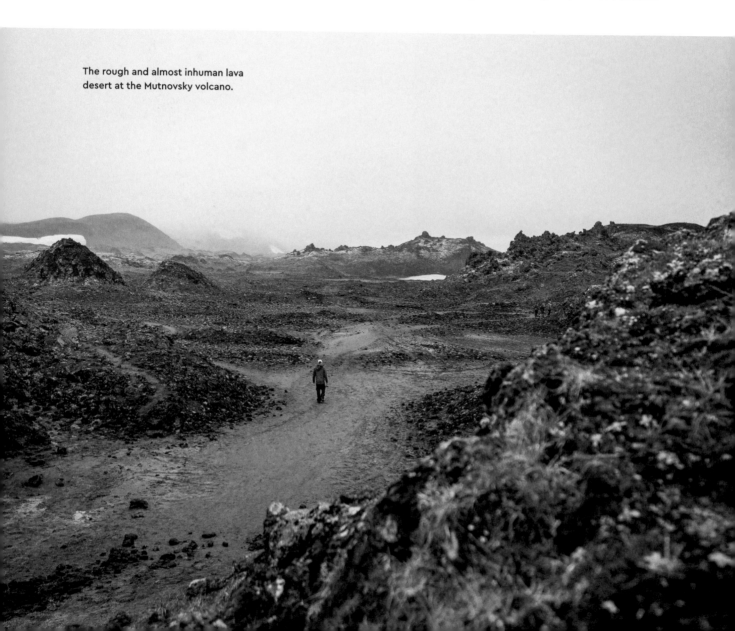

The rough and almost inhuman lava desert at the Mutnovsky volcano.

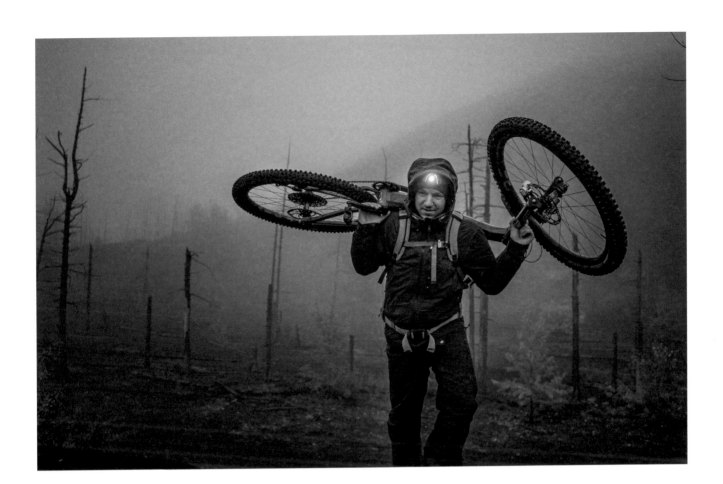

the next day. The sky was starry as we packed up our things and set off for the volcano.

As our headlamps flickered, the treacherous terrain under our feet made conditions highly dangerous. We carried our bikes up the steep ascent along the arduous paths, which lead us to impassable scenes of natural beauty. I see in that hazy twilight the first outlines of the snow-covered Tolbachik become visible: white and majestic, the cone-shaped volcano. At last, to behold the gigantic structure that had drawn us to the east of Russia looming above the black landscape of cooled lava. We reach the summit just before sunrise. Soon after, I place my bike down and realize the sun will soon appear behind the mighty mountain.

My body felt deep anticipation, electricity pulsated through me as I absorbed this incredible moment. During this interval of time, I reflected on everything that had led up to this moment. The months of preparation, bureaucracy, and setbacks

of the journey itself had put a strain on me. Relentless cold nights in the tent and long days in the uncomfortable Kamaz, all for this moment to watch the dawn come against the backdrop of those great mountains. We undertook this journey by ourselves. Standing there in that moment, at the edge of the huge lava desert with a view of the snowy Tolbachik on one side, the faraway Pacific Ocean on the other, and in between, the countless kilometers of wilderness. Time slowed down as we felt that sunrise and the pride in our journey to get to this point. I will always remember sitting perched on my bike in front of that incredible scenery.

Until that morning, it was not clear to us if we would even be able to see the mountain at sunrise. To then stand there after an adventure-filled journey of four weeks and know that we had reached our destination, we paused for a moment. The first sun rays flashed over the horizon and as quick as a flash, off we went. ◆

ALEX

In the region of Kamchatka, there are soldiers, fishermen, and Alex, our guide. He was born on the peninsula and has spent his entire life roaming, learning, and understanding the diverse landscape. A traditional man, Alex doesn't need the buzz of Moscow that attracts so many young people from this rural area to the capital city. He only lasts a few days in civilization before the burning desire for beautiful landscapes and the call of the mountains draws him back again. "Every time I go back to the mountains, something has changed. It's rarely the same place you return to. Everything can look different from what was there before," he says.

Alex loves showing this ever-changing world to tourists with his infectious passion for Kamchatka. "Those who come here are a special kind of people," says Alex. He believes that people who travel to Kamchatka have seen almost everything, otherwise they wouldn't think of spending their holidays in such a remote place.

Alex adores his guests because they are usually interested in learning about the people and regional culture, and sharing stories of their travels so far. Around the campfire, Alex is able to travel the world by absorbing the tales brought by his guests into his imagination without having to leave Kamchatka.

"What exactly does life here look like?" I ask. For Alex, this is easily answered. Employment options are limited. Some people work for the military, which is the most popular employer in the region. "You can be lazy or stupid and still get a really good salary there," he says. "But, in my eyes, it's a simple job and I'm glad I was decommissioned and didn't have to join the military." The other jobs are within fishing. "You don't need any training for that. If you have strength and two hands, you are perfectly suited. You work for two hard months in the summer and can earn around one million rubles, which is the equivalent of about 12,000 euros. You can live on that for the rest of the year and do nothing."

There are arguably reasons why there is a stereotype of people drinking vodka all day long in this Russia frontier. When I bring this up, Alex, who hardly ever drinks himself, laughs. "Especially after the fishing season, in the villages far away from Petropavlovsk, there are only snow, bears, and vodka." Many drink themselves through the winter, but Alex and his colleagues can't understand that. "If you live in a country where you can do lots of sports in summer and winter—from skiing to surfing, everything is possible here—it's a waste to always be drunk."

We ask Alex about a subject that concerns us heavily. In many video and television reports about the region, it is reported that the people here have no interest in environmental protection. Is this true? Alex nods. "There is a huge ocean around us that carries away everything we throw in. There are still too many people here who don't care." However, the next generation may not hold the same ignorant mindset about their local environment. Alex tells us the children are taught about the environment at school, but in his eyes, that is not enough. He describes how there has been a noticeable difference in the last few years, particularly that there is less garbage lying around. Finally, something is changing. Although this change cannot come soon enough.

Alex is also worried about the overfishing of the waters. Salmon are caught in such large quantities that hardly any fish come into the rivers to spawn. This is not only detrimental for the fishermen, but the bears are also affected as they can no longer find enough salmon to eat. As a consequence, the bears wake up halfway through their hibernation and then either freeze to death or go into the cities to hunt. "A hungry bear," Alex says, "will not be stopped by any human being." Alex only buys fish at the market from the fishermen he knows are aware of the environmental impacts of their actions.

He firmly believes that things are getting better step-by-step in his home province because what seems like Kamchatka's greatest weakness is also its greatest strength. I have discovered that what Alex loves so much here is the freedom. "You can do whatever you want," he says. "There are only a few prohibitions. In this country, what you do with your life is up to your imagination." ◆

Alex on a guiding tour and buying fish at a local market.

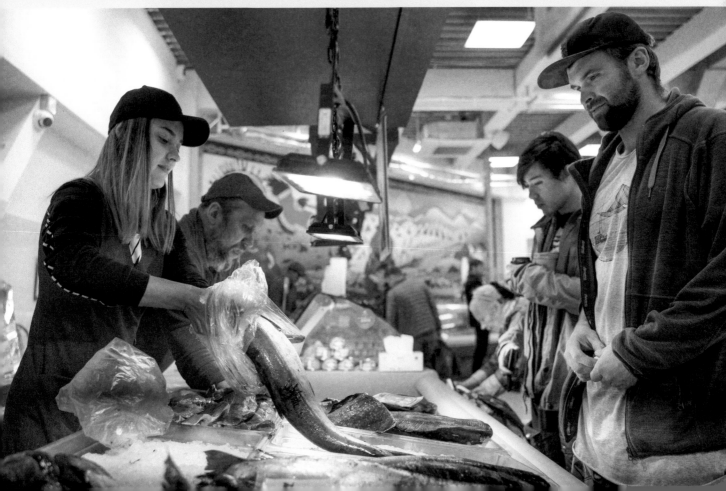

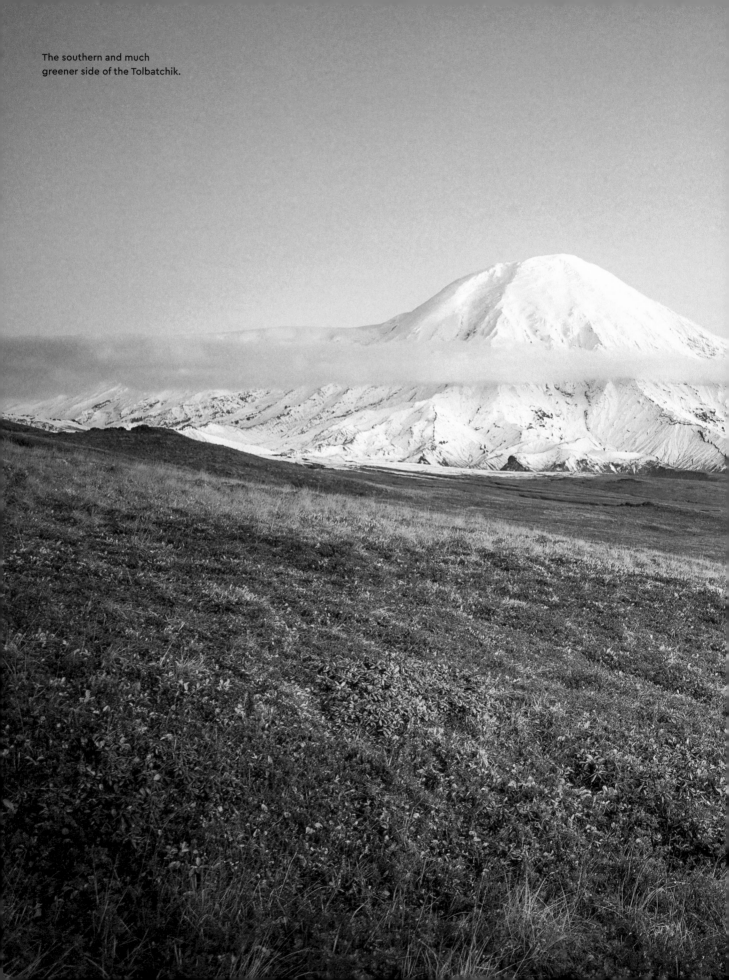

The southern and much
greener side of the Tolbatchik.

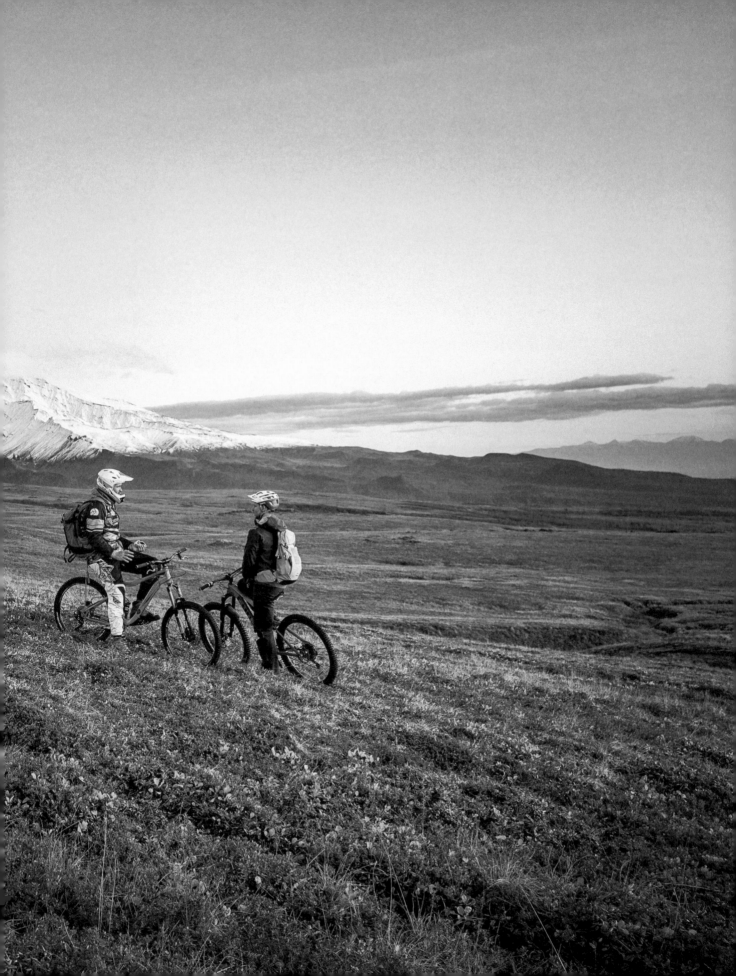

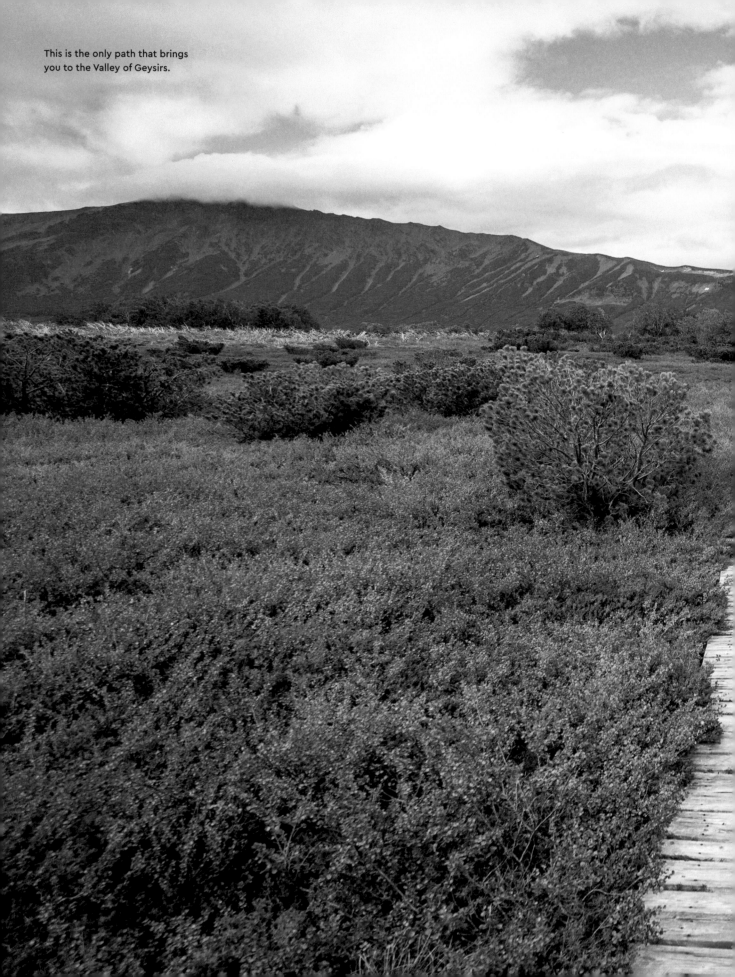

This is the only path that brings
you to the Valley of Geysirs.

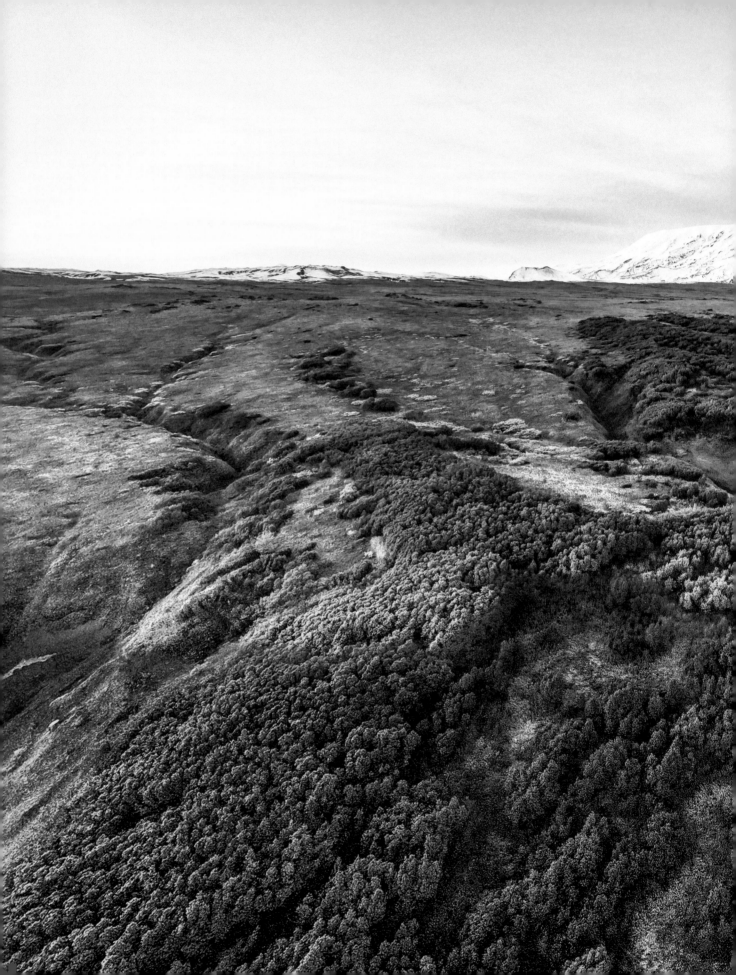

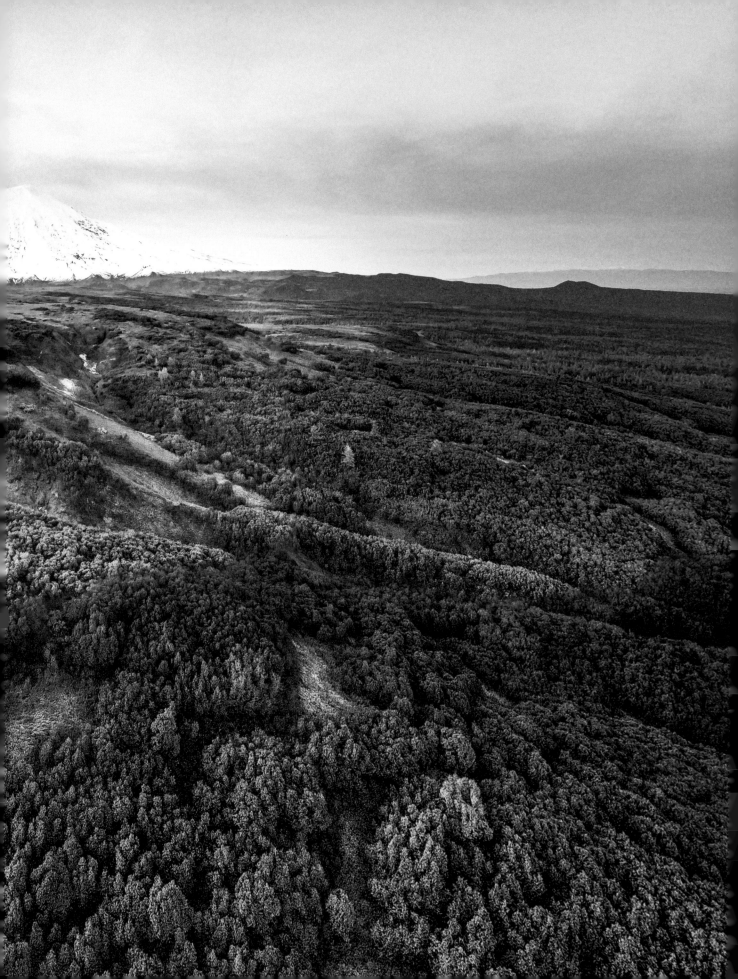

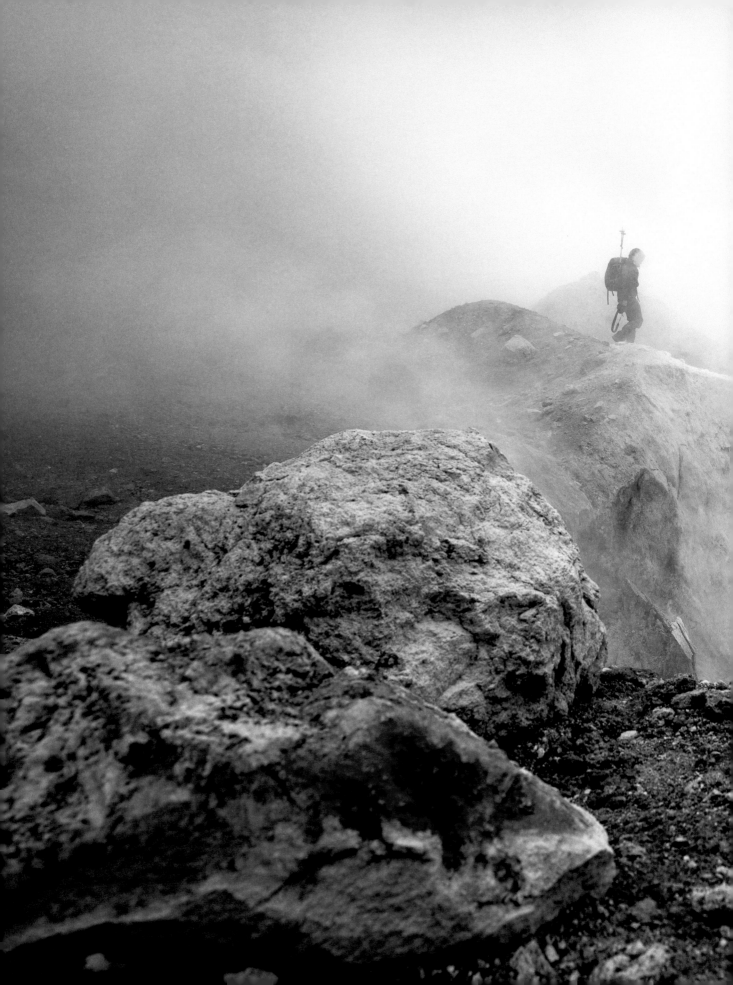

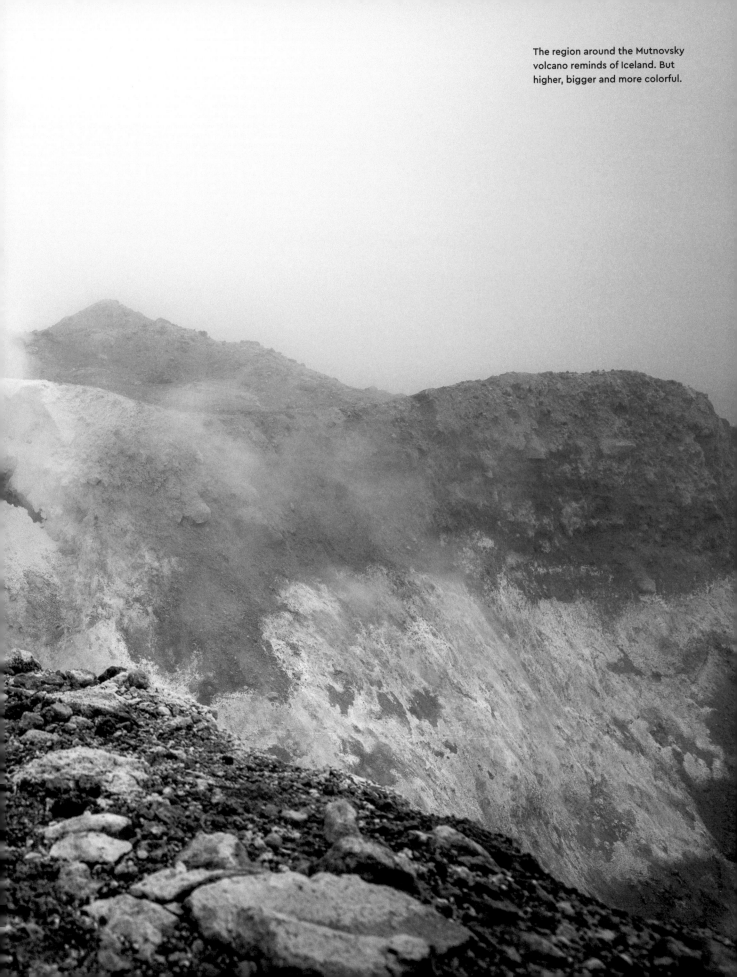

The region around the Mutnovsky volcano reminds of Iceland. But higher, bigger and more colorful.

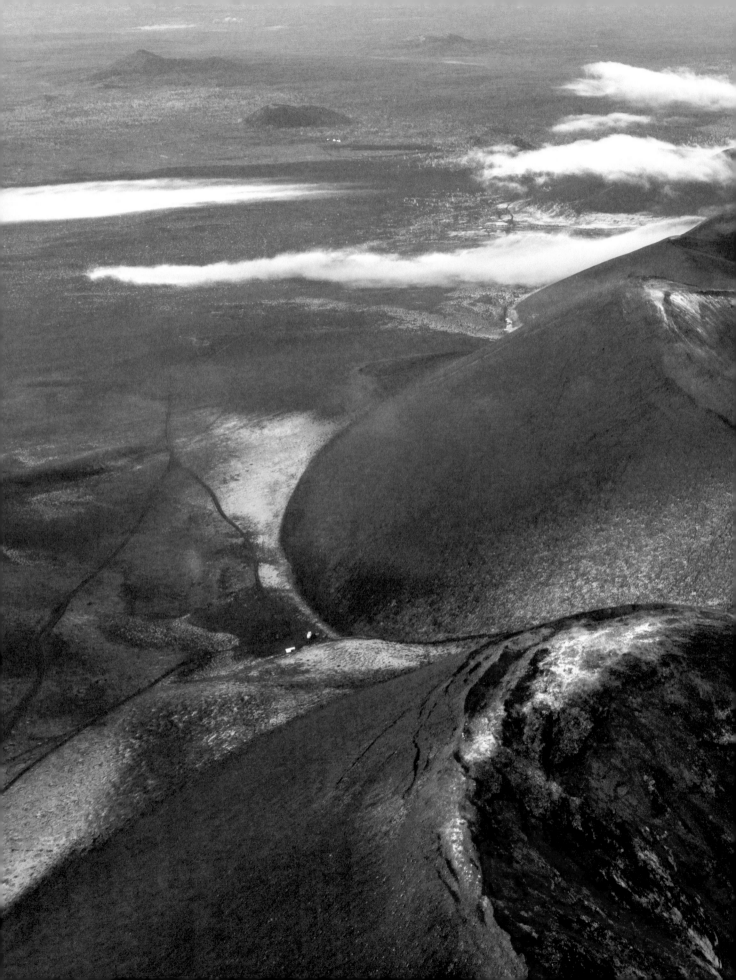

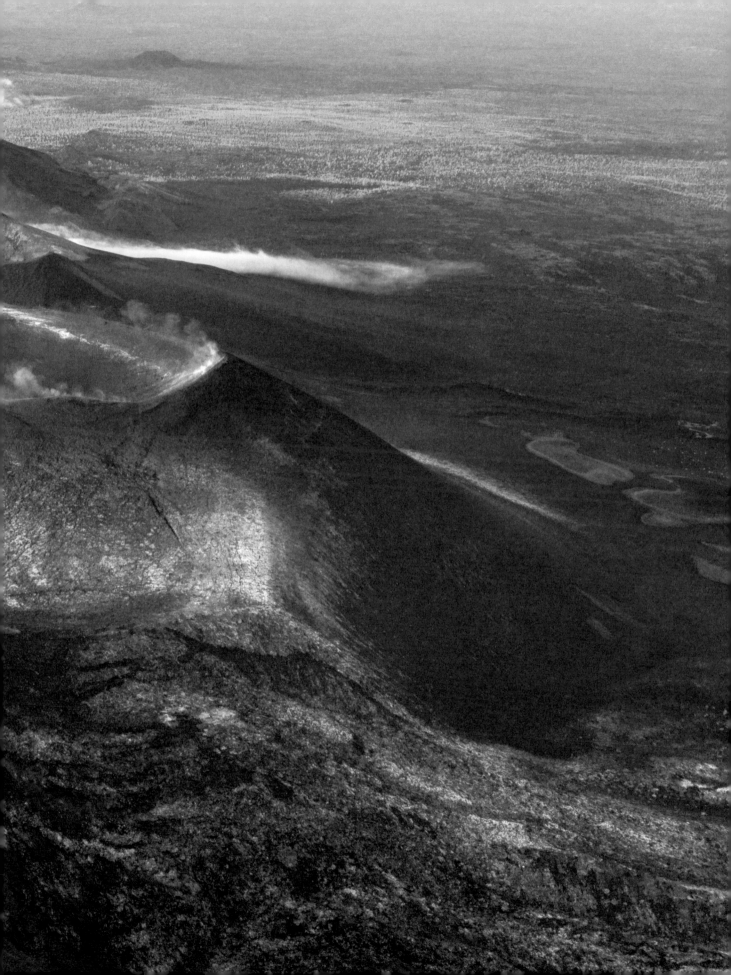

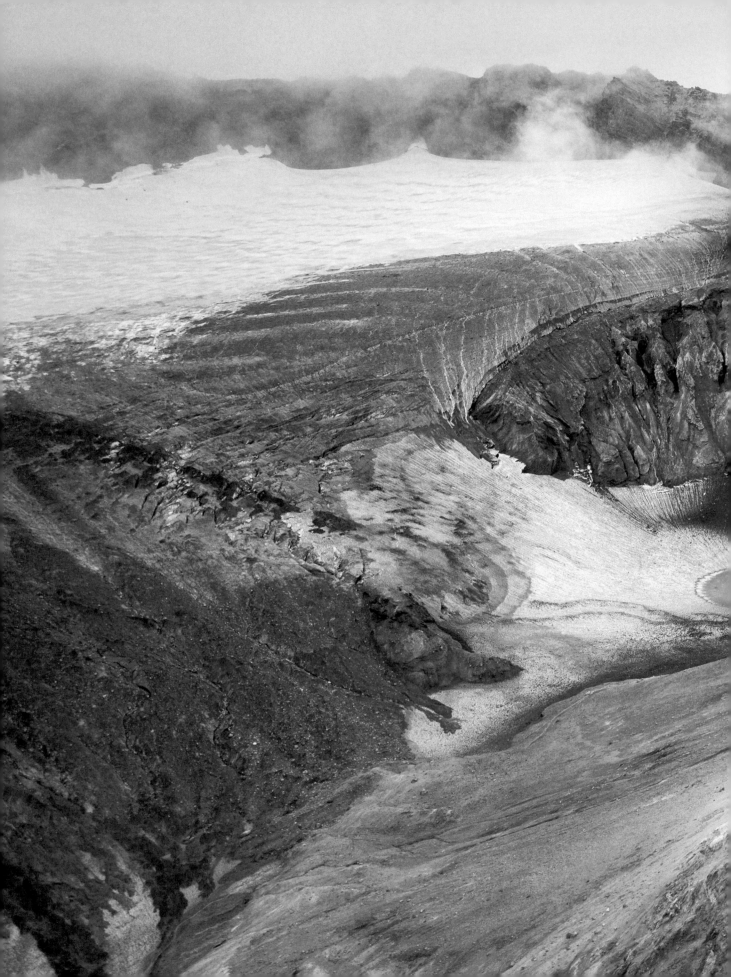

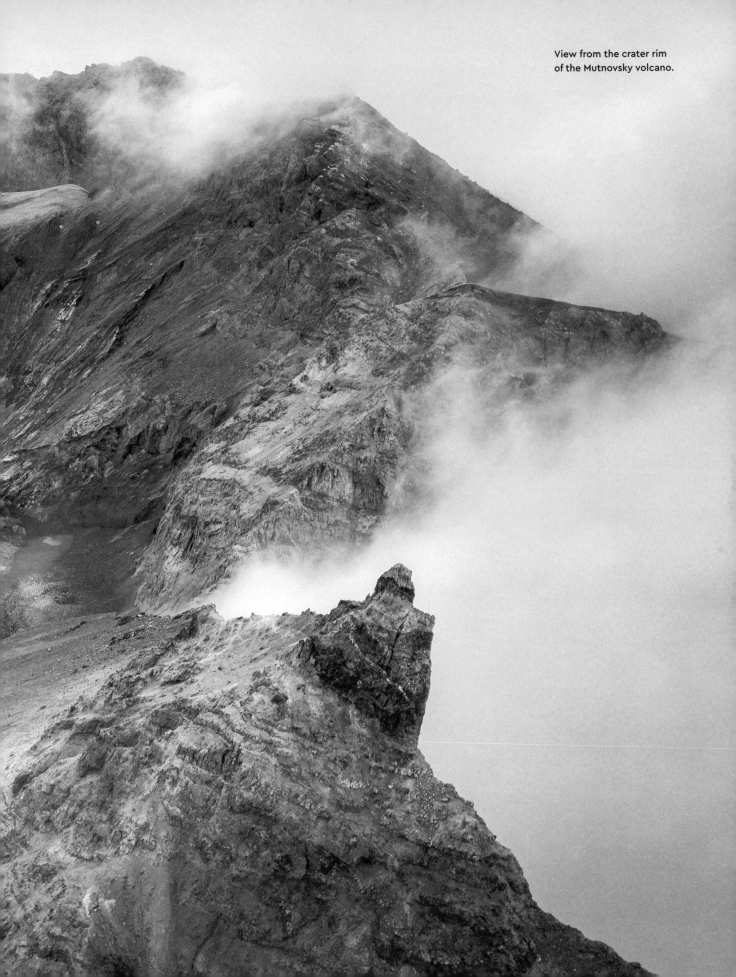

View from the crater rim
of the Mutnovsky volcano.

CUISINE FROM THE ROAD

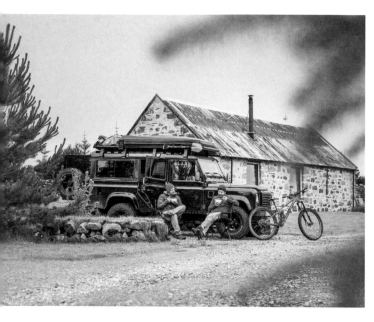

ICELAND
GRILLED LOBSTER TAILS 180
SMOKED PORK BELLY 184

GREENLAND
FRIED HALIBUT 186
PICKLED SALMON 188

KAMCHATKA
BORSCHT 190
SCALLOP CARPACCIO 192
PELMENI 194

ALL-TIME FAVORITES
TOBI'S EGGPLANT CURRY 162
PHILIP'S SIGNATURE BOLOGNESE .. 164
MARKUS' ONE-POT PASTA 166

SCOTLAND
SPICY MUSSELS 168
PAN-ROASTED MUSHROOMS 170
GRILLED VENISON 172
PORRIDGE 174
TWO KINDS OF LAMB 176

FAROE ISLANDS
FAROESE LAMB SHOULDER 178

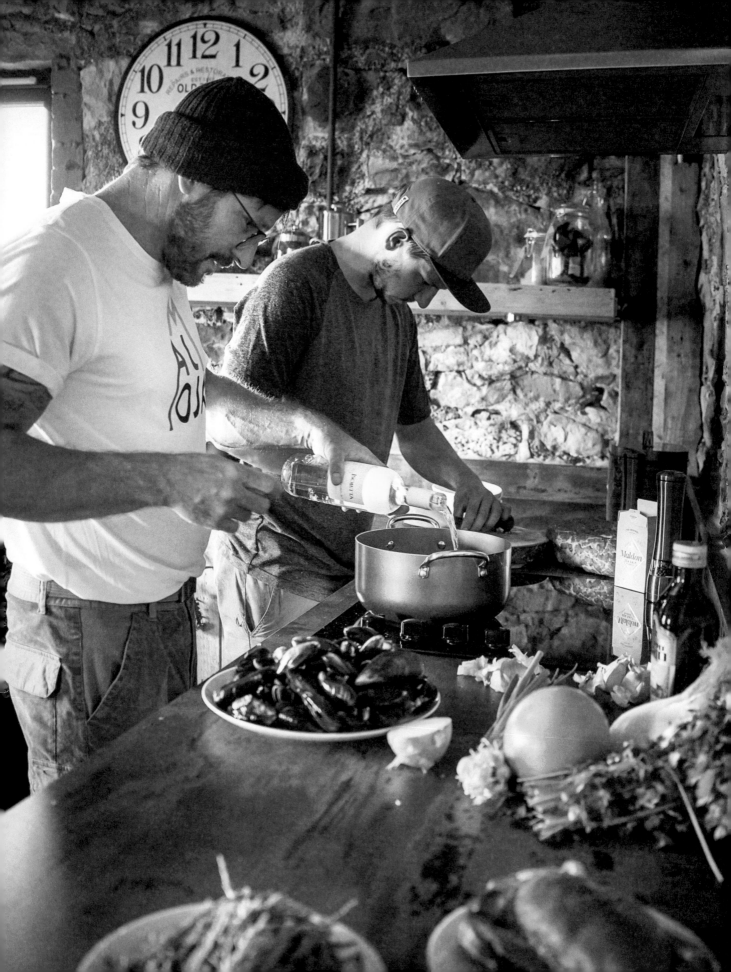

TOBI'S ON-THE-GO EGGPLANT CURRY

The great thing about eggplant curry is that the ingredients are available almost everywhere and do not require cold storage. Whether you are in Greenland or Morocco, this dish can be cooked almost anywhere.

INGREDIENTS
2 servings

2 eggplants
1 onion
2 garlic cloves
1 knob of ginger root
2-3 oz. (60-90 g) Butter
Garam Masala
Salt
Pepper
Honey
Rice

OPTIONAL:
Parsley
Spring onion

Heat around 2 ounces of butter—about a quarter of a standard package of butter—in a pan over medium heat until the whey settles to the bottom. Pour the liquid butter into a large saucepan so that only the whey remains in the pan.
Finely chop the onion, ginger, and garlic, then add to the saucepan and fry.
Dice the eggplants, then add to the saucepan and stir well. If the eggplant begin to look too dry, add more butter. The eggplant should not be seared but slowly boiled down. Stir continuously.
Add salt, pepper, and a good dash of Garam Masala to the eggplant. How much you add is a matter of taste. If you like the spice, use around 2 to 3 teaspoons.
Boil over low heat and stir occasionally until the eggplant is tender and releases some of the butter. Add a teaspoon of honey.
Cook the rice according to the instructions.
Cut the spring onions into thin rings. Just before the rice is ready, add the onions to the eggplant.
When the rice is cooked, place it on the plate with the curry and sprinkle with a little chopped parsley.
Done!

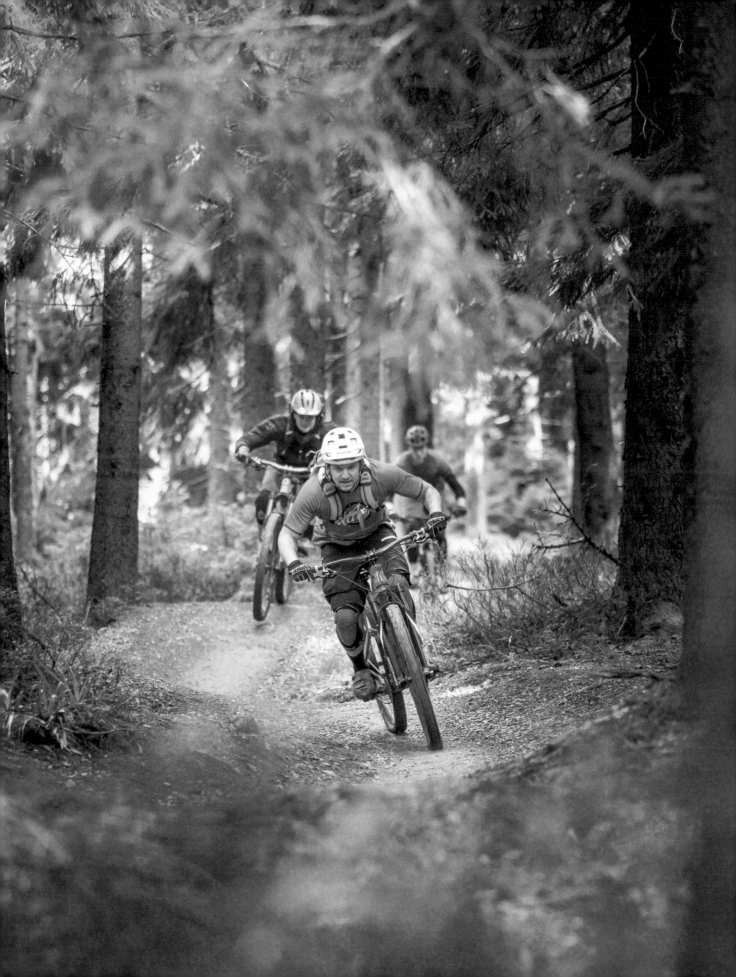

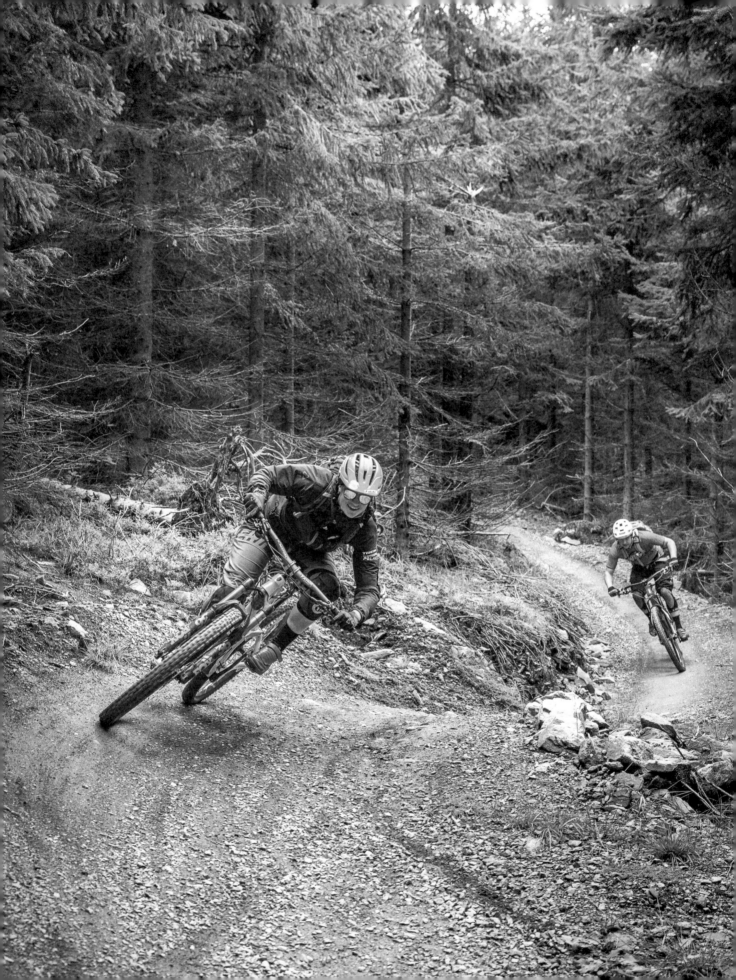

PHILIP'S SIGNATURE BOLOGNESE

Philip associates this recipe with many memories of his childhood. Over the years, he has developed his own version from his mother's recipe and countless visits to restaurants.

INGREDIENTS
4 servings

1 lb. (500 g) ground beef
5.3 oz. (150 g) streaky bacon
3 onions
1 small garlic clove
1 tbsp. balsamic vinegar cream
3⅓ cups (800 ml) of mashed
 tomatoes
Bolognese spice mix
1 lb. (500 g) spaghetti
Parmesan
10-15 cherry tomatoes

Cut the bacon into small cubes and fry in a pan over medium heat.
When it has taken color, remove the bacon from the pan, put it in a bowl, and set aside.
Fry finely chopped onions and garlic in the leftover juice of the bacon.
When they take on color, take off the stove and add them to the bacon in the bowl.
Brown the ground beef in the same pan with the remaining bacon juice.
Season with salt and pepper, and then add the bacon, onion, and garlic mixture to the ground beef and fold in well.
Season with the balsamic vinegar cream and mix well.
Add the mashed tomatoes and stir in well.
Reduce heat and let the mixture boil down, stirring occasionally.
The longer the Bolognese cooks on low heat, the better it will taste in the end.
Make sure that it does not become too dry, and if necessary, add a little more tomatoes or a splash of water.
Bring water to a boil in a large saucepan and add salt. Cook the spaghetti al dente following the package instructions.
Season the Bolognese sauce with another splash of balsamic vinegar cream and the Bolognese spice mix, and place with the pasta on a deep plate.
Halve the cherry tomatoes and place them on top of the pasta.
Sprinkle with a little Parmesan.
Buon appetito!

MARKUS' ONE-POT PASTA
With Smoked Salmon

Fast, uncomplicated, and incredibly tasty— this is what distinguishes hip one-pot pasta. The noodles soak up the flavors of the ingredients, and you really only need a single pot for this quick pasta.

INGREDIENTS
2 servings

1 pt. (½ l) vegetable broth
½ onion
1 garlic clove
2-3 spring onions,
 or 1 leek
4.5 oz. (125 g) smoked
 salmon
9 oz. (250 g) tagliatelle
3.5 oz. (100 g) sour cream
2 cups fresh spinach leaves,
 washed and drained
1 bunch of fresh dill
 or chives, chopped
Juice and zest of ½ lemon
Salt
Pepper

Bring the broth to a boil in a saucepan. Finely chop the onion and garlic, cut the spring onions into strips, and cut the smoked salmon into pieces. Add the pasta, onions, and garlic to the boiling broth. Stir well continuously, ensuring that nothing sticks to the bottom of the pot. After the pasta has been cooking for around two-thirds of the cooking time indicated on the packaging, add sour cream, spring onions, and spinach. Stir in salmon, dill, lemon juice, and zest at the last minute. Season with salt and pepper.
The tagliatelle should be slightly al dente when served, and the sauce should have a wonderful creamy consistency.

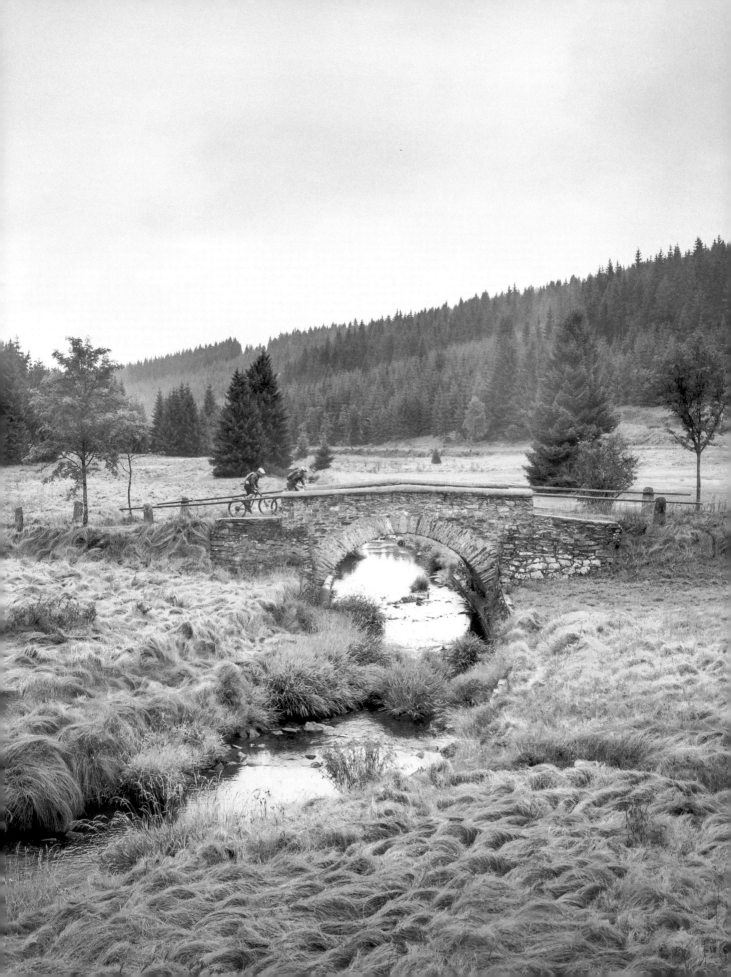

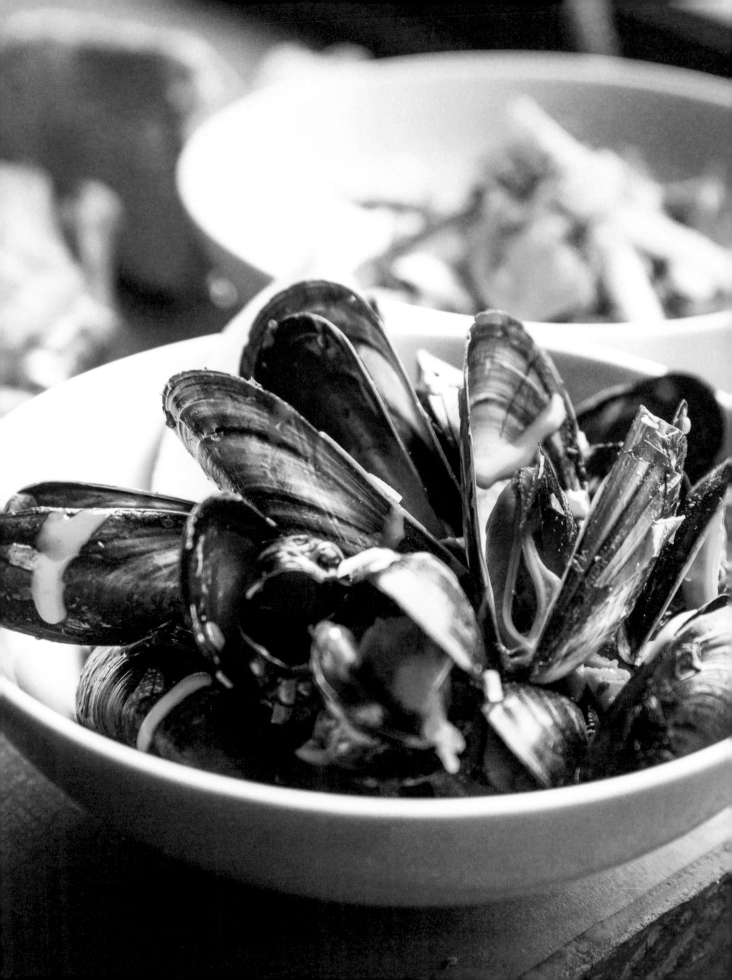

SPICY MUSSELS

With Glasswort Salad

Once again, we were impressed by Scotland's regional seafood. I found inspiration for this colorful dish when I was standing in the rain in the marketplace soaking wet. The cooking session in the cozy, warm—and most importantly—dry bothy resulted in this wonderful mussels dish, which is also great as an appetizer as it combines all five tastes.

INGREDIENTS

2 servings

MUSSELS:
2.2 lb. (1 kg) of mussels
1 cup (¼ l) white wine
½ onion
1 tbsp. olive oil
2 garlic cloves
Salt
Pepper
½ lemon
4 tbsp. mayonnaise
1 tsp. Sriracha, or
 other Asian chili sauce
1 tbsp. lemon juice

GLASSWORT SALAD WITH
GRAPEFRUIT:
2 handfuls of glasswort
1 large grapefruit
½ fennel bulb
2 tbsp. caper berries
3-4 tbsp. olive oil
½ tbsp. honey or
 1 tsp. brown sugar
½ tsp. honey mustard
Salt
Pepper

Mussels should always be fresh, so before cooking, rinse them briefly with cold running water. Then peel the onion and garlic, chop finely, and briefly sauté in a saucepan with olive oil. Add mussels, salt, and pepper, stir briefly, and add the white wine. Add half a cup of water if necessary to ensure the mussels don't stick to the saucepan. Bring the mussels to a boil with the lid closed. Stir occasionally and continue to simmer for about 5 to 10 minutes.

In the meantime, prepare the sauce. Put the mayonnaise, Sriracha, and lemon juice in a bowl and stir.

While the mussels are simmering, wash the glasswort with cold water and drain well. Fillet the grapefruit with a knife and collect the juice. Wash and finely chop the fennel. Mix the grapefruit juice with honey, mustard, and olive oil to make a dressing. Season with a little salt—glasswort tastes salty—and pepper.

Put the glasswort, grapefruit pieces, and caper berries in a bowl, and marinate with the dressing.

Arrange the salad in separate small bowls.

Drain the mussels and place them on top of the salad, drizzle with the mayonnaise sauce and garnish with lemon wedges. Serve everything on a tray with crispy baguette and the remaining sauce.

Preparation time: 20 min.
Cooking time: 10 min.

PAN-ROASTED MUSHROOMS
With Lamb Liver

Mushrooms freshly foraged in the forest are a real delicacy—provided you know for sure what you are collecting or eating. Otherwise, there could be nasty surprises. If you have the slightest doubt as to whether a species is edible, absolutely leave the mushroom or consult an expert. Only pick small amounts and remember to leave some to nature: mushrooms are not long-lasting anyway. Before eating, mushrooms should be cleaned with a knife, not washed with water.

INGREDIENTS
2 servings

1 lb. (500 g) forest
 mushrooms, for example
 chanterelles or porcini
7 oz. (200 g) lamb liver
1 onion
1-2 garlic cloves
1 bunch of parsley
1 tbsp. olive oil,
 or other frying oil
1-2 tbsp. balsamic vinegar
1 tsp. butter
Salt
Pepper

A wonderfully simple dish that can be prepared on a flame almost anytime, anywhere. This dish can be easily made vegetarian by simply leaving out the liver and replacing it with tofu pieces.

We got fresh lamb liver directly from the farmer in Scotland. Alternatively, you could also use veal liver or beef steak strips.

If there is no way to get fresh forest mushrooms, or if they are not in season, you can also use king oyster or portobello mushrooms from the supermarket.

Dab the liver with a paper towel and cut it into cubes. Roughly chop the cleaned mushrooms and peel the onion and garlic. Cut the onion into strips and finely chop the garlic and parsley.

Sear the liver in a pan in hot oil, then add the mushrooms and sauté well, then deglaze with balsamic vinegar and season with salt and pepper. Add the onion, garlic, and butter. Add the chopped parsley just before serving. The liver should still be slightly pink inside when serving, otherwise, it will be too dry.

Instead of reheating, use the leftovers for some crispy crostini. Simply fry, grill or toast a few slices of baguette with a little olive oil and pour the remains from the pan over it.

Preparation time: 30 min. +
24 hrs. rest
Cooking time: 1 hr.

DARREN'S GRILLED VENISON

With Leek Oil and Mashed Celery Root

When we visit Darren in his restaurant, we are more than thrilled. His small kitchen is on the ground floor of an old castle, which is located directly on the Atlantic coast and has been converted into a hotel. It only accommodates a limited number of guests, who all eat here in the evenings. Thanks to his relationship with Niall and the local butchers who work with him, Darren can use top quality meat for his game dishes.

INGREDIENTS
4 servings

Venison steaks, 4 pieces
 of 6.3 oz. (180 g) each
2 leeks
2 cups (500 ml) grapeseed
 oil
¾ cup (200 ml) of chicken
 broth
½ cup (100 ml) game
 stock
Oil
Salt
Pepper

PUREE:
½ lb. (250 g) floury
 potatoes
7 oz. (200 g) celery root
⅔ cup (150 ml) whole milk
1 oz. (30 g) butter
Parmesan
Nutmeg
1 sprig of thyme

Place the venison steaks in a 3 % brine (around ½ tsp. salt per ½ cup (100 ml) water) for 24 hours and store in the refrigerator. Remove the meat from the brine, pat dry and cook in a vacuum-sealed bag (sous vide) for 35 minutes at 130 °F (55 °C).

Peel the potatoes and celery root, and cook in salted water. Add the sprig of thyme to the water.

Wash the green heads of two leeks and cut them into fine rings.

Heat the grapeseed oil to 160 °F (70 °C) and add leeks. Fry for 6 minutes and stir occasionally. Remove leeks from pan and let cool in a bowl, reserving the oil.

Heat the chicken stock and game stock in a saucepan and let them boil down slightly at a low temperature, then season with salt and pepper.

Drain the potatoes and celery root. First, crush them in a bowl with a fork and then puree with a hand blender. Add the butter, milk, and nutmeg into the mixture and season with salt and pepper. Then keep the puree warm.

Meanwhile, heat a charcoal grill to 650 °F to 750 °F (350 to 400 °C) and sear the meat.

Cut the meat into strips and add it to the center of the plate on the celery root puree.

Remove the broth from the stove and mix with a little reserved leek oil. Pour into a small bowl. Pour a drizzle of leek oil on the meat and the puree on the plate.

Serve everything together.

PORRIDGE

With Honey and Wild Berries

Originally from Scotland, warm oatmeal was not considered a delicacy for a long time. But it has since blossomed into a trendy athlete's breakfast—and for good reason. There are countless tasty variations, and due to its relatively high carbohydrate and liquid content, it is a suitable meal to start an active day.

INGREDIENTS

2 servings

1 cup fine oat flakes
1 tsp. cane sugar
1 pinch of cinnamon
1 cup water
1 cup dairy, almond
 or oat milk
1-2 tbsp. honey
4 tbsp. mixed wild berries

Simmer the oat flakes with milk, water, cinnamon, and sugar while stirring continually until a creamy porridge is formed. Divide the porridge between two bowls or cups.

Sprinkle the berries on top and garnish with honey. If you like, you can also add nuts, roasted seeds, or other fruit. If you use apple or pear, grate coarsely beforehand and cook briefly in the porridge.

Preparation time: 15 min. +
time to heat the grill
Cooking time: 1 hr.

TWO KINDS OF LAMB
(Skewers and Ribs)

As a follower of the nose-to-tail movement, I believe it's important to use the lesser-known and unpopular meat pieces and create a tasty dish from them. Following this tradition of cooking all edible parts, you get significantly more servings per slaughtered animal, which makes meat consumption more sustainable. Offal is not for everyone, at least not yet. Although lamb heart, liver, and ribs are not available everywhere in the world, in Scotland they are available at every good butcher. Alternatively, for this recipe, you can use beef or veal for the skewers, and pork for the ribs.

INGREDIENTS
2 servings

LAMB RIBS:
1 lb. (500 g) lamb ribs
1 pt. (½ l.) ale,
 or other dark beer
4 tbsp. ketchup,
 or barbecue sauce
2 tbsp. honey
1 tbsp. cane sugar
1 tsp. Worcestershire
 sauce
1-2 garlic cloves
Salt
Pepper
1 small chili pepper,
 optional

LAMB SKEWERS:
½ lb. (200 g) lamb liver
½ lb. (200 g) lamb heart
Salt
Pepper

Simmer the ribs in a saucepan with salted water and three-quarters of the beer for about 30 minutes. The ribs should be just slightly covered.

In the meantime, peel the garlic and chop finely. Stir together the ketchup or barbecue sauce, honey, cane sugar, and Worcestershire sauce to make a marinade, then add the garlic. Stir in the rest of the beer, season with salt and pepper, and add chopped chili pepper if you like.

Drain the ribs and place them on a medium-hot grill. Keep some of the hot cooking liquid and stir a few tablespoons into the marinade.

Turn the ribs occasionally and keep brushing the marinade on both sides. Grill the ribs gently for about 20 to 30 minutes until they shine beautifully, possibly putting the lid on the grill.

Dab the liver and heart well with a paper towel, and use a sharp knife to remove any fibers that have grown on them. Slice into cubes and put on metal skewers. Season with salt and pepper, and place the skewers on the grill for the last 10 minutes of the ribs cooking time. Brush with a little marinade to taste.

A crisp green salad and grilled white bread are the perfect side dishes to the ribs and skewers. You can also serve baked potatoes with quark and herbs or potato wedges.

Preparation time: 10 min. +
at least 48 hrs. marinating time
Cooking time: 10 hrs.

FAROESE LAMB SHOULDER

In Black Beer

In the Faroese capital Tórshavn, we ate in one of the most rustic restaurants on the island, famous for its phenomenal shoulder of lamb that's known even beyond the borders of Faroe. This dish combines two things of which the Faroese are particularly proud: lamb and beer.

INGREDIENTS

2-4 servings,
depending on the size
of the lamb shoulder

1 shoulder of lamb
2 pt. (1 l) black beer
Salt
Pepper
Rapeseed oil

Place the shoulder of lamb into a large ziplock or vacuum bag and pour the black beer inside—without adding any spices—so that the beer completely covers the lamb. The size of the shoulder determines the amount of beer needed, but the rule is actually quite simple: too much beer is almost impossible, but too little is possible. Using an air-tight bag is also crucial. If you use a bowl or roasting tin, the meat will float in the beer and could dry out in the air.

Store the bag in the fridge for at least 48 hours. However, the time span can be extended considerably up to 3 or 4 days. The longer the meat soaks in the beer, the stronger the taste.

When you are ready to cook, take the shoulder out of the bag and reserve the beer stock for later. Dab the shoulder with a kitchen towel and fry it in rapeseed oil in a large pan with salt and pepper. Then deglaze with half of the black beer stock and let it stew at 200 °F (95 °C) for 10 hours.

After braising, season the roast stock with salt and pepper and serve everything together with vegetables. Root vegetables roasted in the oven provide the perfect accompaniment.

GRILLED LOBSTER TAILS

With Orange Cocktail Sauce

Preparation time: 10 min.
Cooking time: 25 min.

For years, lobsters were on every menu in Iceland and were prepared in all types of ways. But with the rise of tourism and the increasing demand for these delicious little crustaceans, it's become more difficult for restaurants to access sufficient supply. Now you need to search for a restaurant that serves lobster, where it's often not displayed on the menu and instead only available by special request in order to reserve the dish for locals. So if you know where to look, or you are with people who know their way around, lobster can still be found.

INGREDIENTS
2 servings

3 lobster tails
⅓ lb. (125 g) butter
Garlic
Thyme
Dill
Chives
Salt
Pepper

FOR THE ORANGE
COCKTAIL SAUCE:
½ cup (100 ml) mayonnaise
½ cup (100 ml) ketchup
1 organic orange, grated
3 tbsp. Grand Marnier

Set up a charcoal kettle barbeque with a zone of indirect heat up to 480 °F (250 °C).

Cut the lobster tails in half and sear both sides of them quickly on high heat. Place them on the indirectly heated side of the grill and let them simmer for 2 minutes.

In the meantime, place a cast-iron pan on the grill and fry the chopped garlic and herbs briefly in the melted butter. Season to taste with salt. Extra salt can be added here as the lobster tails are not seasoned. Put the lobster tails into the pan and spoon the herb butter over them evenly.

Switch the pan to the indirectly heated side, close the lid for a few minutes until the lobsters are cooked. Sprinkle them with the melted herb butter from time to time.

Mix the mayonnaise, ketchup, grated orange, and Grand Marnier thoroughly and place on a plate with the lobster tails. Serve with a fresh salad and light, airy bread to accompany the lobster.

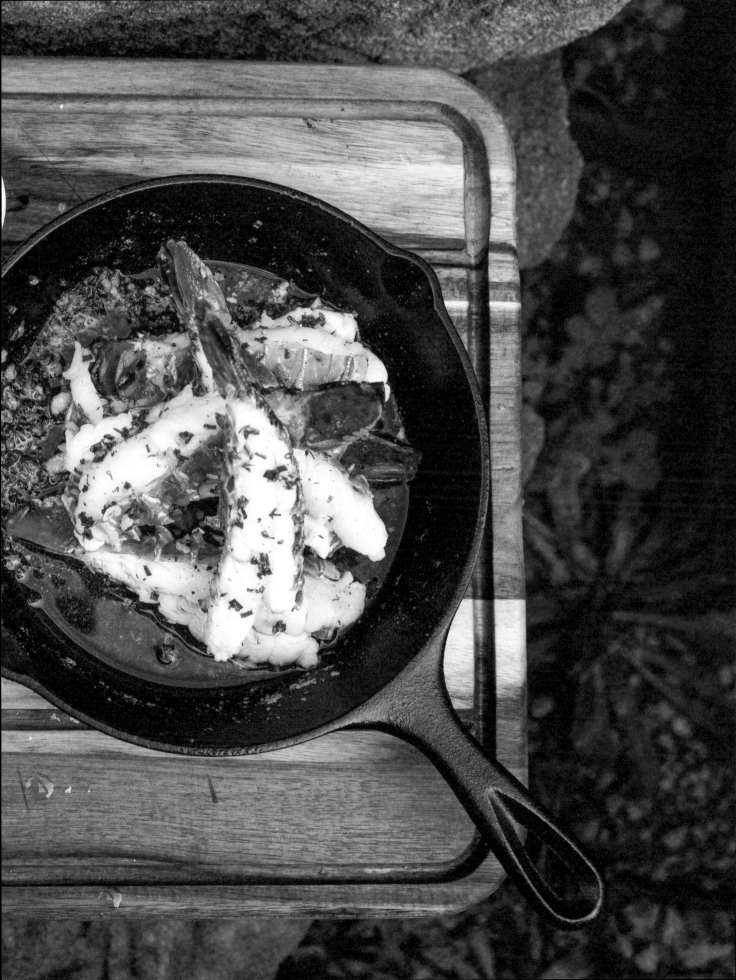

Preparation time: 1.5 hrs.,
including 1 hr. the day before
Cooking time: about 3.5 hrs.

ICELANDIC PORK BELLY

With Pumpkin Cream and Winter Vegetables

The new Nordic cuisine, in which regionality and seasonality play a major role, has found its way to Iceland. Since the summers in Iceland are short, cold, and windy, not all ingredients are always available locally. Therefore, cabbage and pumpkin are often used because they are easy to store.

INGREDIENTS
6 servings

1 lb. (500g) boneless
 pork belly
¾ cup (200 ml) craft beer
1 tbsp. cherry chipotle
7 oz. (200 g) brussels
 sprouts
7 oz. (200 g) parsnips
7 oz. (200 g) carrots
1 lb. (500 g) butter

PUMPKIN CREAM:
Half of Hokkaido
 pumpkin, pitted
3.5 oz. (100 g) butter
Salt
Pepper
Nutmeg

Use a box knife to carve a chessboard pattern into the rind of the pork. Make sure that the cut is not so deep that it goes into the meat, otherwise, the rind will fall off after cooking.

Mix the beer with the cherry chipotle, and spray it into the pork belly at several points using a meat injector. Also, rub the outside of the pork belly with the mixture and, if possible, put it in the fridge overnight.

Fire up the smoker and bring it to a constant temperature of 230 °F (110 °C). Place the pork belly in the smoker with the rind facing up and smoke for 3 hours.

After 2 hours, place the pitted pumpkin half on baking paper with the fruit flesh facing down. Put it in the smoker and cook for about 45 minutes.

Wash the parsnips and carrots, and cut them into 1 inch-wide (2 cm-wide) pieces so that everything cooks evenly. Place the pieces with a little salt in a saucepan with water, and then place on the smoker's firebox 30 minutes before serving and cook.

Take the pumpkin out of the smoker. Use a spoon to scoop out the pulp and place in a bowl, then add the butter and nutmeg. Mix with a blender. Season to taste with salt and pepper.

Increase the temperature in the smoker to 390 °F (200 °C) to give the belly the final touch.

Drain the vegetables and reserve about ⅔ cup (150 ml) of the cooking water. Whisk the water and the butter to a frothy sauce, add parsley, and add to the vegetables.

To serve, spread a serving of pumpkin puree on a plate. Cut the pork belly into slices and arrange on the pumpkin puree, and then place vegetables next to the pumpkin puree.

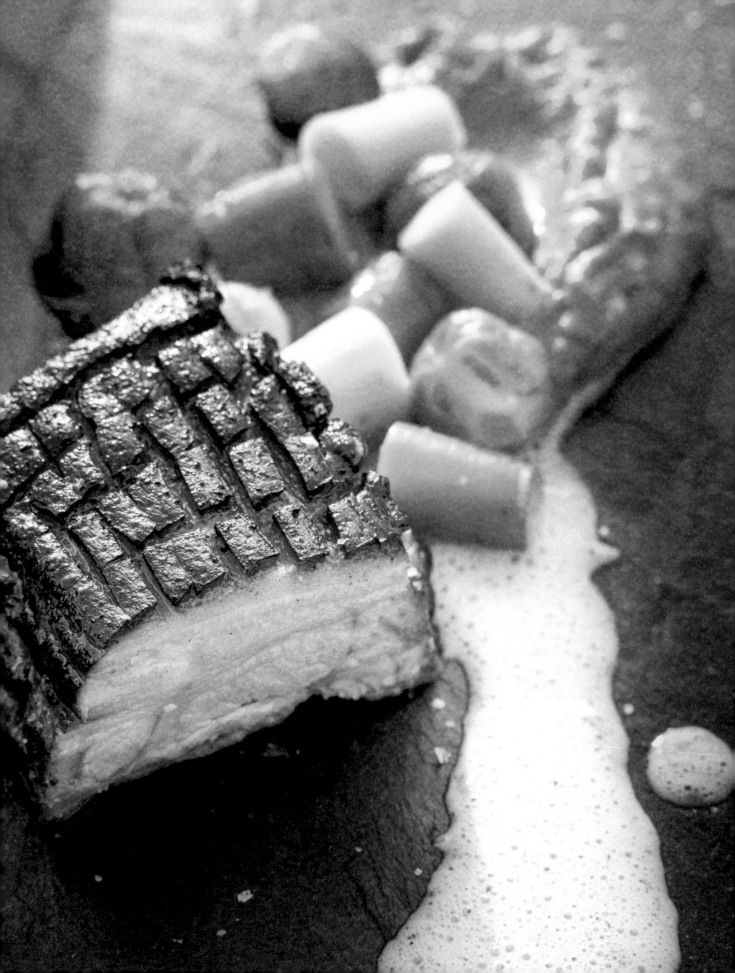

FRIED HALIBUT
In a Shallot and Red Wine Sauce

Preparation time: 10 min.
Cooking time: 1 hr.

Of course, fish is at the top of the menu in Greenland and served in a wide variety of ways and methods of preparation. Simon explains that he has to wait almost four weeks for various ingredients to arrive from Denmark by ship, and as a result, they are not as fresh as he prefers. That is why he uses as many local products as possible. The fish on his plate could hardly be any fresher.

INGREDIENTS
4 servings

Halibut, 4 pieces of
 around 3 oz. (80 g) each
10 shallots
⅔ cup (150 ml) of
 white wine vinegar
2 tsp. sugar
¾ cup (200 ml) of red wine
3.5 oz. (100 g) crème
 fraîche
⅔ cup (150 g) of cream
3.5 oz. (100 g)
 cold butter, cut into
 small pieces
2 garlic cloves
Salt
Pepper
Parsley, for garnish

Peel the 4 smallest shallots, cut them in half, and heat them with the cut side down in a pan with a little oil. When the shallots begin to take on color, deglaze with ¼ cup (50 ml) of white wine vinegar and immediately add 2 teaspoons of sugar. Carefully turn the shallots and let them caramelize. When the liquid has boiled, remove the shallots from the heat and set them aside.

Peel the rest of the shallots, chop them and sweat them in a saucepan with a little oil. When the shallots take on color, add the remaining white wine vinegar. When the hissing stops, add the red wine and cook the shallots over a medium flame until the liquid is reduced by about half.

Heat a pan with butter over medium heat and add two halved cloves of garlic, cut side facing down. Season with salt.

Put the fish in the pan and fry in the butter. Keep pouring the liquid butter over the fish with a spoon. Turn the fish over after 3 to 5 minutes.

Add the crème fraîche and cream to the shallot red wine sauce and mix together with a hand blender. As soon as a creamy mixture is formed, gradually mix in the pieces of cold butter. Hold the blender at an angle: a third of the blender's head remains above the surface and draws some air, making the sauce foamy. Season with salt and pepper.

Put the sauce in a deep plate and put the fish in the middle. Place the glazed shallots around the fish in a semi-circle. Garnish with a little parsley if you like.

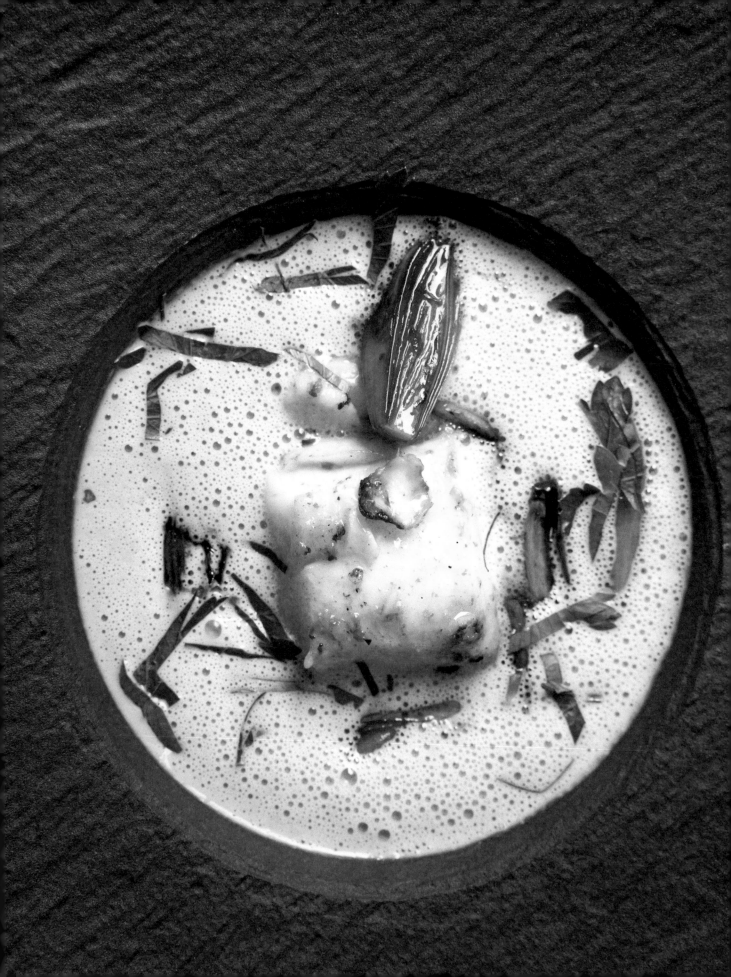

SIMON'S PICKLED SALMON
With Fermented Fennel and Star Anise

Preparation time: 2 weeks
Cooking time: 40 min.

Fermentation is one of the oldest methods of preserving food. The best known fermented food in Germany is probably sauerkraut. But you can also ferment many other things. And when you run a restaurant in a country like Greenland, you have to be resourceful to keep the kitchen going and use the ingredients available. Simon also uses ancient techniques, which he combines in his recipes with modern processes.

INGREDIENTS
4 servings

FERMENTED FENNEL:
1 lb. (500 g) fennel
2½ tsp. salt

SALMON:
10.5 oz. (300 g) salmon
 fillet
⅓ cup (65 g) of sugar
2 tbsp. salt
1 tsp. star anise
½ tsp. fennel seeds

STAR ANISE CREAM:
3.5 oz. (100 g) crème
 fraîche
3.5 oz. (100 g) whipped
 cream
½ tsp. star anise,
 mortared
1 pinch of sugar
1 pinch of salt
Dill

Slice the fennel thinly and cut it once in the middle to form strips around ¾ inch to 1 inch (2 to 3 cm) long.

Mix the fennel strips well with the salt, and put them in a vacuum or ziplock bag. Seal the bag airtight and store at room temperature for 3 to 5 days, until the bag bulges like a pillow through the fermentation process.

Cut the bag open, place the fennel in a new sealed bag, and put it in the fridge for at least a week. After that, the fennel is nonperishable for several months.

Grind star anise and fennel seeds into a powder using a mortar and pestle. Put the mixture through a sieve in a bowl, and mix with the sugar and salt.

Cut the salmon into four equal slices, sprinkle the spice mixture on all sides, and rub in well. Now put in the fridge for 10 to 12 hours, until the sugar and salt have drawn the water out of the fish.

Mix the crème fraîche and the whipped cream, and season with salt, sugar, and anise. Beat the mixture airily.

Take the salmon out of the fridge and place it in a circle on a plate, put fennel in the middle, and spread the anise cream spottily.

Finally, garnish with a little chopped dill.

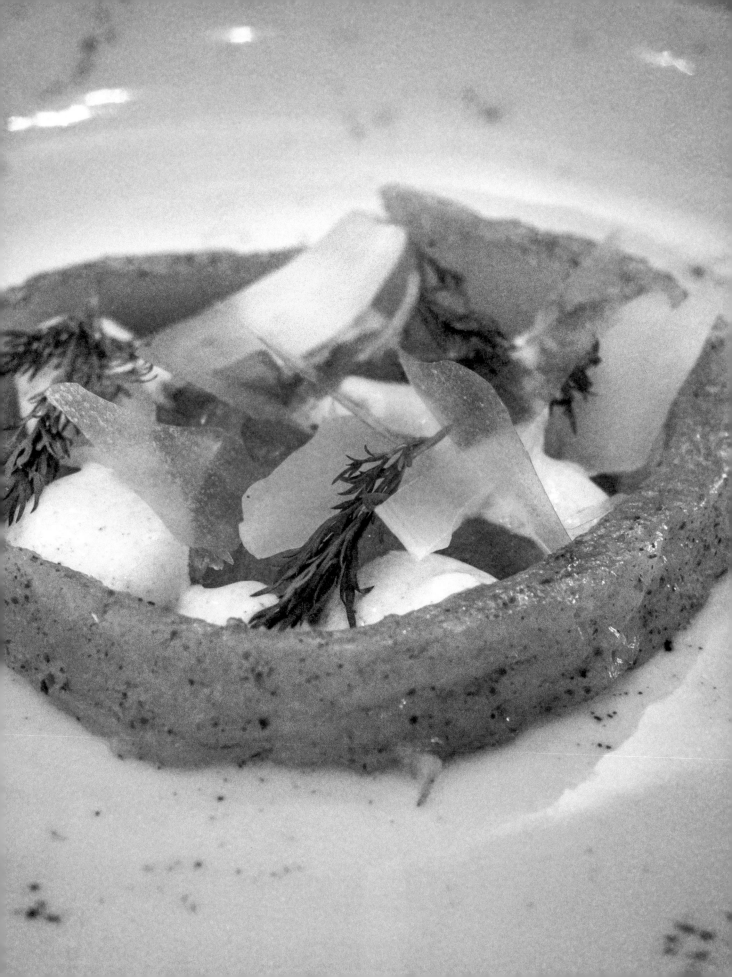

BORSCHT

Preparation time: 30 min.
Cooking time: about 2.5 hrs.

It was a long day on the road. In our Kamaz—a Russian brand of off-road trucks—we drove for hours through the hinterland around the Tolbachik volcano. We put up our tents in icy temperatures and stormy weather on a plateau at the foot of the volcano, which was close to a little shelter. We were all shaken and frozen. In the hut, we sat tightly together around a table that could easily be converted into a bed at night and tried to get the feeling back in our feet and fingers. Everyone was relieved when our cook Anja came in with a large pot of borscht—the best way to prepare yourself for an icy night in a tent.

INGREDIENTS
3-4 servings

12-14 oz. (350-400 g) beef
1 pt. (500 ml) beef broth
1 beetroot
7 oz. (200 g) white
 cabbage
2 potatoes
1 carrot
1 onion
2 tomatoes or
2 tbsp. tomato sauce
1 tbsp. vinegar
1 tbsp. sugar
1 bay leaf
1 garlic clove
1 pinch of sugar
Salt
Pepper
Vegetable oil

Cover the meat with water in a saucepan and cook on a low heat for two hours.

Peel the beetroot, carrot, garlic, and onion, and cut into strips.

In a second saucepan, fry the onions and garlic until glassy with a little oil and a pinch of sugar, then add the carrots and beetroot and deglaze with the vinegar.

Add tomatoes and broth, and braise for about 15 to 20 minutes.

Next, cut the cabbage into strips and add to the vegetables in the pot. Braise everything for another 15 to 20 minutes.

After cooking, remove the meat from the cooking water, cut into cubes, and put in the saucepan with the vegetables. Peel and dice the potatoes, and then add them to the pot. Simmer for another 7 to 10 minutes until the potatoes are done.

Take the soup off the stove and let it steep for 20 minutes. Now it is ready to serve. Season to taste with dill, coriander, and sour cream.

Preparation time: 2 hrs.
Cooking time: 75 min.

SCALLOP CARPACCIO
With Smoked Lemon and Mango Mayonnaise

We mainly survived on fish soup and tea while on the road in Kamchatka, exploring the region around Tolbachik. During the lengthy car journey towards Petropavlovsk, the capital of Kamchatka, we were longing for a satisfying restaurant to get to know the local cuisine better. We discovered this dish, which combines regional products with modern twists.

INGREDIENTS
2 servings

MANGO MAYONNAISE:
1 egg, room temperature
2 tsp. mustard
¾ cup (200 ml) rapeseed
 oil
Salt
Pepper
Half of a mango, peeled

SCALLOP CARPACCIO:
2 scallops, as fresh
 as possible. Use frozen
 if you don't trust
 how long they have been
 on the fresh counter
1 lemon
2 tbsp. butter
Half a bunch of chives
Smoking chips
Wild berries

For the smoked lemon, light the grill and add the smoking chips, which have been soaked for two hours, directly onto the red hot coals. Place the halves of lemon onto indirect heat and close the lid to smoke for one hour.

For the mayonnaise, ensure all the ingredients are at room temperature, otherwise they will not combine correctly. Put the egg, salt, and pepper into a food processor and whisk. Slowly drizzle the oil into the mixture. It is important to add the oil gently and slowly enough that the trickle does not break off. Puree the peeled mango in a blender. Add the mango puree to the finished mayonnaise. Season with salt to taste.

Cut the scallops into thin slices with a sharp knife, and lay them onto the fan side of the scallop shells. Heat the butter in a small pan and squeeze in the juice of the smoked lemon. Chop the chives and add them to the butter lemon sauce. Place the mayonnaise onto the back of each shell, and pour the butter lemon sauce over the carpaccio. To serve, sprinkle finely chopped wild berries over the scallops to give them color and sweetness.

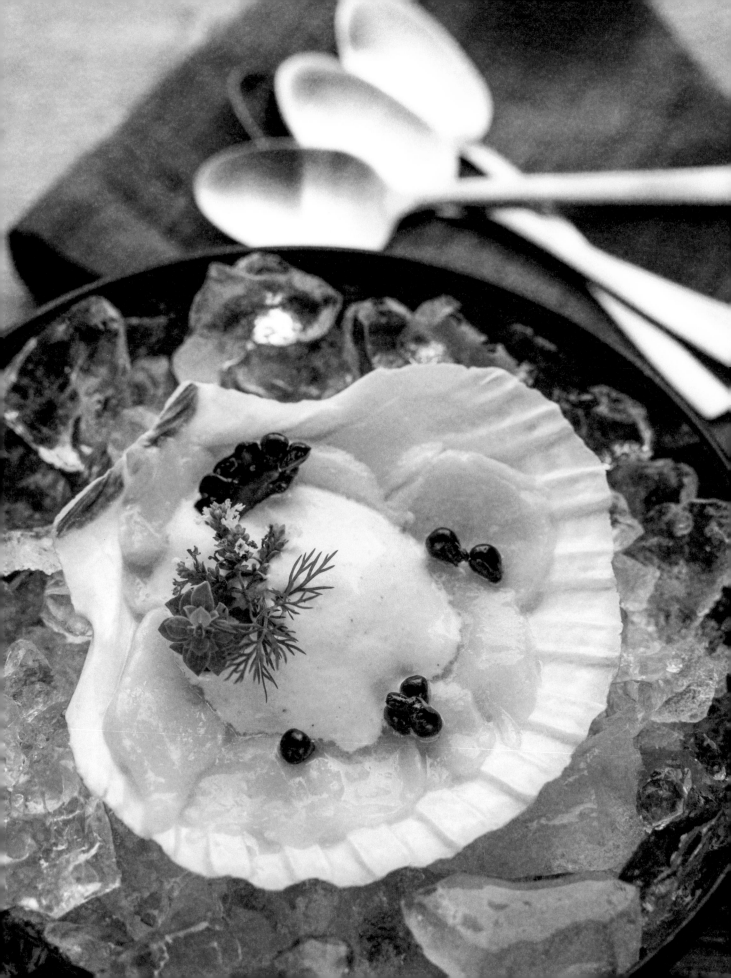

PELMENI
With Salmon Filling

Preparation time: 10 min.
Cooking time: 20 min.

Whether it's ravioli in Italy, wonton in China, or pelmeni in Russia, every country has its own style of dumplings—similar in principle, but culminating in very different tastes. Pelmeni are traditionally filled with minced meat, but in Kamchatka, salmon is particularly popular. They are usually served in a broth with dill and sour cream.

INGREDIENTS
2-3 servings

1½ cups (200 g) of flour
5.3 oz. (150 g) salmon
 fillet, skinless
2 garlic cloves
2 eggs
Salt
Pepper
Dill
1 tbsp. sour cream
1 tbsp. cold water
1 tbsp. of olive oil
2 qt. (2 l) vegetable
 stock

Mix the flour, eggs, a pinch of salt, olive oil, and 1 tablespoon of cold water in a food processor, or knead by hand into a smooth dough.

Cut the salmon into a fine tartar, and mix with finely chopped garlic. Finely chop the dill stalks and stir into the tartar with salt, pepper, and sour cream.

Roll out the pasta dough around 0,2 inch to 0,4 inch (0,5 to 1 mm) thick. It is important to fold and roll out the dough over and over until it becomes smooth and binds together well, so it does not dissolve in the stock afterward. Cut out circles from the finished dough. You can use a glass as a template.

Place around one teaspoon of the salmon tartar in the middle of each dough circle, then fold in half to form a crescent and press together well. To securely seal the edges of the dumpling, brush the edges with water.

Bring the vegetable stock to a boil, and cook the dumplings for about 10 minutes. Serve the cooked pelmeni with finely chopped dill and sour cream on the side.

NORDIC CYCLE

Bicycle Adventures
in the North

This book was conceived, edited, and designed by gestalten.

Contributing editor: **Tobias Woggon**
Edited by **Robert Klanten** and **Maria-Elisabeth Niebius**

Written by **Tobias Woggon** and **Thomas Lambertz**
Recipes on pages 166, 169, 170, 174 and 176 by **Markus Sämmer**

Design, layout and cover by **Léon Giogoli**

Typefaces: Cera Pro by **Jakob Runge**,
Lab Mono by **Martin Wecke**

Cover photography and images by **Philip Ruopp**

Printed by Grafisches Centrum Cuno, Calbe
Made in Germany

Published by gestalten, Berlin 2020
ISBN 978-3-89955-863-0

Special thanks to: **Thomas Lambertz**

Asta Briem und **Magne Kvam** (Icebike Adventures),
Anette und **Bo Lings** (Hotel Sisimiut), **Alex Pugovkin**
(Kamchatka Freeride Community), **Niall Rowantree**
(West Highland Hunting), **Alexander Schulz**,
Philipp Heinrich, **Dirk Meinel**. **Thomas Slavic**,

Greta Weithaler, **Michal Prokop**, **Max Schumann**,
Steffi Marth, **Simon Harrisson**, **Darren Ross**

Birgit und **Hartmut Woggon**, **Hans-Ulrich-Werner
Ruopp** und **Monika Schwenk**.

© Die Gestalten Verlag GmbH & Co. KG, Berlin 2020

All rights reserved. No part of this publication may
be reproduced or transmitted in any form or by any
means, electronic or mechanical, including
photocopy or any storage and retrieval system,
without permission in writing from the publisher.

Respect copyrights, encourage creativity!

For more information, and to order books, please visit
www.gestalten.com

Bibliographic information published by the Deutsche
Nationalbibliothek. The Deutsche Nationalbibliothek
lists this publication in the Deutsche Nationalbibliografie;
detailed bibliographic data is available online at
www.dnb.de

This book was printed on
paper certified according
to the standards of the FSC®.

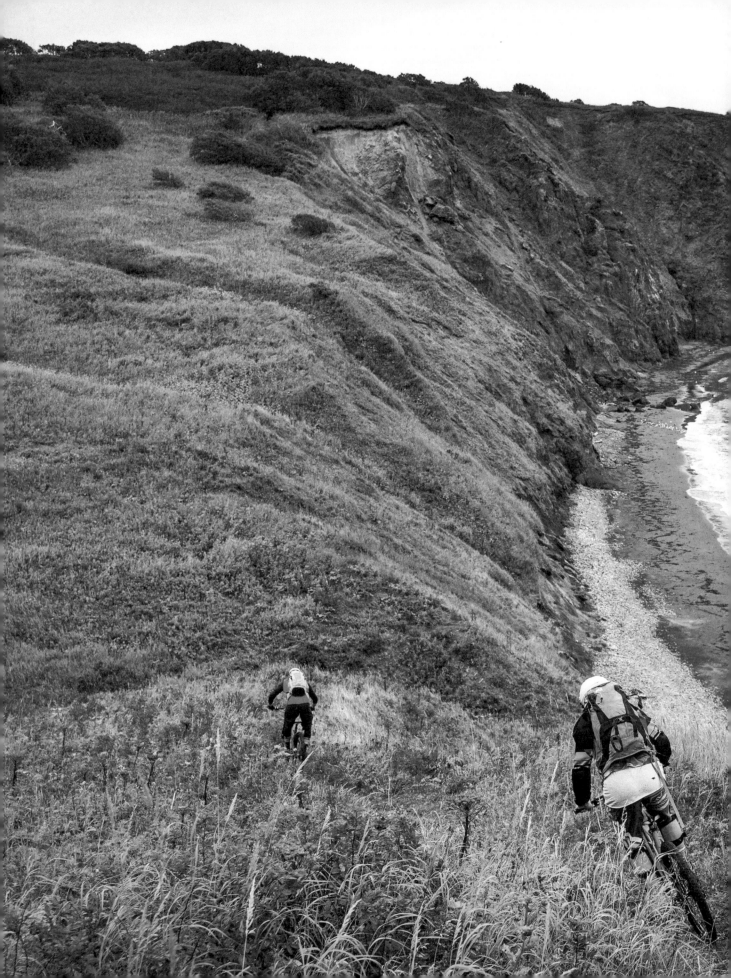